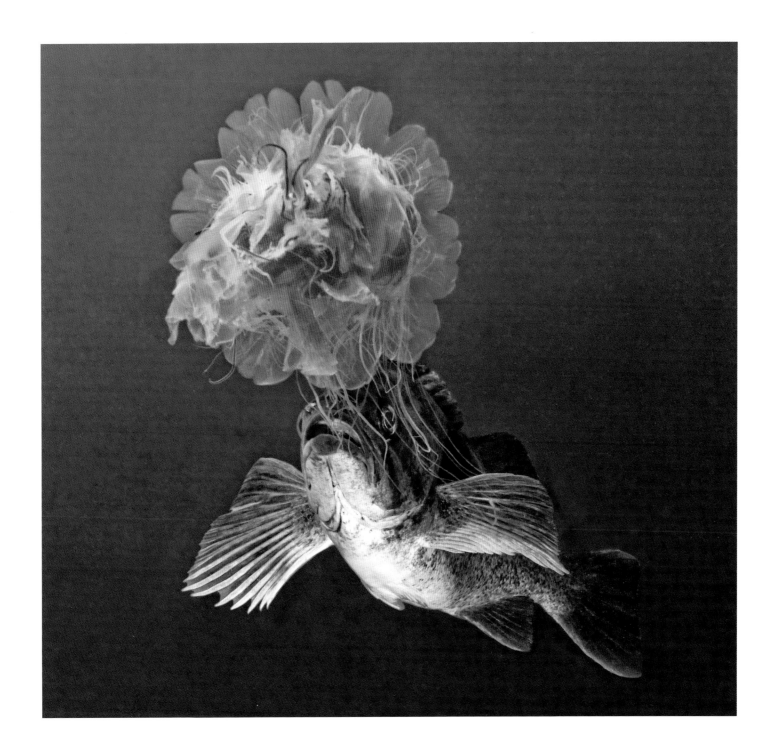

BENEATH

THE UNDERWATER WILDERNESS
OF THE PACIFIC NORTHWEST

text and photography by

DAVID HALL

foreword by **CHRISTOPHER NEWBERT**

introduction by **SARIKA CULLIS-SUZUKI**

COLD SEAS

 David Suzuki Foundation

 GREYSTONE BOOKS
Vancouver/Berkeley

 UNIVERSITY OF
WASHINGTON PRESS
Seattle

For Gayle Jamison—my wife,
best friend, dive companion, travel agent,
editor, and ambassador-at-large

15 16 17 18 19 5 4 3 2 1 15 16 17 18 19 5 4 3 2 1

Published in Canada by
Greystone Books Ltd.
www.greystonebooks.com

David Suzuki Foundation
219–2211 West 4th Avenue
Vancouver BC Canada V6E 4S2

Cataloguing data available from
Library and Archives Canada
ISBN 978-1-77164-152-4 (pbk.)
ISBN 978-1-55365-871-9 (epdf)

Editing by Nancy Flight
Cover design by Naomi MacDougall
and Nayeli Jimenez
Text design by Naomi MacDougall
Cover photographs by David Hall
Printed and bound in China by
1010 Printing International Ltd.

Published in the United States by
University of Washington Press
Box 359570
Seattle, WA 98195-9570 USA

Library of Congress Cataloging-in-Publication Data

Hall, David, 1943

Beneath cold seas : the underwater wilderness of the Pacific
Northwest / David Hall; foreword by Christopher Newbert;
introduction by Sarika Cullis-Suzuki.

ISBN 978-0-295-99488-8 (pbk.)

1. Underwater photography.
2. Marine animals—Pacific Ocean—Pictorial works.
3. Marine animals—Northwest, Pacific—Pictorial works.
I. Title.

TR800.H255 2011 778.7´3—dc22 2011010287

Greystone Books gratefully acknowledges the financial
support of the Canada Council for the Arts, the British
Columbia Arts Council, the Province of British Columbia
through the Book Publishing Tax Credit, and the Govern-
ment of Canada through the Canada Book Fund for our
publishing activities.

page 1: Blue rockfish with lion's mane jelly (jellyfish)
pages 2–3: Black rockfish in a kelp forest
right: Harbor seal
pages 6–7: A moon jelly and cross jellies
float beneath the surface

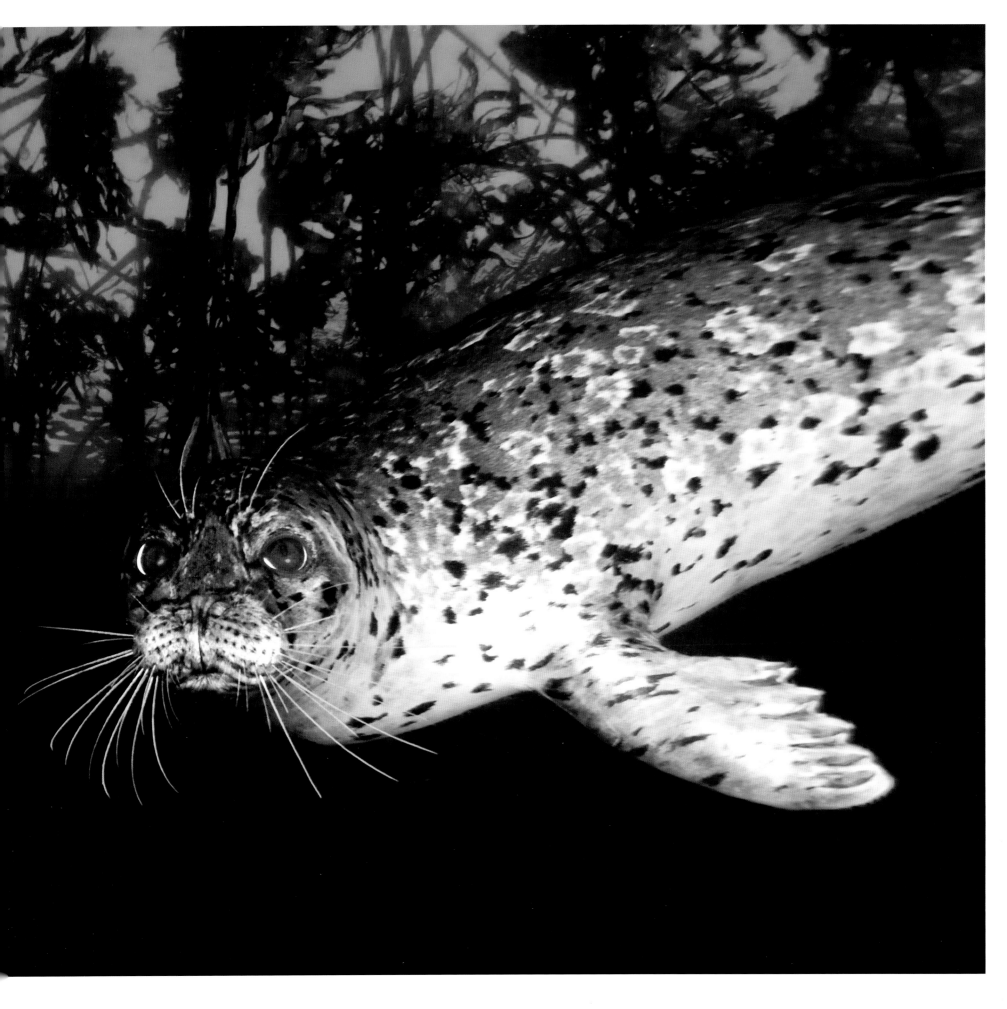

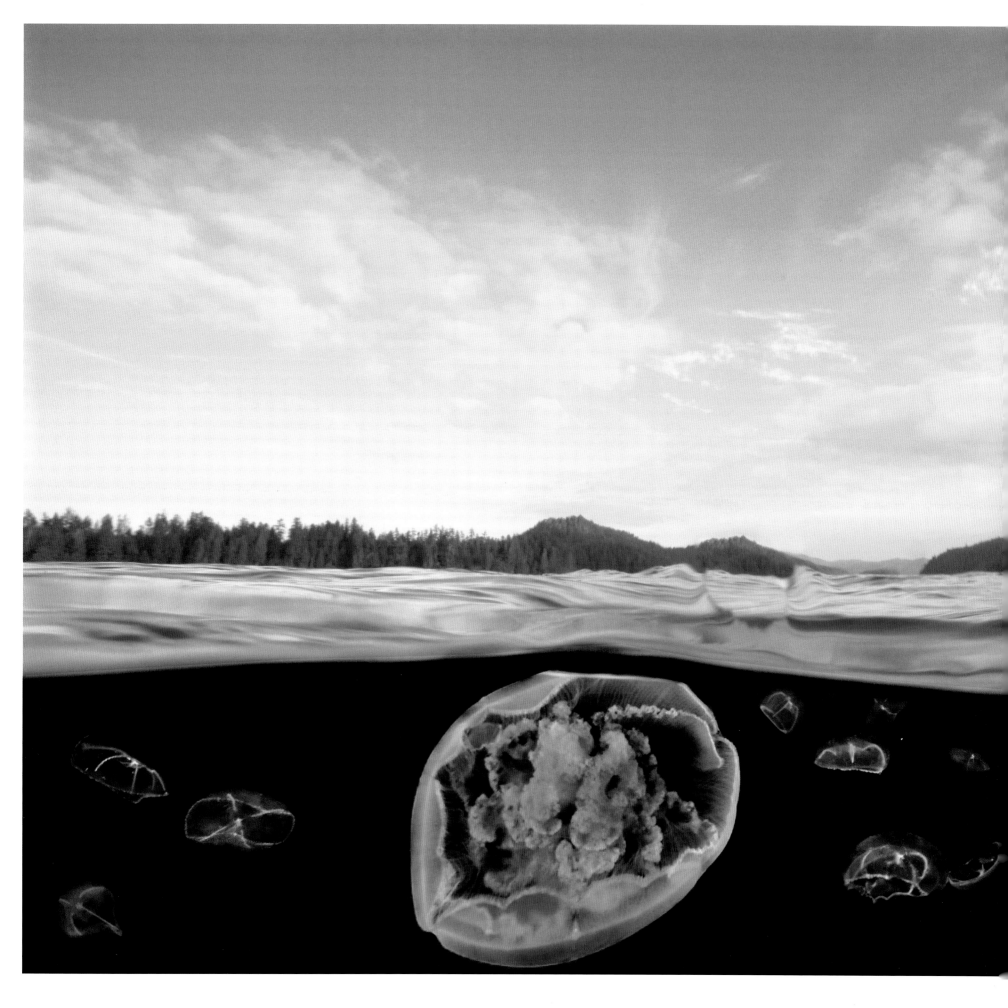

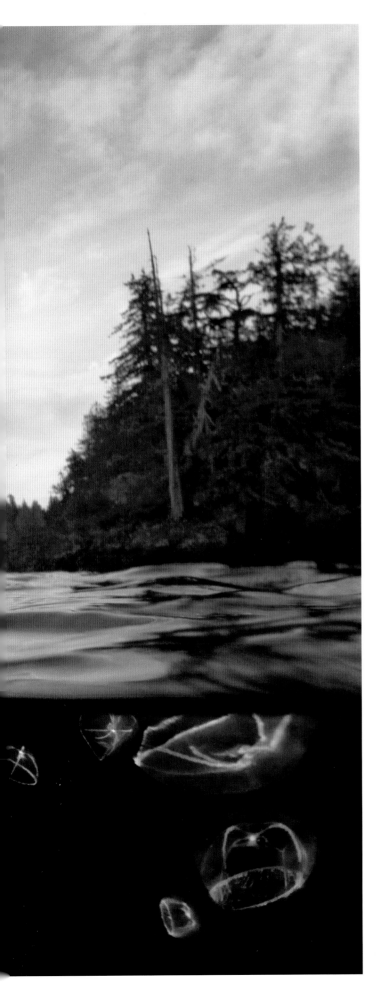

CONTENTS

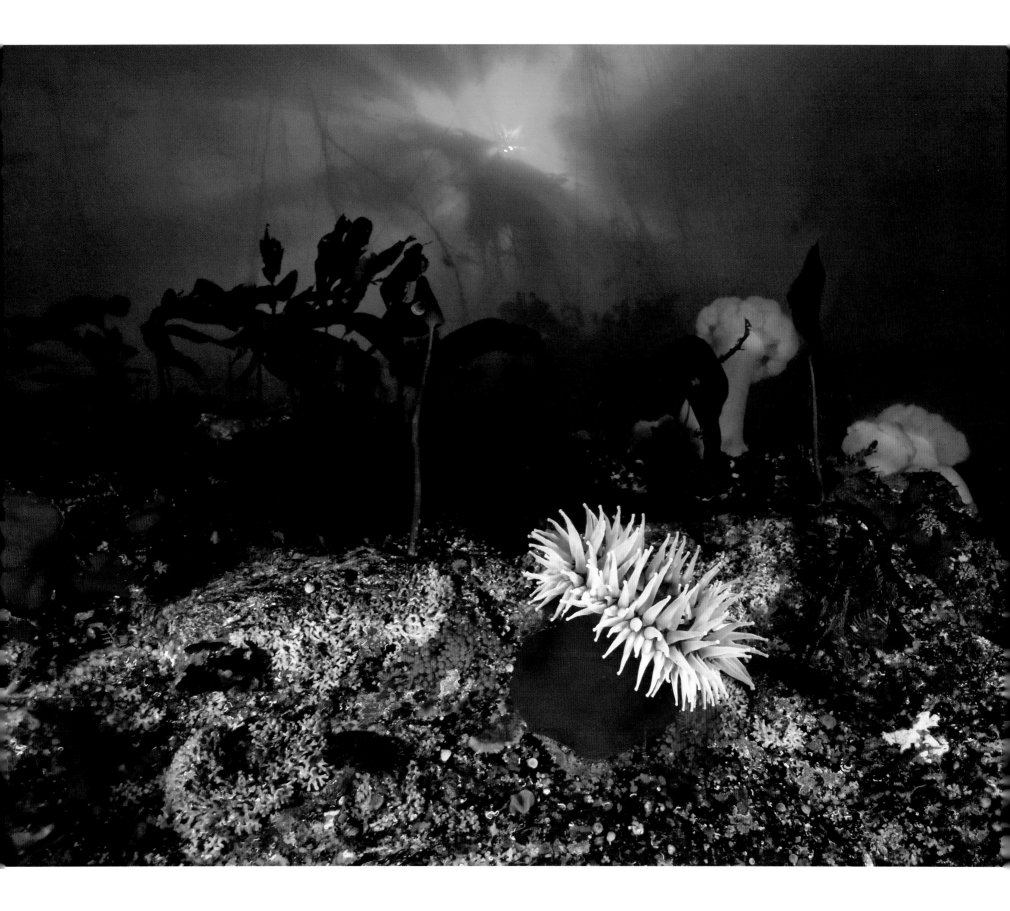

FOREWORD

CHRISTOPHER NEWBERT

THE BEAUTY of a flawlessly executed, perfectly composed underwater photograph seldom reflects the extreme technical difficulty or environmental obstacles that had to be overcome to make the image, much less the physical handicaps and physiological dangers that marine life photographers routinely work with. Instead, the viewer is likely captivated by the exotic subjects and often extravagant colors found in these images from an alien world, far from the familiar and comfortable milieu in which most people view them.

Even terrestrial wildlife photographers can rarely appreciate the many disadvantages an underwater photographer must overcome to achieve even modest results, much less spectacular ones. Divers are limited by their finite air supplies to underwater working times typically of less than an hour. They cannot enjoy the luxury of prolonged shooting sessions, protected from the elements by a tent or blind and comforted by a thermos of hot coffee and a ready supply of food while waiting for their subjects to appear and perform. What's more, every minute they are submerged, their bodies absorb increasing amounts of nitrogen, the excess of which must be safely released upon ascent if they are to avoid the painful, possibly crippling effects of decompression sickness.

Additionally, as divers descend ever deeper, the ambient pressure mounts and the nitrogen in their air supply has a progressive narcotic effect on their thought processes. So in an endeavor where underwater photographers must make precise technical judgments quickly and accurately, the mind is increasingly dulled by the simple act of breathing the very air needed to survive. At greater depths, even vision is adversely affected, yet underwater photographers still must get their shots while simultaneously monitoring the critical aspects of their dive—such as their remaining air supply and remaining safe bottom time, calculating whether or not they have enough air to safely return to the surface.

Underwater photographers must also work in a weightless, neutrally buoyant state. They are not aided by gravity to steady themselves for a shot. Tripods are not practical, the subjects are generally moving, and the photographer is often pushed this way and that by currents and surge in an environment constantly in motion. Complicating matters even more, unlike their above-water counterparts, who make frequent use of telephoto lenses to produce tightly composed images while working undetected at a safe distance from their subjects, marine life photographers—owing to the rapid attenuation

of light underwater as well as the dense particulate matter dispersed throughout even the clearest seas—must generally be within a few feet or less of their intended subjects if they hope for a sharp, color-rich final image. Underwater photographers cannot change lenses while on a dive but must make do with the optic they find themselves with, regardless of what might suit a particular subject best.

These problems and many more face marine life photographers in the best of circumstances. But in a working environment that is inherently hostile to cameras and photographers alike, there is a special breed of underwater photographer who chooses to work in the most difficult of all ocean environments, where the light levels are low, the water is generally murky, and the temperatures are bone-numbingly cold. I'm speaking of locations such as the Pacific Northwest. To everything else I have noted you can now add the extreme bulk and encumbrance of a dry suit, forty or more pounds of lead around the waist to offset the buoyancy of the dry suit, and thick gloves that insulate one only for a short period from the cold but at all times from sensitivity to touch. If one considers all of these disadvantages, the resulting photographs are all the more remarkable. Even manipulating the camera controls with such burdens is an exceptional achievement.

Among these bold and hearty cold-water specialists, David Hall rises above the rest. He combines the inquiring and exacting eye of a scientist with the soul and vision of an artist to produce uniquely beautiful underwater images that educate as much as they inspire. I have known and dived with David for some fifteen years, and in this time I have never encountered anyone as fully committed to his art and craft as David. When other divers and I have long ago retreated to the dive boat to warm up, relax, eat, read, or socialize, David is usually still underwater, coaxing the last molecules of air from his tank, searching for one more subject to shoot, seemingly oblivious to the physical needs that drove the rest of us to the surface much earlier. His relentless inquisitiveness about the underwater world may drive his work—and he has a near-encyclopedic knowledge of species and behaviors—but while other scientifically oriented photographers may be content to simply record what they see and observe, David captures his subjects with a flourish, creating singular works of art that tell a story—a story spoken from the heart. For this reason, I find David's work intriguing and satisfying on so many levels.

In *Beneath Cold Seas,* David Hall's stunning pictures and eloquent words tell the story of life within the frigid waters of the Pacific Northwest, an ecosystem rich in variety, abundance, and intrigue yet so physically challenging to work in that it dissuades most photographers lacking David's single-minded dedication and willingness to endure the adversity and discomfort of shooting in such conditions. David's love of the sea and his intense intellectual curiosity about its inhabitants somehow shield him from the many hardships encountered while photographing them. We are all beneficiaries of his passion. *Beneath Cold Seas* is an extraordinary work that stands alone in its achievement.

previous spread: Rose anemone
facing page: Northern kelp crab

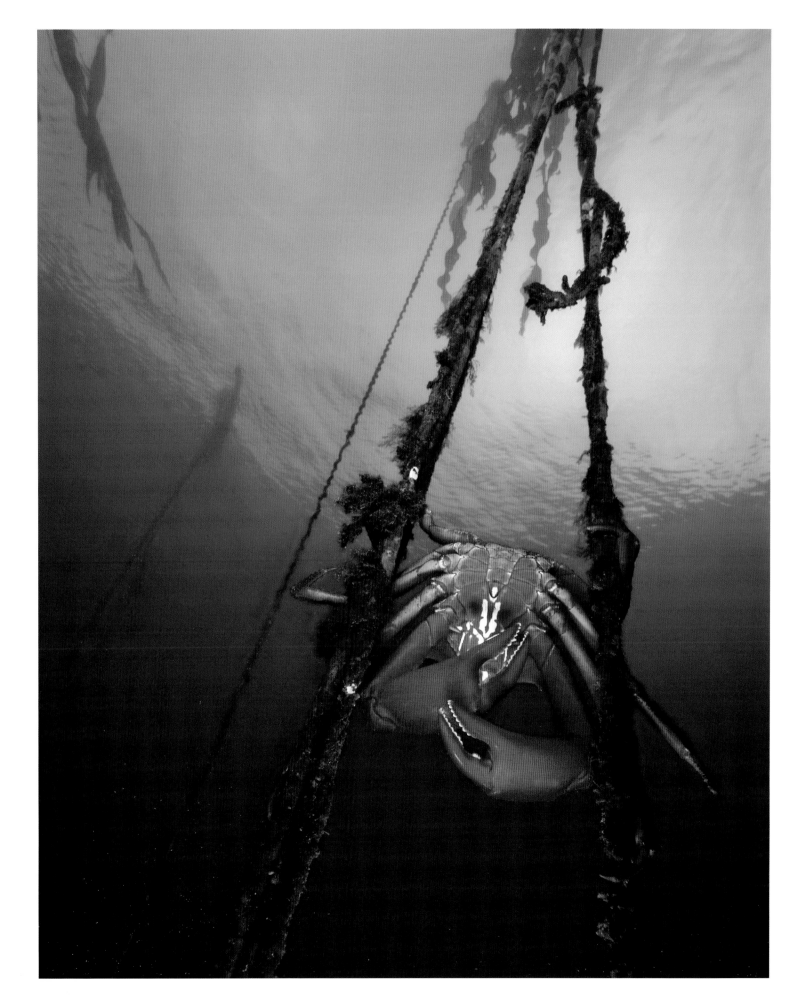

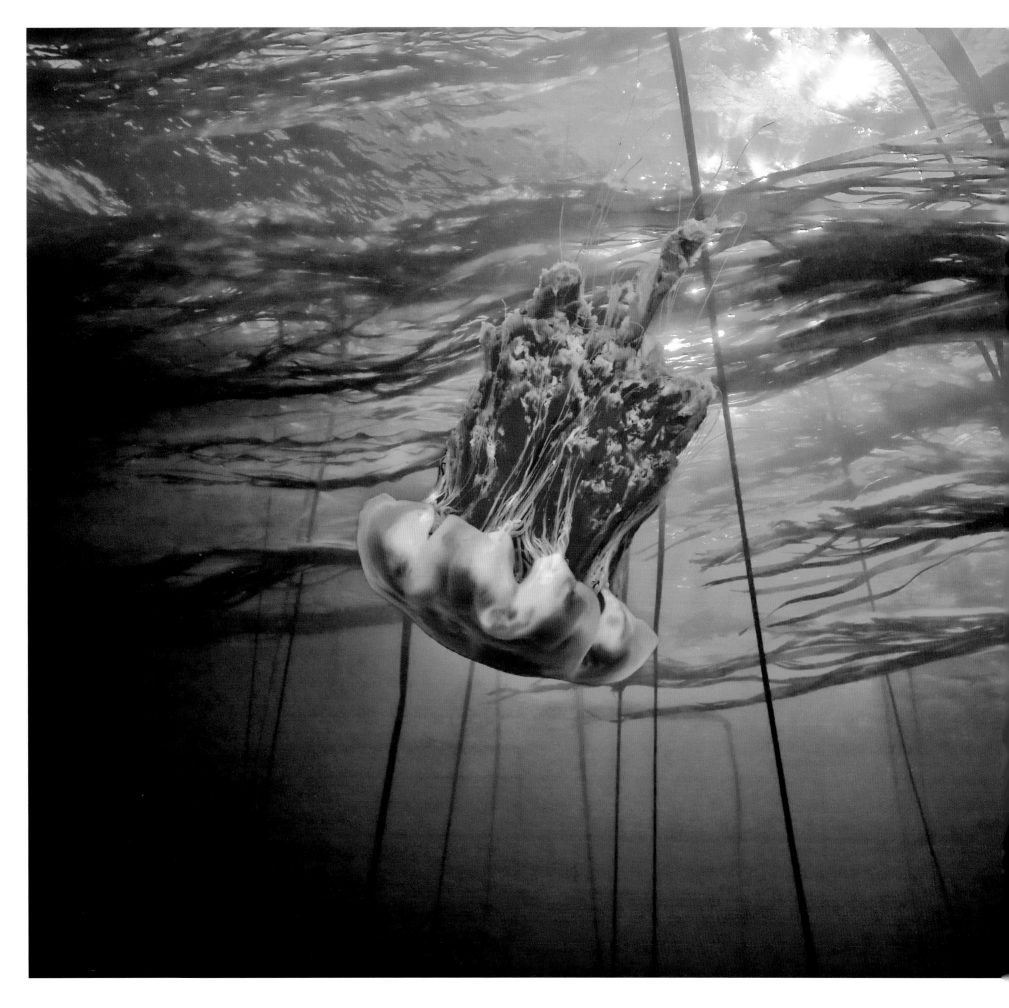

PREFACE

DAVID HALL

M Y FIRST dive at Browning Passage in British Columbia was an unforgettable experience and marked the beginning of a love affair with the Pacific Northwest that continues to this day. The year was 1995. I had already been photographing underwater for more than twenty-five years and thought I had pretty much seen the best of what the ocean had to offer me. I couldn't have been more wrong.

Nearly all of my early diving was done in tropical Atlantic and Indo-Pacific waters, on some of the most beautiful coral reefs in the world. Corals and coral reef fish are sublimely colorful and, combined with clear tropical water, can make for wonderful underwater photography. Cold-water fish are often drab, the corals are unimpressive, and cold seawater is typically green and murky from an abundance of phytoplankton. Given these facts, you might logically ask: why this book?

Part of the answer lies in the amazing variety of invertebrate life—much of it endemic—inhabiting the Pacific coastal waters of North America. Particularly notable is the diversity of sea stars, lithode crabs, nudibranchs, chitons, anemones, and jellyfish. Add to this a surprising number of unique fish, an impressive array of marine plants, and some very photogenic marine mammals, and you will better understand my enthusiasm.

I returned to the Pacific Coast of Canada a dozen times in fifteen years and eventually concluded that the photographic records of those trips deserved a book of their own. While all of the photographs in this collection were made in Canadian waters, the animals and plants recorded do not recognize international borders. Virtually all of them can also be found south or north of British Columbia, in the coastal waters of northern California, Oregon, Washington, and Alaska, a region collectively referred to by marine biologists as the Pacific Northwest.

I gratefully acknowledge the contributions of the many people who helped me to complete this project. I thank Al Spilde, Dan Ferris, Chris and Belinda Miller, Larry Arvidson, and Conor McCracken for their support during my dive trips. I am grateful to Brandon Cole for his technical advice and to Andy Lamb, Dr. Greg Jensen, Dr. Jeff Marliave, Dr. Daphne Fautin, Roger Clark, Dave Behrens, Rick Harbo, and Neil McDaniel, for their help with species identifications. I am indebted to Sarika Cullis-Suzuki and the David Suzuki Foundation for their support and to Dr. Ted Pietsch, Bob Morton, Pat Soden, Rob Sanders, Nancy Flight, Peter Cocking, Naomi MacDougall, Jamie Hall, Yva Momatiuk, and John Eastcott for helping me to bring this book to publication.

We humans tend to protect what we know and value, and so wild-life photography can be a powerful tool for promoting awareness and conservation. And even though the animals of the sea provided the initial inspiration to take up underwater photography, it was the work of several outstanding photographers that challenged me to create images that transcend their subject matter and hopefully will motivate more people to protect the increasingly fragile web of life on our planet.

My work has been influenced by many fine photographers, but it was the images of three artists in particular that affected me most deeply. I am indebted to Eliot Porter for his color landscape and bird photography, to Douglas Faulkner for his early exploration of the artistic potential of underwater photography; and to Christopher Newbert for his uncompromising approach to art and for showing us that the whole is not necessarily equal to the sum of its parts.

APRIL 2011

previous spread: Lion's mane
jelly and bull kelp
right: Mixed seaweeds at low tide
following spread: Queen Charlotte
Strait, British Columbia

14

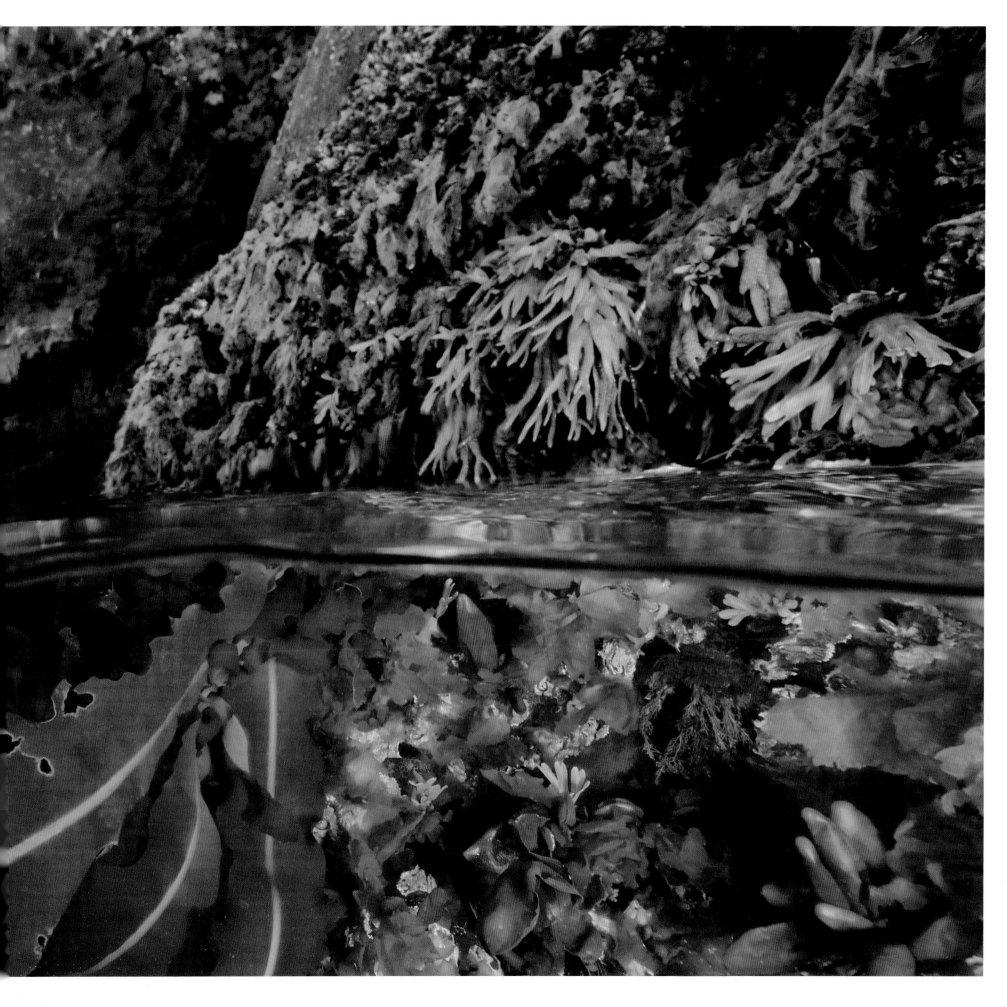

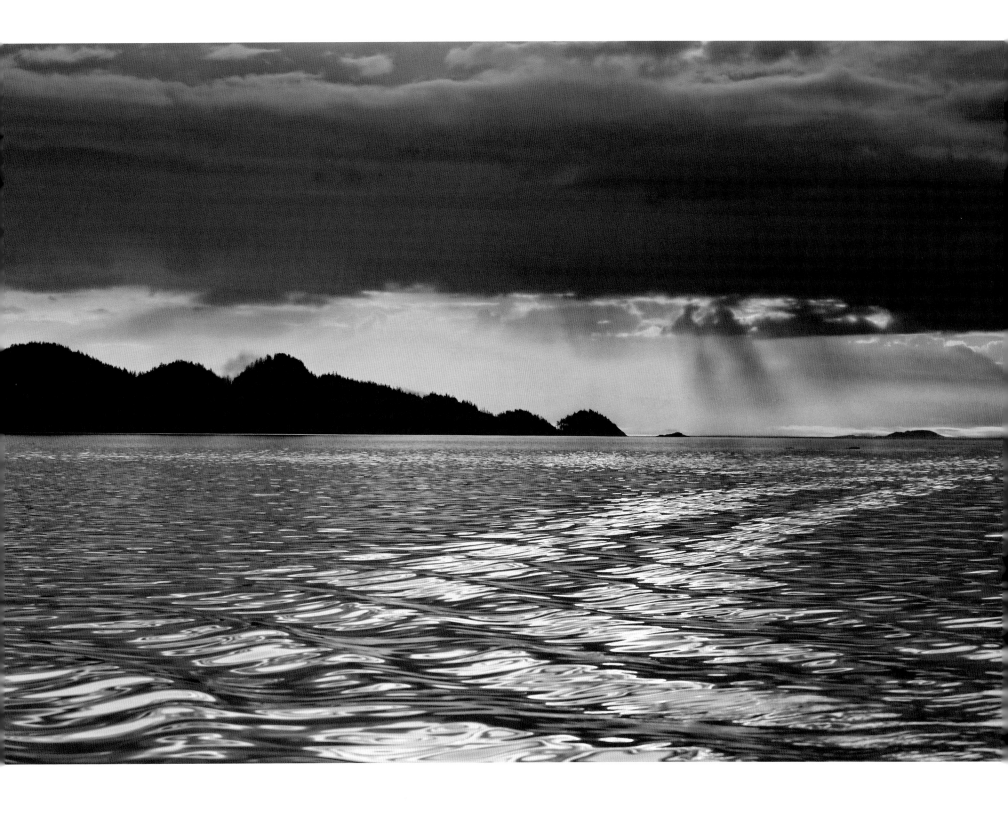

INTRODUCTION

SARIKA CULLIS-SUZUKI

I'T's AUGUST. I'm on a boat in Haida Gwaii (formerly known as the Queen Charlotte Islands), British Columbia. The waves are getting thicker, and the rolling of the vessel adds to my urgency to get in the water. The cramped boat lurches unpredictably in the swell, and with weights strapped to my waist and tank leashed to my back, I struggle to stay put; moving around on board has become dangerous. People are tense. We've been suited up for two hours; sweat rolls off my brow and down my neck. I've made the classic mistake of thinking about going to the bathroom, and now I can't stop. I want to get into the water. Now.

Suddenly the boat stops and it's time to get in and the captain is shouting go go go, now's the time now's the time and the mask goes on and the reg goes in and—I fall back.

The moment I hit the water, I'm weightless. As I descend deeper, all the discomfort and noise disappear, and I'm conscious only of the rhythmic rasping of my own breath. Everything else is so, so quiet.

Ten feet below the surface a fried egg jelly catches my attention, suspended in the water column a mere foot from my face. I stare up at the medusa's white tentacles glowing in the rays of sunlight. Now at almost fifty feet, the bottom of the ocean comes up at me. It's dark down here, as the sun's penetration wanes, but I am still struck by

all the color. I add air to my buoyancy compensator—I don't want to sink right to the bottom: the entire ocean floor is studded with thorny red and purple sea urchin.

My buddy, a local Haida diver, points out a whitish oval creature on a rock: abalone. My eyes slowly catch on, and I begin to see the flattened mollusks dotting rocks beneath us. Much more visible on the sand below are red sea cucumbers, competing with giant, white plumose sea anemones for whatever seafloor is left. A few species of nudibranch (also known as sea slugs) cling to bull kelp, and above my head circles a school of black rockfish, hundreds strong. I've never seen so many together in one place; I didn't even know they schooled. As they leisurely swim in and out of the kelp, seemingly undisturbed by us, I wonder at my lack of urge to grab them; here, under the waves, one feels more like privileged spectator than hungry predator.

Forty minutes have already passed—impossible. I don't want to go back to the world above.

The Pacific Northwest, as generally described by marine biologists, extends from northern California to southeastern Alaska. Its long and varied coastline includes white, sandy beaches, sheltered bays, ragged cliffs, and wild, howling channels. The waters of the Pacific Northwest are cool, characterized by a large diversity of marine habitats and

ecosystems, including kelp forests, eelgrass beds, rocky and cobble shores, and estuaries, as well as strong upwelling and currents that carry an abundance of nutrients; the result is a prolific coast, home to herring, killer whales, eagles, salmon, black and grizzly bears, sea lions, and halibut, among many other species.

The area's coastal richness has allowed people, too, to flourish. Shell middens, evidence of the region's earliest inhabitants, can be found all along the coast, and old tools unearthed during archaeological digs reveal sophisticated fishing gear that dates back several millennia. One theory, known as the kelp highway hypothesis, even suggests that the highly productive kelp forests and web of life they support allowed people to migrate from the old world to the new, feasting on seafood from North America all the way down to South America. We do know that these abundant waters have nourished people for over ten thousand years.

When people think of the Pacific Northwest, one animal in particular comes to mind: salmon. This coastline is home to five species of salmon: chinook, sockeye, pink, chum, and coho. Salmon have been part of people's diets along the coast for at least 7,500 years, and today they continue to support a valuable fishery. Beyond feeding us and countless other animals, salmon nourish the surrounding land as well. Bears bring dead or dying salmon onto the riverbanks and into the forest to feast on. Then, as the leftover carcasses and bear droppings decompose, nutrients are shed into the soil. Nearby shrubs, mosses, and old-growth trees all contain traces of salmon. Maggots emerging from the rotting salmon carcasses are in turn eaten by birds—and the complex interconnectivity of life is revealed.

One of the most extraordinary events on the planet is the salmon spawn. After almost an entire life spent at sea, these fish find their way back to their natal rivers and battle their way upstream to reproduce. Their life's purpose complete, salmon wait for death, their weary bodies mottled and disintegrating, spent. Some of these powerful moments are captured in *Beneath Cold Seas*.

The Pacific Northwest is also home to over a dozen species of shark, from the reclusive bluntnose sixgill to the skatelike angel shark and famed great white (some of the largest ever recorded were found on the Pacific coast). They share the ocean with well over a hundred species of jellyfish and a diversity of seaweeds, deep-water corals, and nudibranchs. And the colors! When we think of vibrant sea creatures, we tend to envision coral reefs and tropical waters. But although temperate oceans are colder and darker, life within them is still bright. Consider the dazzling yellow stripes splashing the flanks of China rockfish or the neon feathered tips of the clown nudibranch. Then there's the oily shimmer of the red algae *Mazzaella splendens*, rippling pink, blue, and green with each pulse of a wave. Perhaps most spectacular is the nighttime show of jellyfish; there is nothing more exhilarating than turning off your flashlight during a night dive and watching bioluminescence create an underwater kaleidoscope of stars around you as you move through the water. You'll meet some of these remarkable species and wonder at their impossible colors as you look through this book.

As fascinating as the ocean and its creatures are, we know comparatively little about them; other realms of Earth are better understood (and even non-Earth: the moon and outer space take up a disproportionate amount of our fascination). The ocean continues to confound and mystify. Many momentous discoveries have been made only recently. The ancient coelacanth, considered extinct for 80 million years, was discovered alive in the late 1930s. Seamounts, underwater mountains that support the deepest living plants, thousand-year-old corals, and hosts of deep-sea fish remain largely unexplored. The high seas—the areas of ocean beyond national limits—historically thought to be the watery equivalents of terrestrial deserts, may contain close to half of the ocean's animal biomass. In the late 1970s, in one of the most significant discoveries in the marine realm, scientists found communities of deep-sea oases around superheated springs supported not by sunlight and photosynthesis like the rest of the

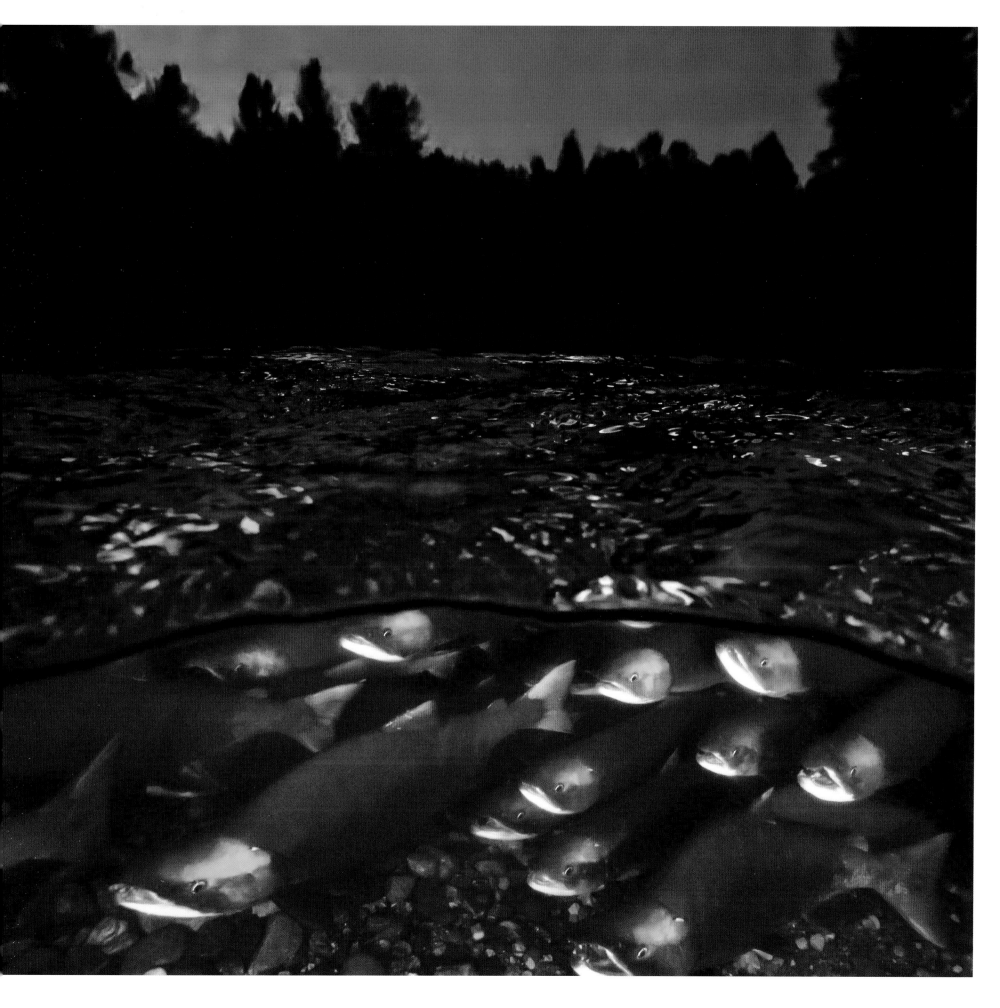

world but by chemosynthesis, the breakdown of chemical compounds by bacteria.

Truly, the ocean remains one of the last great unknowns.

Yet just as we are making discoveries, we are also finding out what is being lost. One cannot learn about the wonders of the ocean without also learning of its suffering. Today's oceans are changing, mostly because of us. Overfishing, climate change, the introduction of foreign species, habitat loss, and pollution have fundamentally altered the sea. Not even the remotest shores of Antarctica have escaped our influence. The resilience of oceans is being tested on an unprecedented level. From the huge garbage patches found at the centers of each of the five great ocean gyres to the decline of global coral reefs and the forecast that the world's commercial fish stocks could collapse in their totality by midcentury, the future of the global ocean looks bleak.

The Pacific Northwest faces its own challenges. Less than 2 percent of British Columbia's waters are protected; of these protected areas, less than 1 percent are completely closed to all harvesting. Farms in this province produce more salmon than fisheries catch from wild populations and are sources of sea lice, which can kill young wild salmon. In the U.S. waters of the North Pacific, about 70 percent of commercial fish stocks have either collapsed or are being overfished. Oil companies push for tanker routes along the Pacific coast, despite the possibility of a deadly oil spill. Bottom trawling, including the highly damaging (and economically questionable) deep-sea trawling—a fishing method that some have likened to clear-cutting a forest to catch a squirrel—continues all along the coast. And although climate change is manifesting itself through ocean acidification, changes in water temperature, and a rise in sea level, both the U.S. and Canadian governments refuse to impose significant cuts in greenhouse gas emissions.

Along the coast of the Pacific Northwest, we often overlook our marine history. We see our waters as relatively healthy, our fisheries as still productive, and our coasts as more or less intact. Salmon and herring seem plentiful. But compared with what? Without knowing what once was, it becomes difficult to create a vision of what ought to be.

The term "shifting baselines syndrome," an evocative expression coined by fisheries scientist Daniel Pauly, describes the collective memory loss from one generation to the next. As one generation disappears, so does the knowledge of what once was; new norms are established, with no understanding of the "original" baseline. In contrast, oral traditions or stories can recollect times, events, and norms that otherwise are being forgotten. As a result of shifting baselines, unnatural states are accepted as normal.

Here's an example: I was shocked to discover that just fifty years ago, there were so many basking sharks in the Strait of Georgia that they impeded boat traffic. As a result, these harmless goliaths were targeted and killed off; today, there are none left in the strait. People of my generation consider a sharkless strait normal. Unfortunately, many other species along our coast have been overfished or even extirpated, including northern abalone, sea otters, and Steller's sea cow.

Not only are we disconnecting ourselves from the past, we are also distancing ourselves from the present. One summer, family friends from Tokyo visited us on Quadra, an island in the middle of the Strait of Georgia. My sister, Severn, and I were excited to show the children around, but they were scared of the natural world and in the end would not go outside, because they were afraid of the wind. Through a glass window, they looked out at the sea.

Sadly, this is as understandable as it is distressing. These children grew up in a reality where life can be spent almost entirely indoors, where everything is controlled, where nature and urban living have somehow become so effectively separated that they are discordant in a child's mind.

But this disconnect also occurs in places where we'd least expect it. A few years ago, I was a teaching assistant for an introductory biology

course for undergraduates at the University of British Columbia. The UBC campus practically sits on the beach. Wreck Beach, famous for its nudity and colorful characters, is perhaps the most beautiful in Vancouver and receives sun longer than any other. For one of our field trips, I took the students down to Wreck. In a class of over thirty, barely a handful had been to the beach before—this one or any—ever. Some students wore high heels down the steep, muddy stairs that led down to the sea.

How important is it for us to grow up steeped in or connected in some way to nature? How does a child who grows up scaling trees feel in a forest compared with one who has never stood under a tree? And how do these experiences affect our decisions later in life? Our inability to connect with and respect the ocean stems in part from a lack of direct experience.

A couple of years ago, I decided to look for solutions to local problems on our coast that were leading to tangible, positive change. I was shocked when the scientists I talked to had difficulty identifying any. Although the number of groups, coalitions, projects, and initiatives created to address conservation and sustainable ocean management on the Pacific Northwest is impressive, the output is much less so. Sadly, talk outweighs action.

There are, thankfully, some exceptions. In 2007 California established the first of five networks of Marine Protected Areas (MPAs) that range in protection from no-take of any life to limited commercial take. These MPAs will ultimately span the entire length of the state's long coastline. In Oregon, critical research on the recent emergence of dead zones—areas of ocean with low oxygen levels—is underway. Within the Pacific Northwest, some groundfish fisheries have considerably reduced bycatch as a result of new, tradable catch shares and close monitoring (which includes 100 percent video surveillance). In 2010, the terrestrial boundaries of Gwaii Haanas on Haida Gwaii were extended into the sea to include a National Marine Conservation Area; this is the first large land-sea-protected system in Canada and is leading the discussion on unified ecosystem protection and indigenous co-management.

These are crucial steps. But we must acknowledge the facts. Today just over 1 percent of our global oceans is protected (compared with 13 percent of land), and of this area very little is no-take. In the Pacific Northwest, there are only a handful of no-take areas.

It was in one of these no-take protected areas that I met David Hall for the first time. Standing in our long underwear in the empty parking lot, David and I readied ourselves for a dive in Whytecliff Park, West Vancouver. We had bonded previously through e-mail over our shared obsession with Pacific spiny lumpsuckers, an almost perfectly globular fish about the size of a grape. Little is known about this adorable fish, and since neither of us had ever seen a lumpsucker before, we were both raring to find one.

It was September, and a typical BC day: overcast, drizzly, and chilly. I was instantly impressed with David. Although he has done thousands of dives, many in some of the most spectacular (and warm) sites around the world, his enthusiasm for this dive was obvious. While I procrastinated in pulling on my damp wetsuit, I watched with wonder as David began to disappear under layer upon layer of equipment; it appeared the only thing matching his enthusiasm for diving was the weight of his underwater camera gear.

Although it took us ages to get ready (and the water visibility was less than ideal that day), it proved an exceptional dive. David forced me to be patient. Meticulously setting up each shot, he spent minutes on end hovering in one spot above the seafloor, suspended, focusing, adjusting the light, refocusing. While I waited I noticed things I would have normally swum right by. And in these subtle details—barnacles with their featherlike cirri rhythmically groping for plankton, filtering the sea; the stretched arms of sunstars, timidly sensing others, then curling away; little puffs of sand created by the rapid breath of a half

buried flounder, now exposed—the elegance and perfection of the ocean was revealed, delicately and constantly contributing to the tapestry of life.

David and I never saw a spiny lumpsucker on that dive, but we vowed to continue our search for the loveable lump when next he came out west.

Whether we live near the coast or have never visited the ocean before, we are connected to it. Our gilled ancestors came out of the sea. Today, through all the necessities that the ocean provides—regulating climate and freshwater systems, producing even more oxygen than the Amazon rainforest, absorbing carbon, providing food and medicines, and instilling in us a profound sense of peace—we remain dependent on it.

That family from Tokyo who visited us on Quadra Island came back a few years later, and this time they refused to stay in the house. Instead, they spent every night camped in a tent outside. Something had shifted. They were no longer afraid; they were enthralled. This connection, this firsthand experience in the natural world, is what will ultimately determine our success in ocean conservation. And it only takes one such experience.

For those places few can go, photographs provide a shortcut. David's photographs help us zoom in, focus, and see with clarity the exquisiteness of what lies below the waves. I hope this book fills you with excitement and wonder, inspires you to explore and connect with the natural world, and helps you recognize what we still have: a complex and vulnerable wilderness beneath cold seas.

Kelp forest floor with crimson
anemones and red soft coral

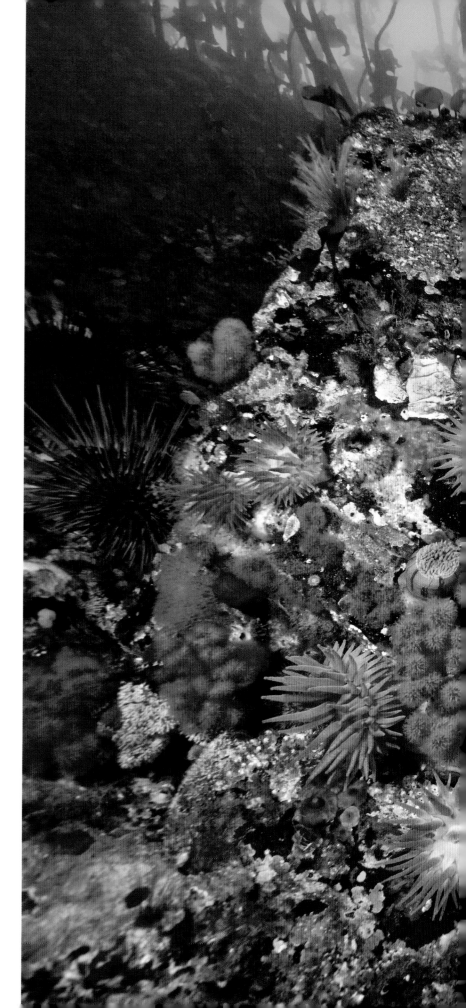

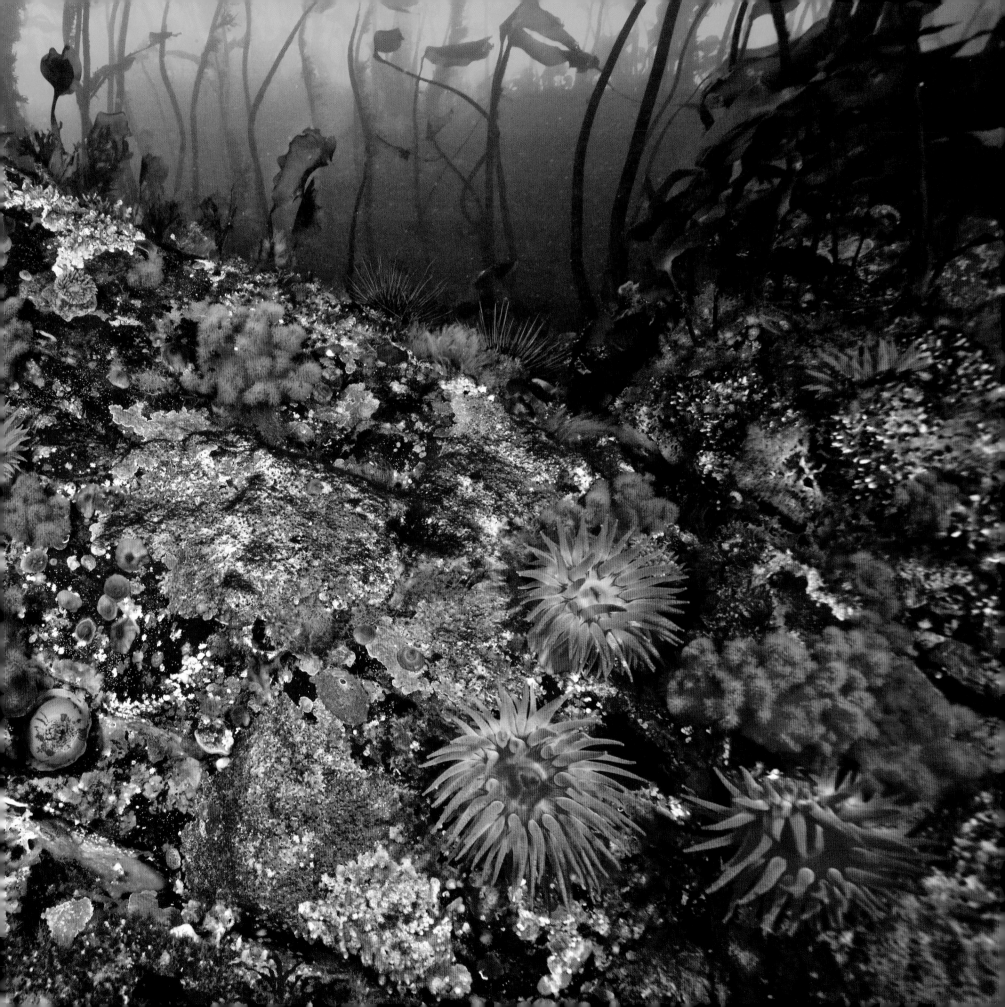

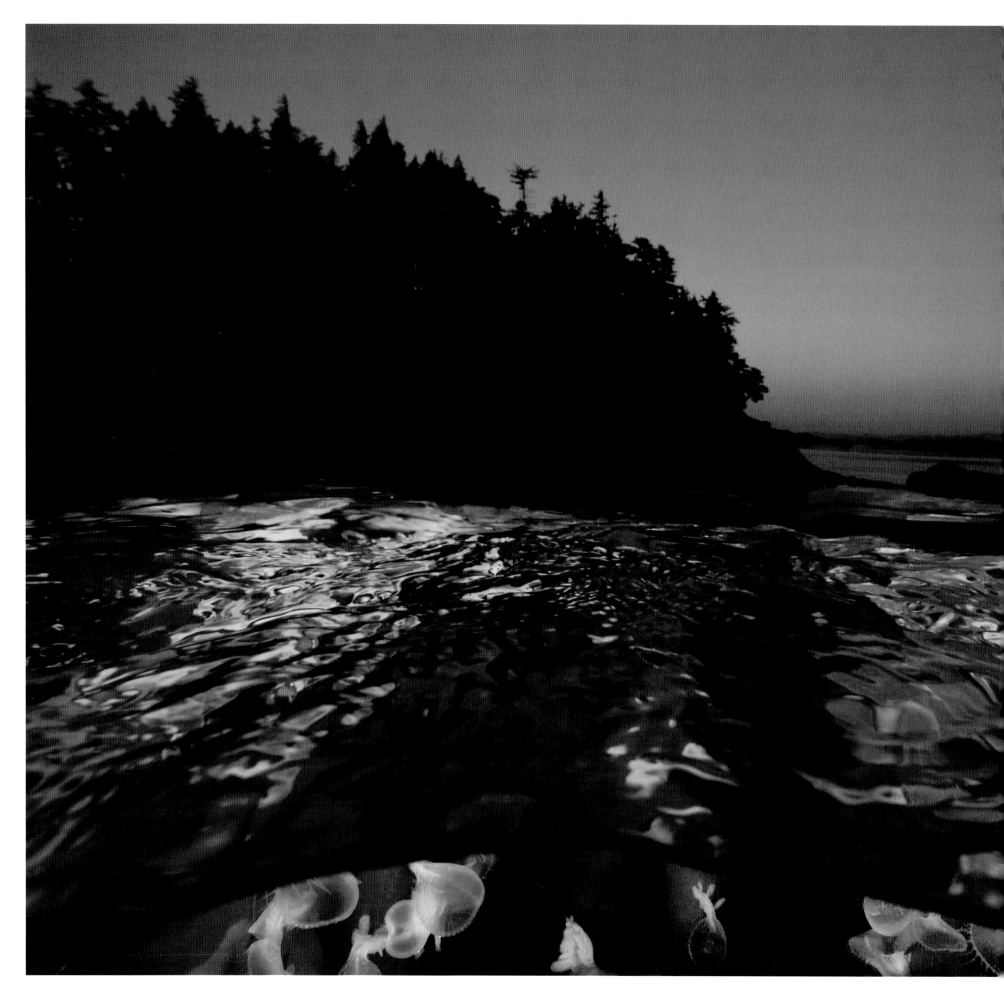

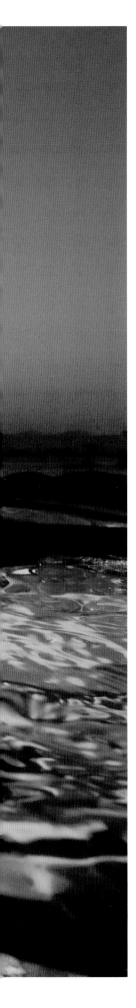

BENEATH COLD SEAS

Photographs and Vignettes

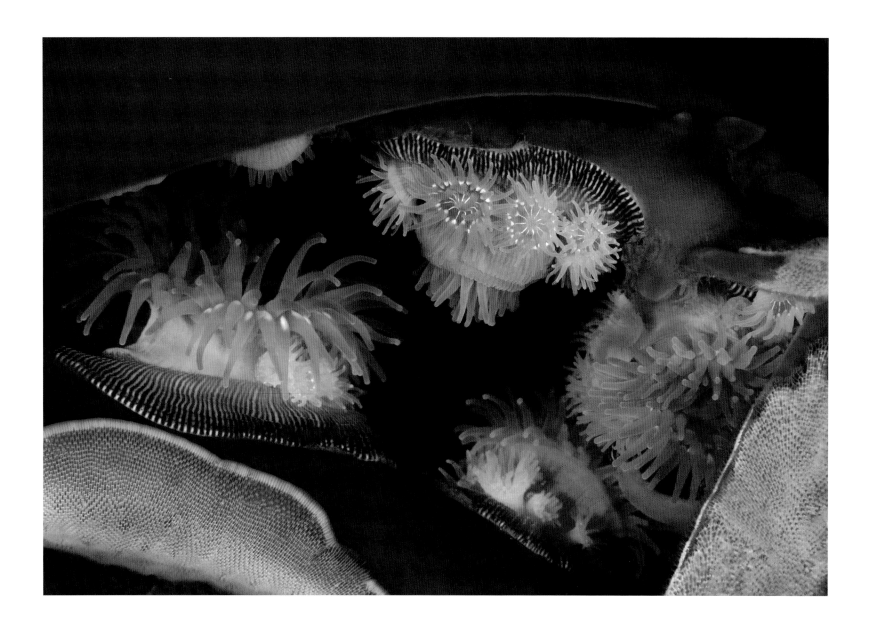

previous spread: Hooded nudibranchs clinging to kelp

above: Proliferating anemones on kelp

facing page: Mosshead warbonnets

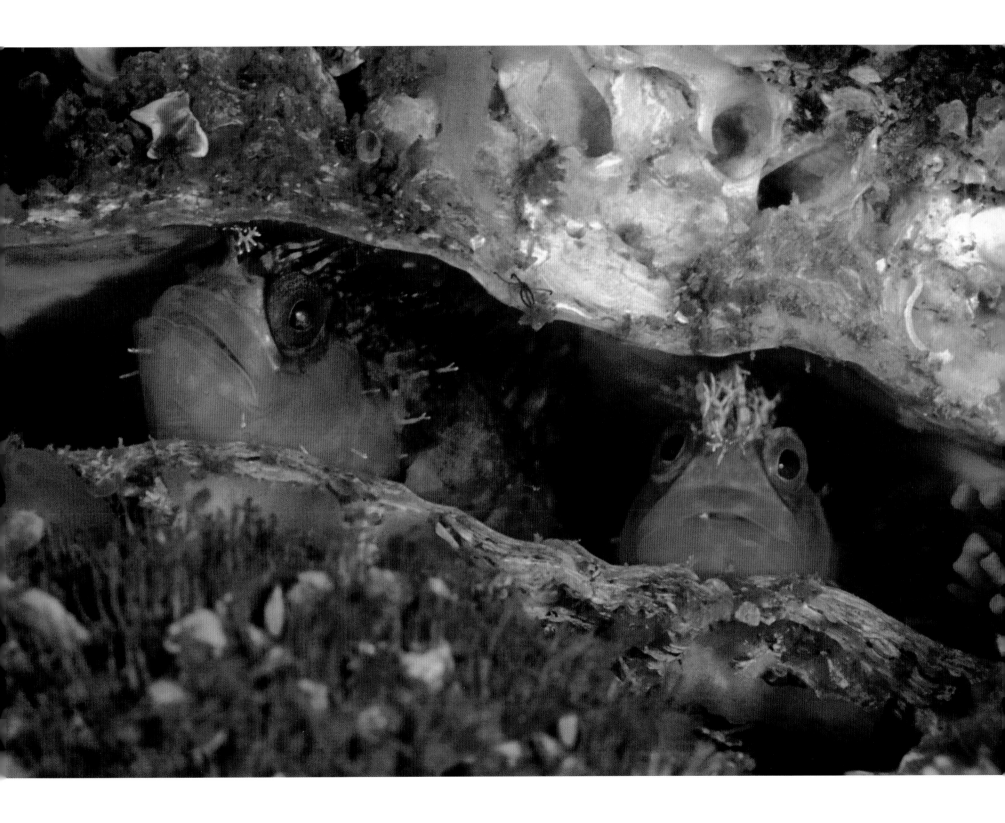

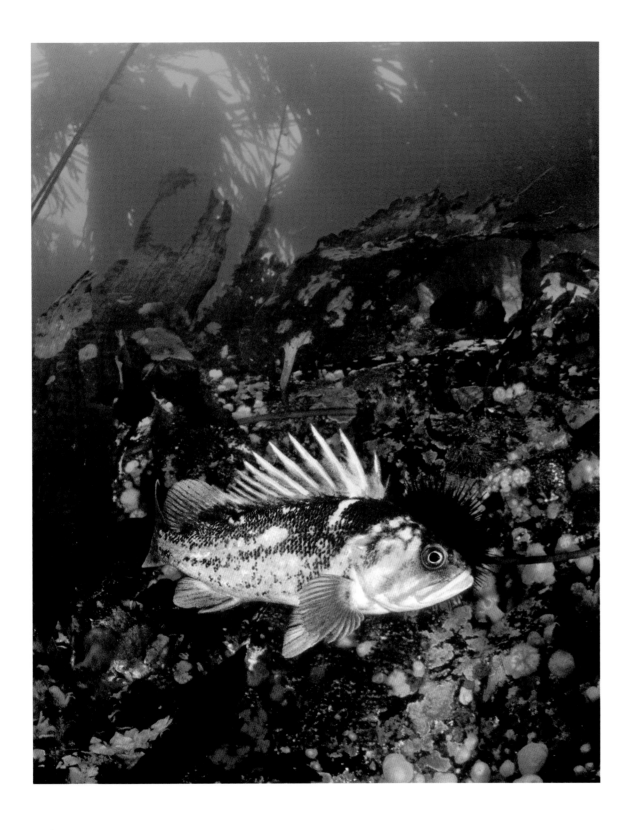

facing page: Orange sea pens

left: A copper rockfish

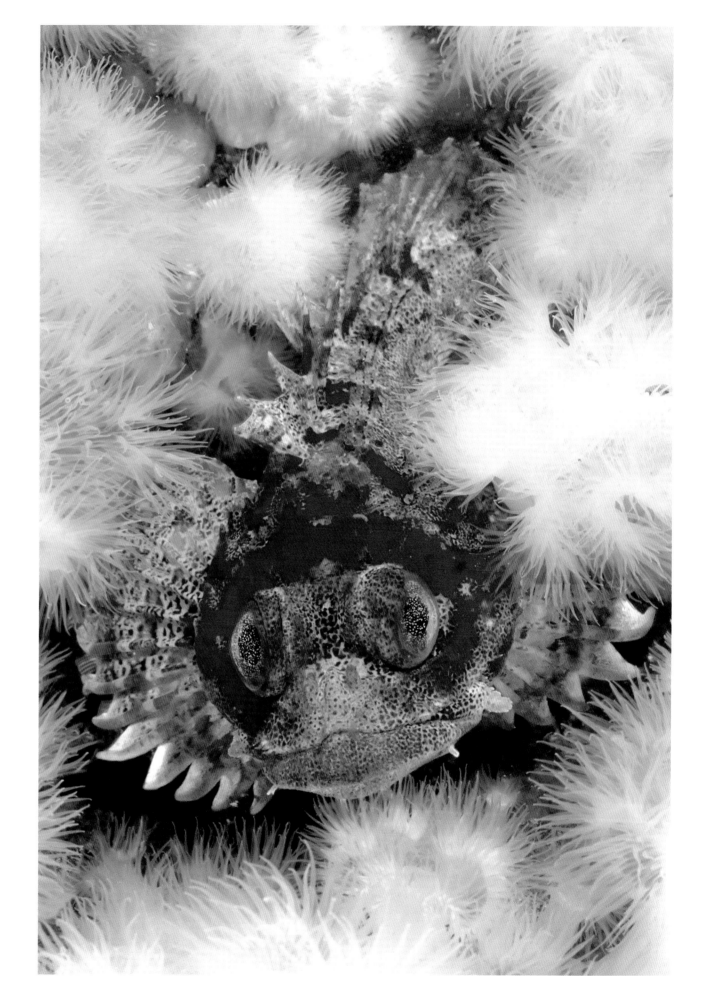

Red Irish lord sculpin

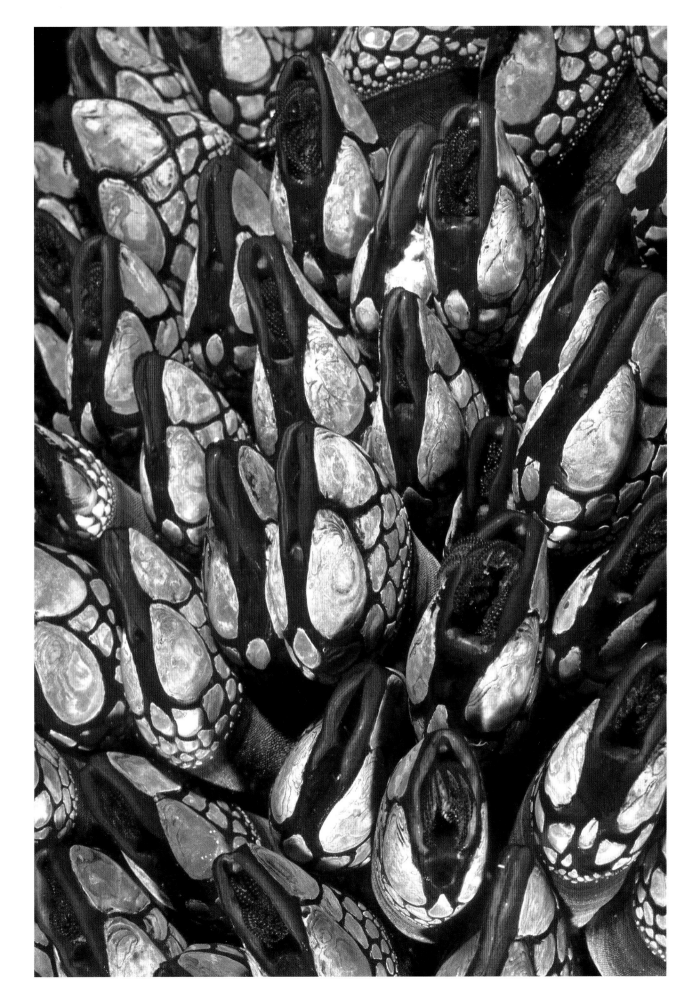

Gooseneck barnacles

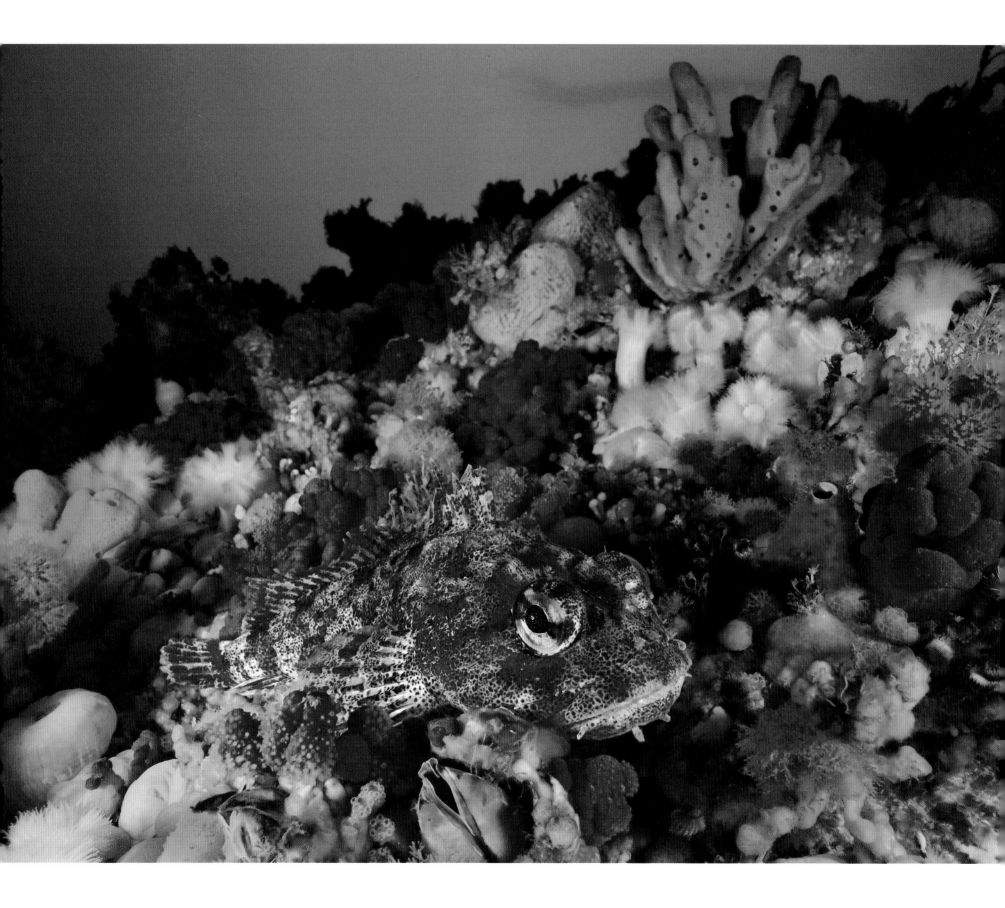

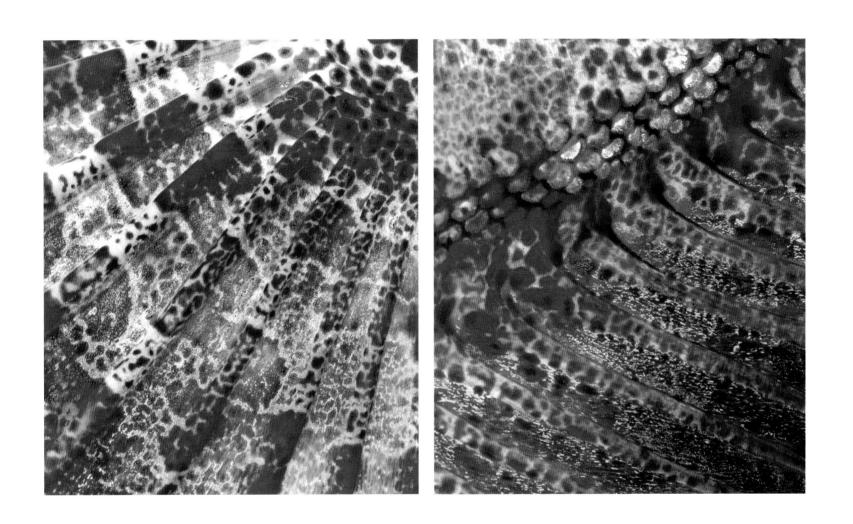

facing page: Red Irish lord sculpin

above: Red Irish lord (detail of fins)

following spread: Stubby squid

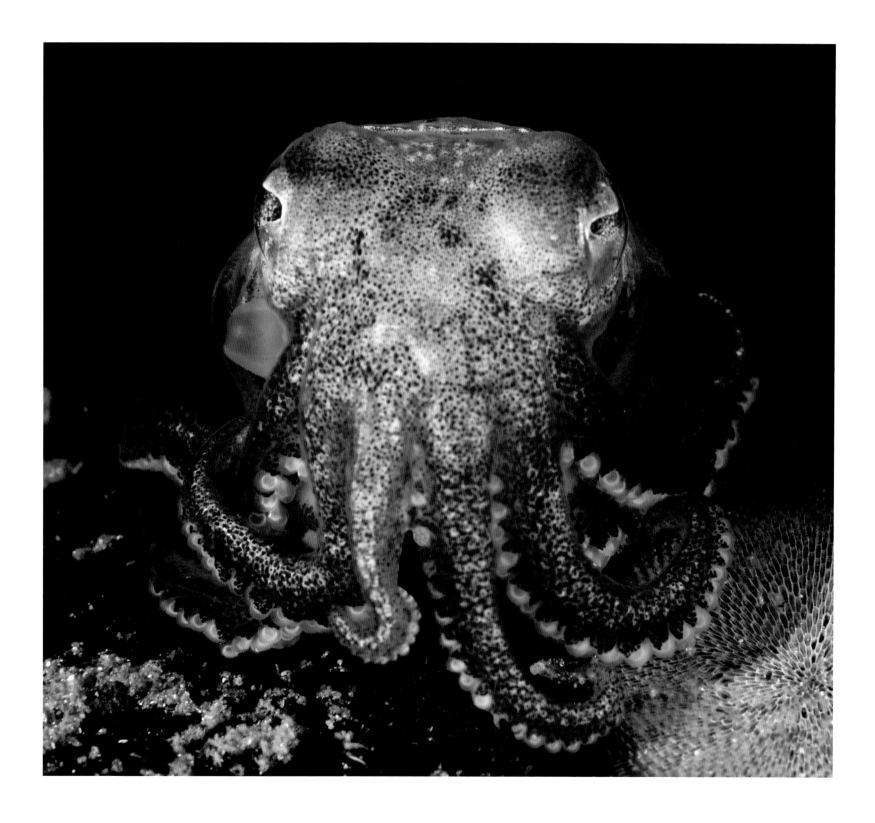

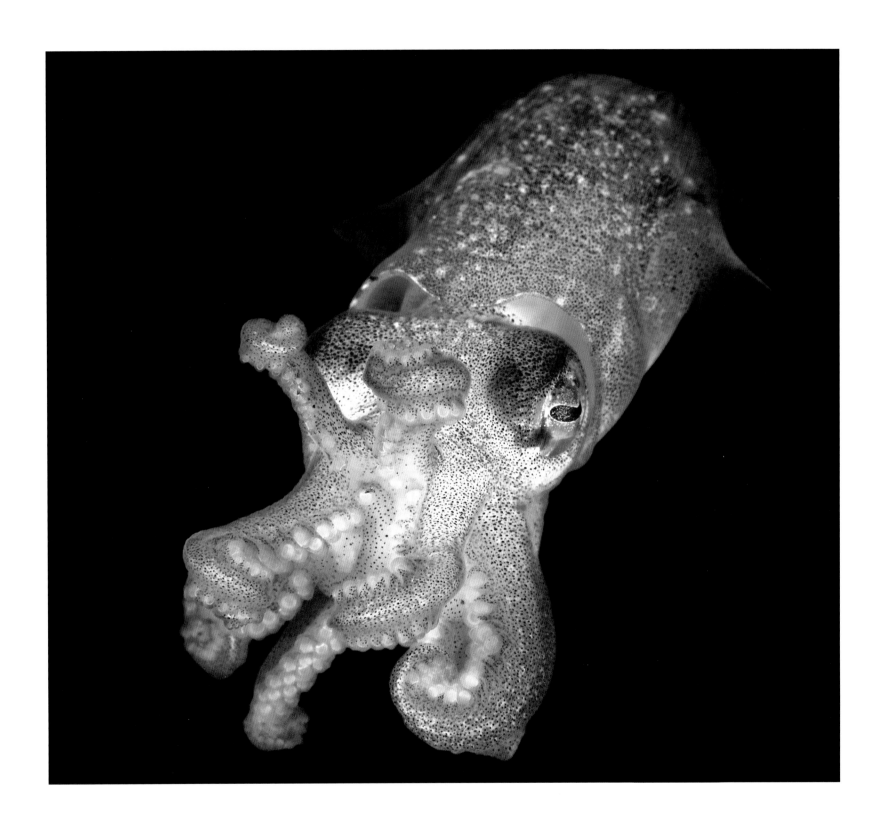

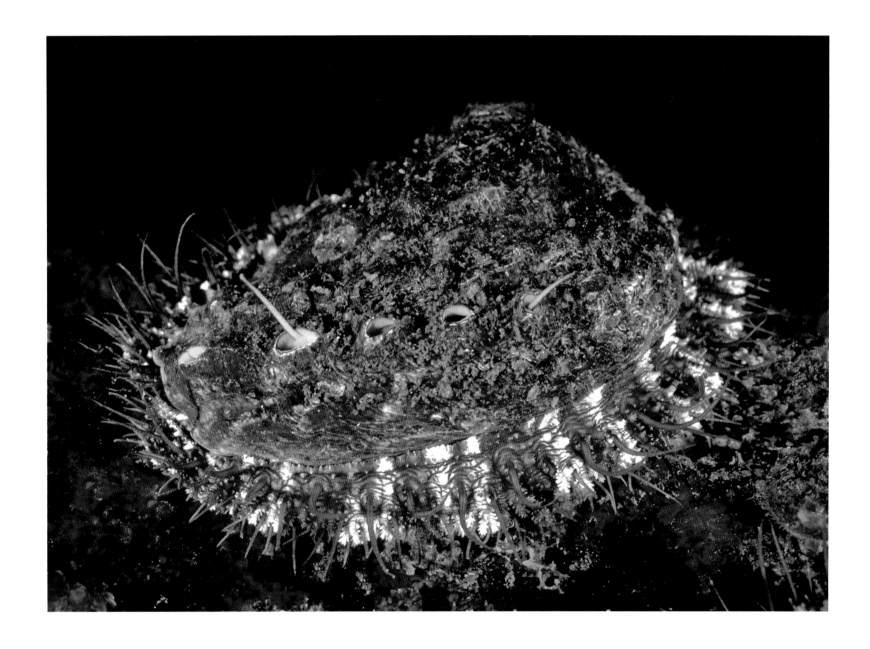

above: Northern abalone

facing page: Male painted greenling

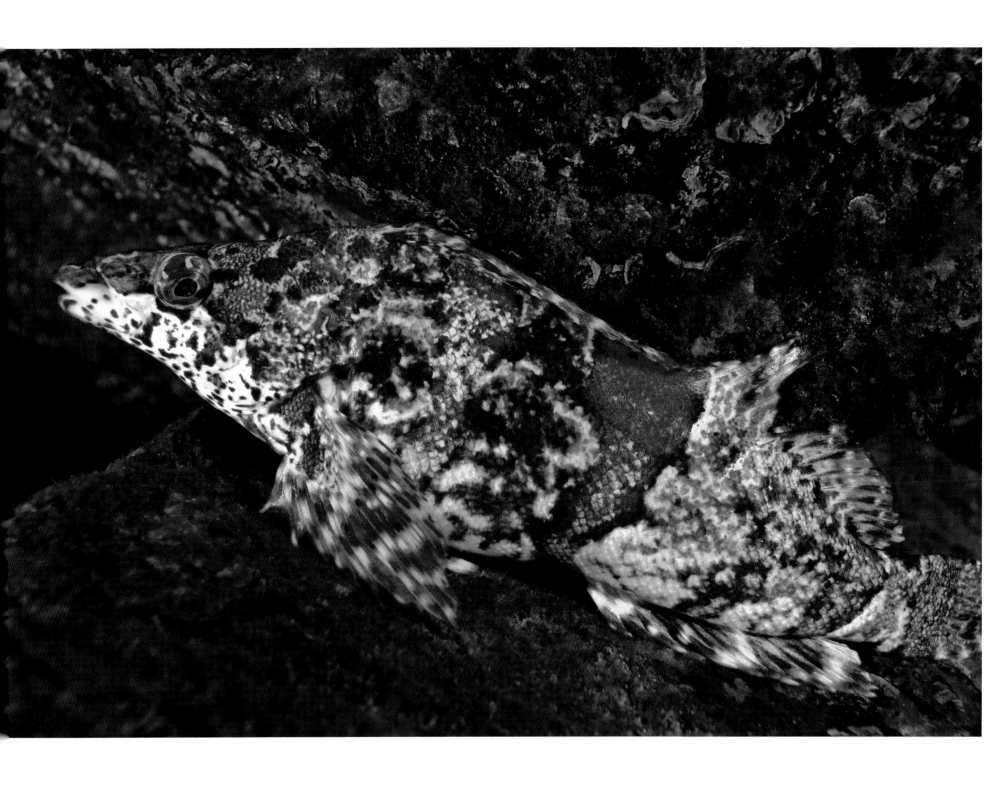

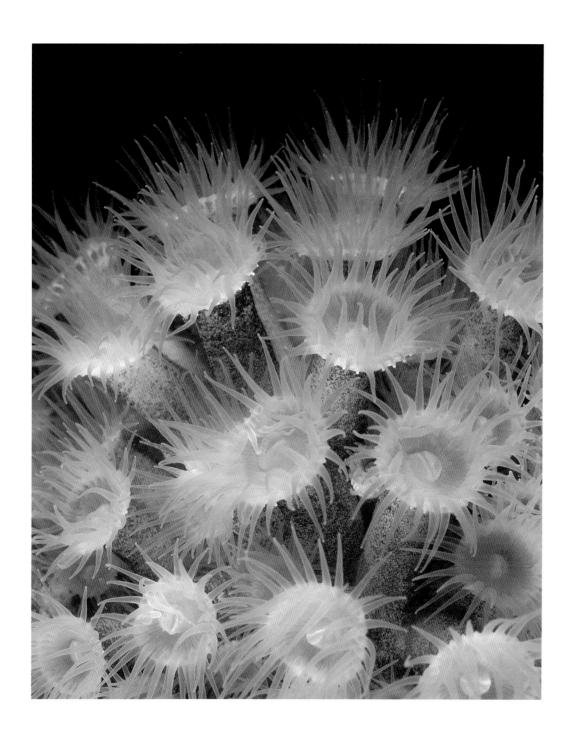

above: Orange zoanthids

facing page: Scalyhead sculpin

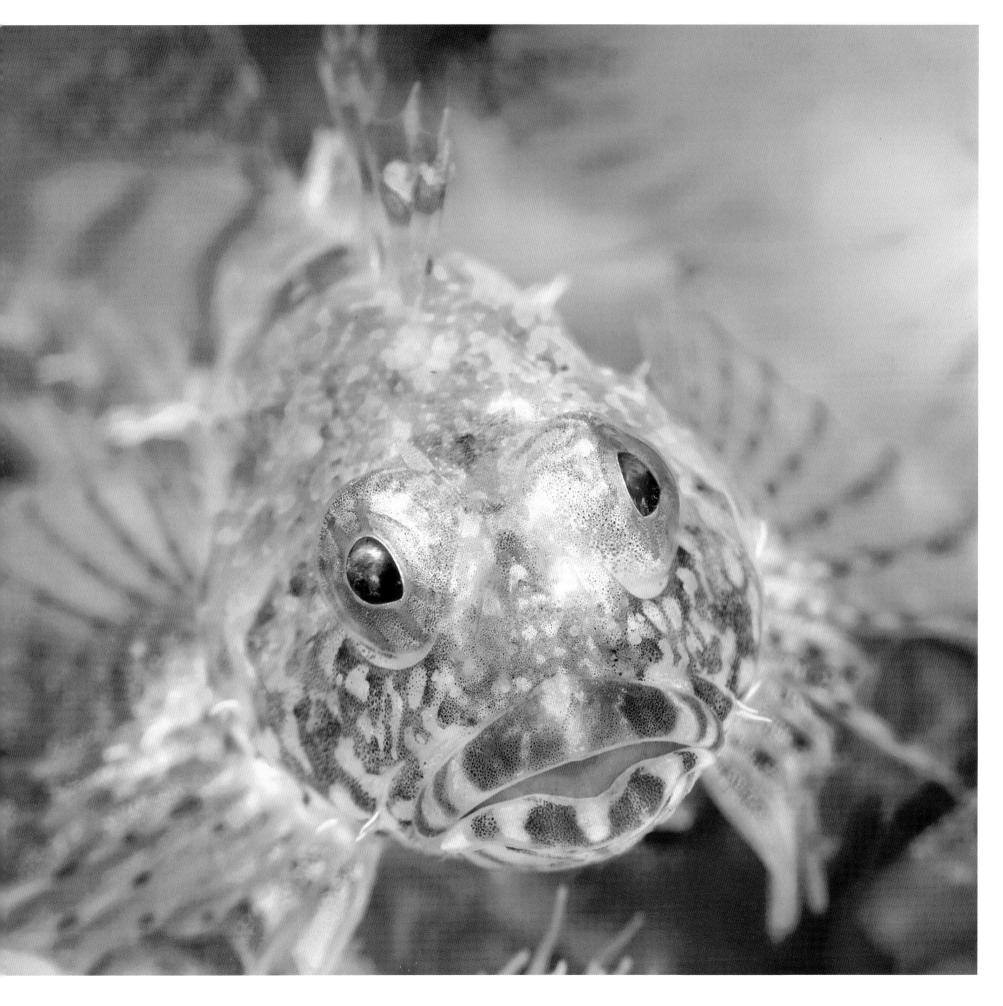

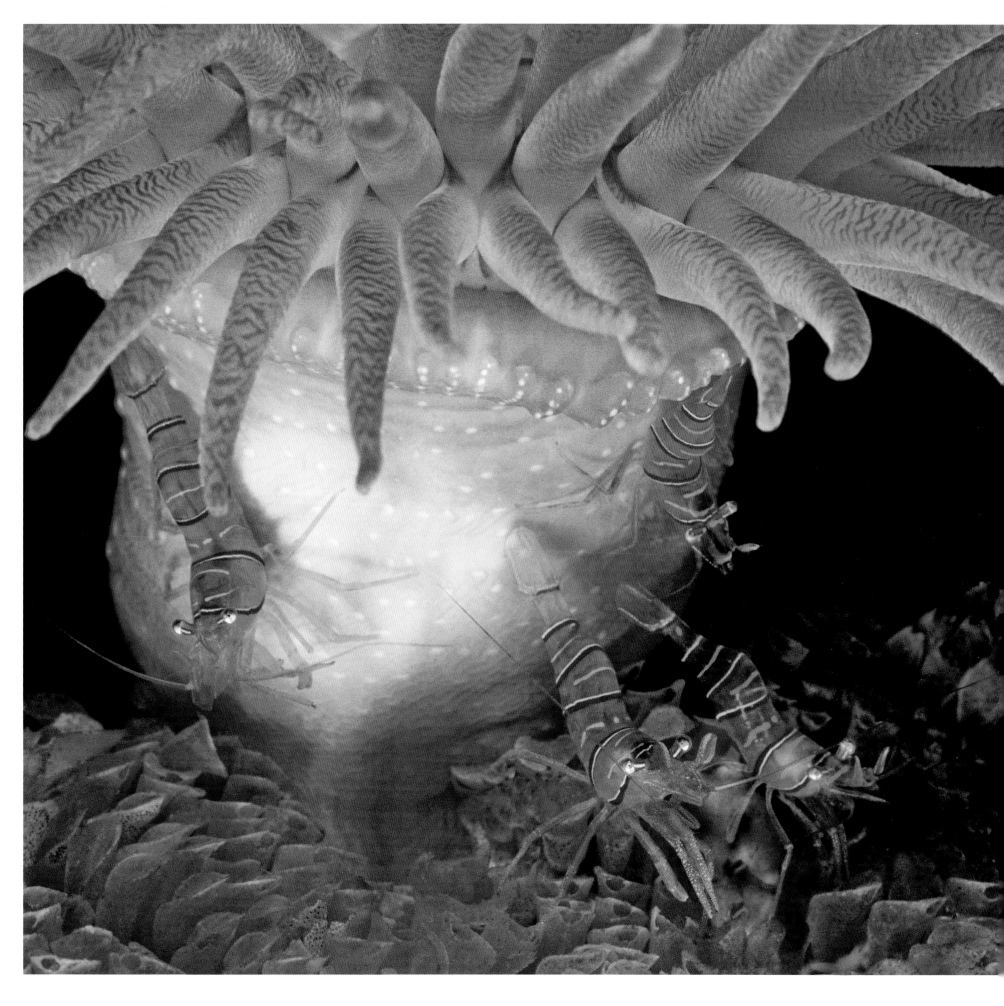

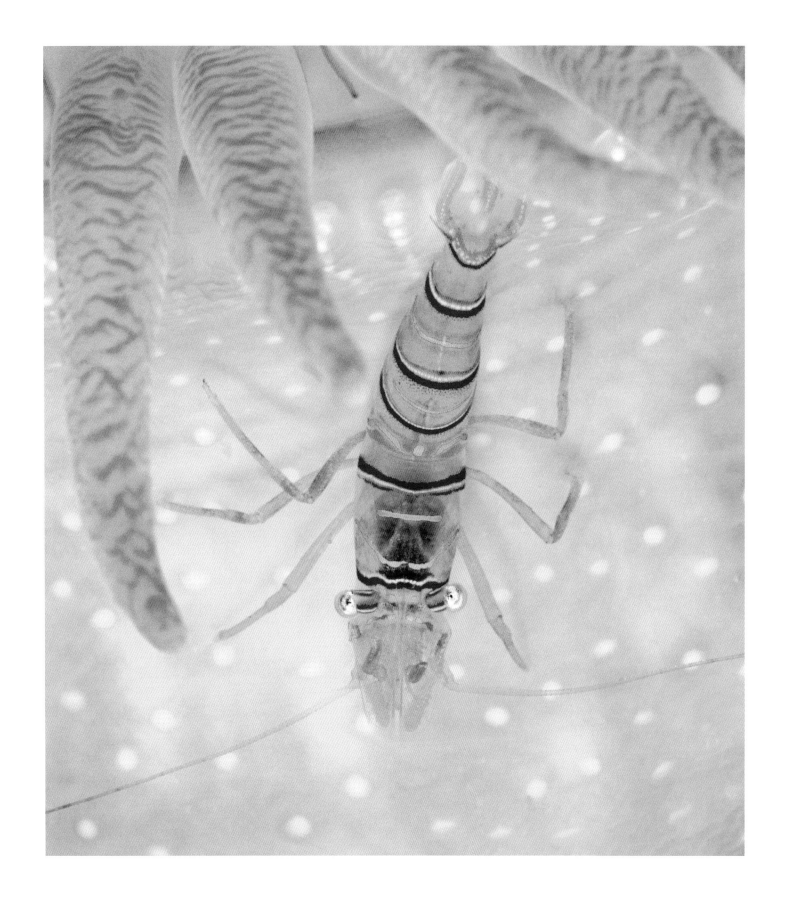

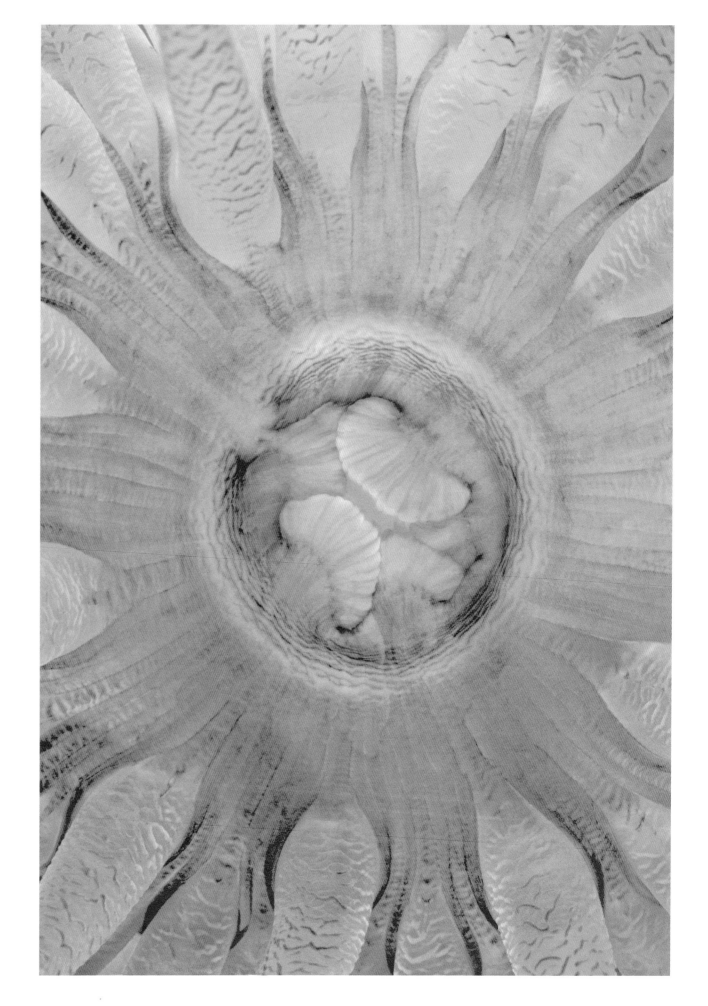

previous spread: Candy stripe
shrimps with crimson anemone

right: Mouth of crimson anemone

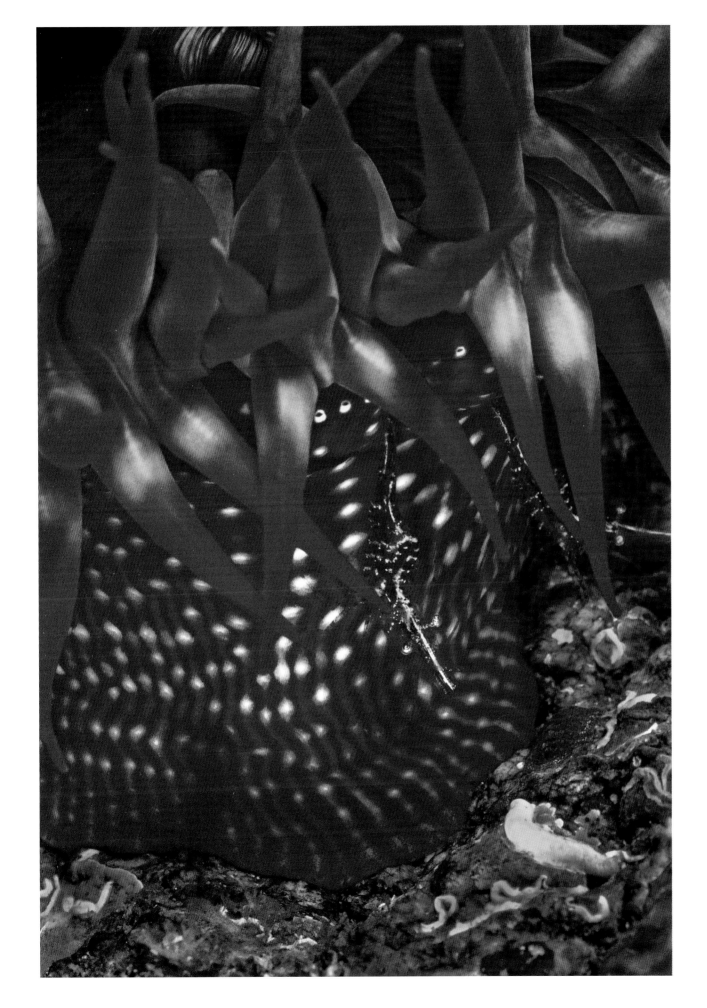

left: White-spotted rose
anemone with Kincaid's shrimps
following spread, *left*: Four kinds
of anemones; *right*: Oral disk
of rose anemone

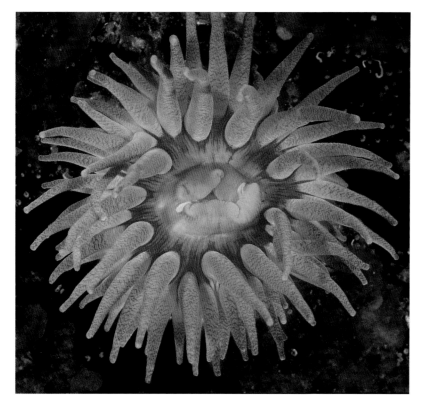
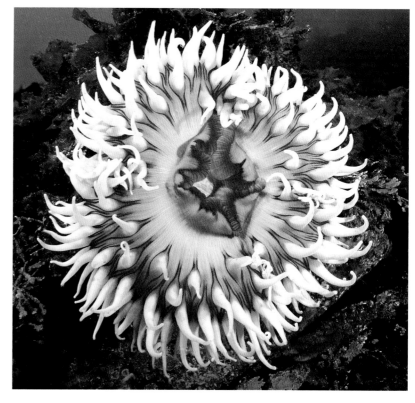
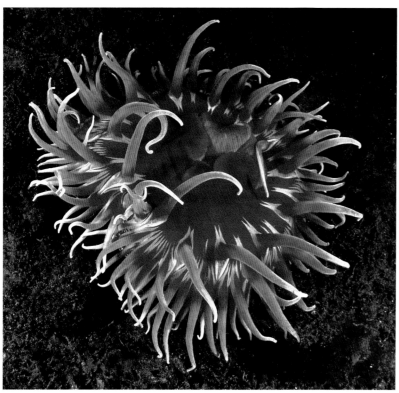
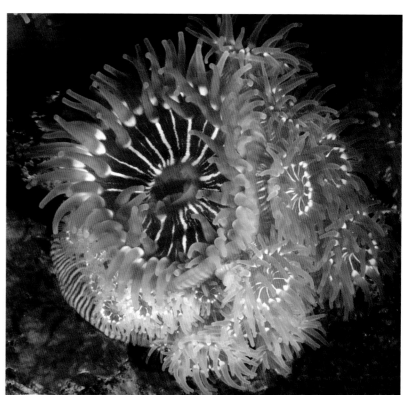

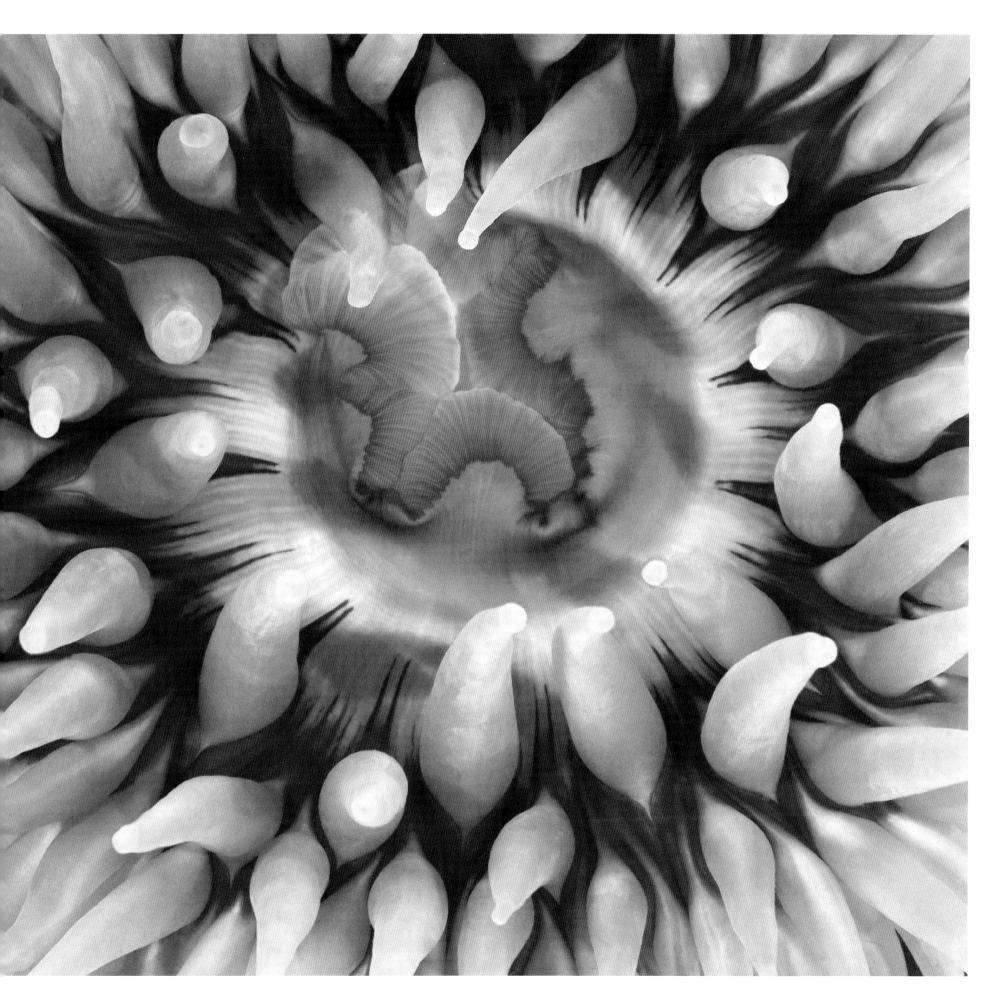

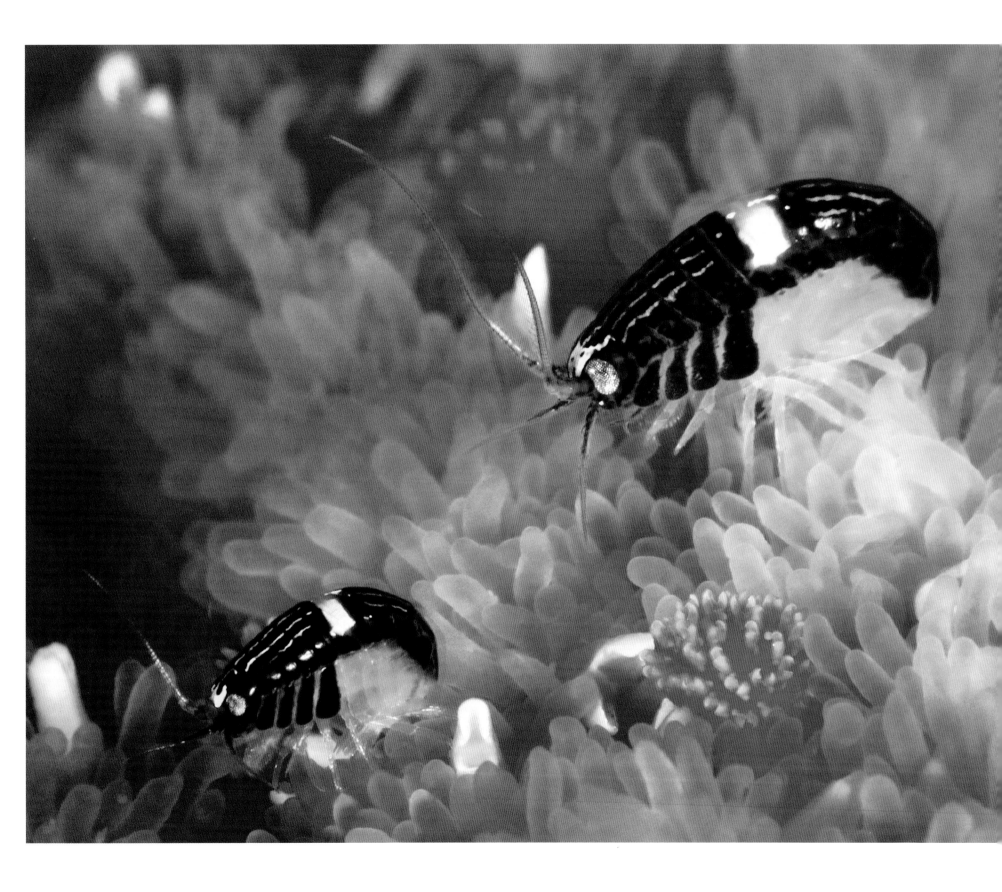

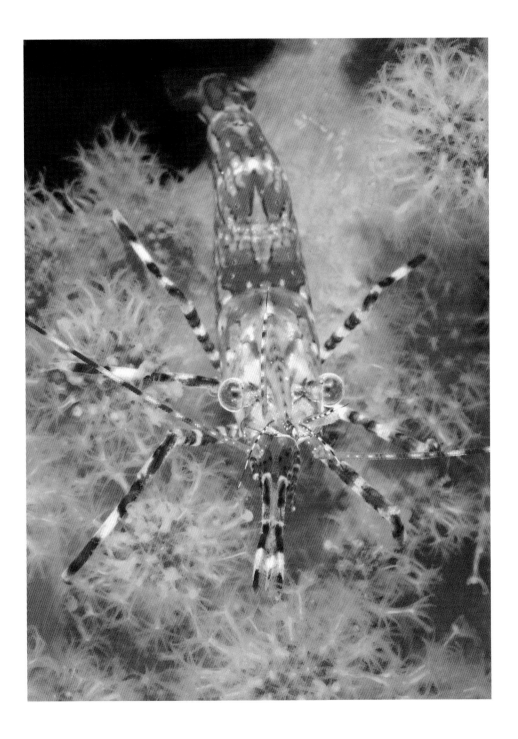

facing page: Black-and-white amphipods

left: Coonstripe shrimp

above: Yellow sea spider

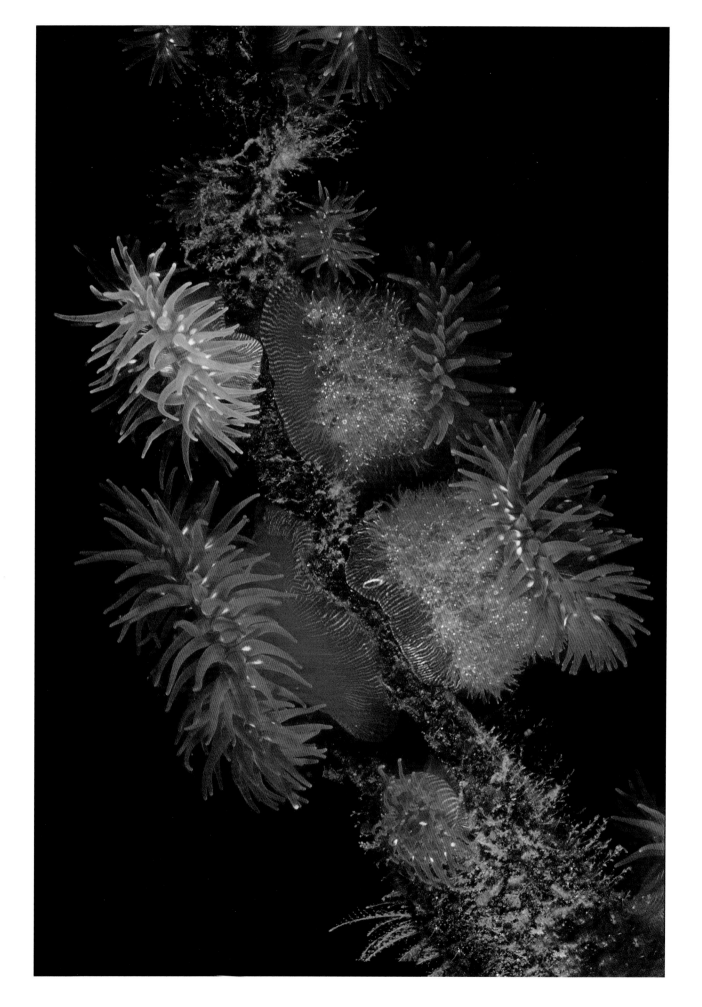

Brooding and proliferating
anemones

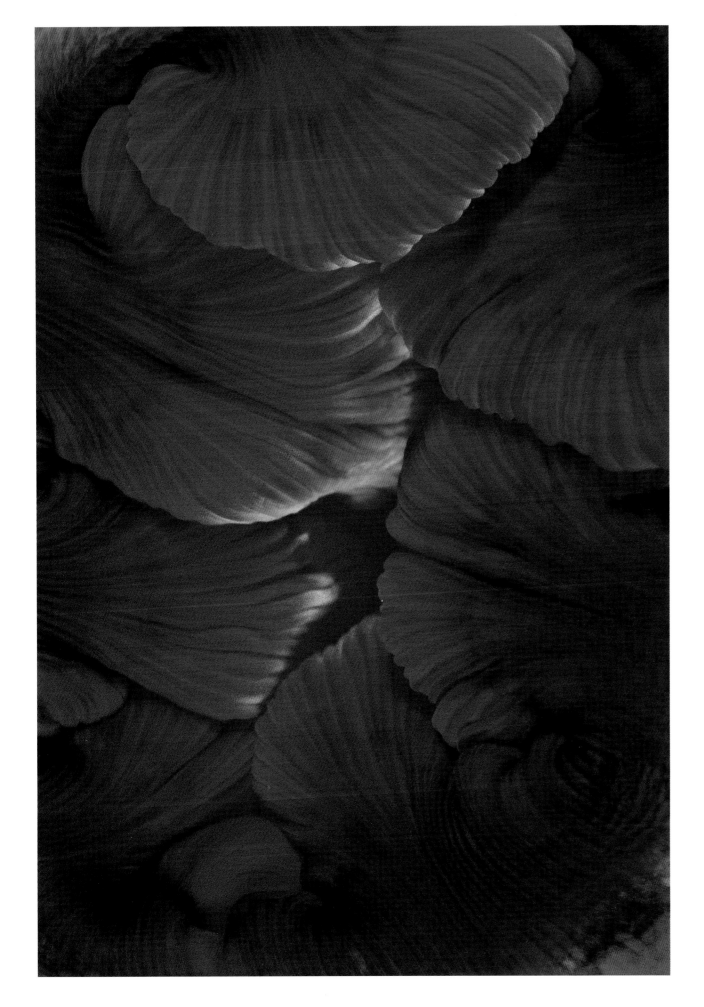

The mouth of a painted anemone

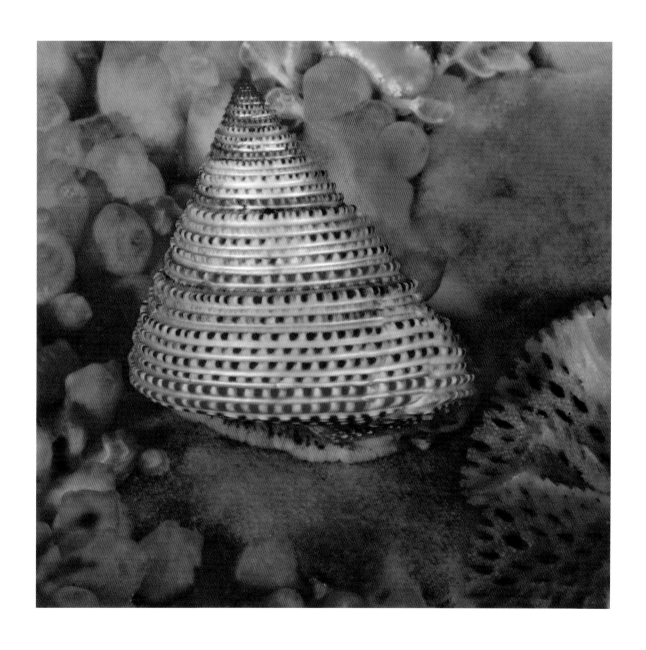

above: Purple-ringed topsnail

facing page: Red sea cucumbers
and plumose anemones

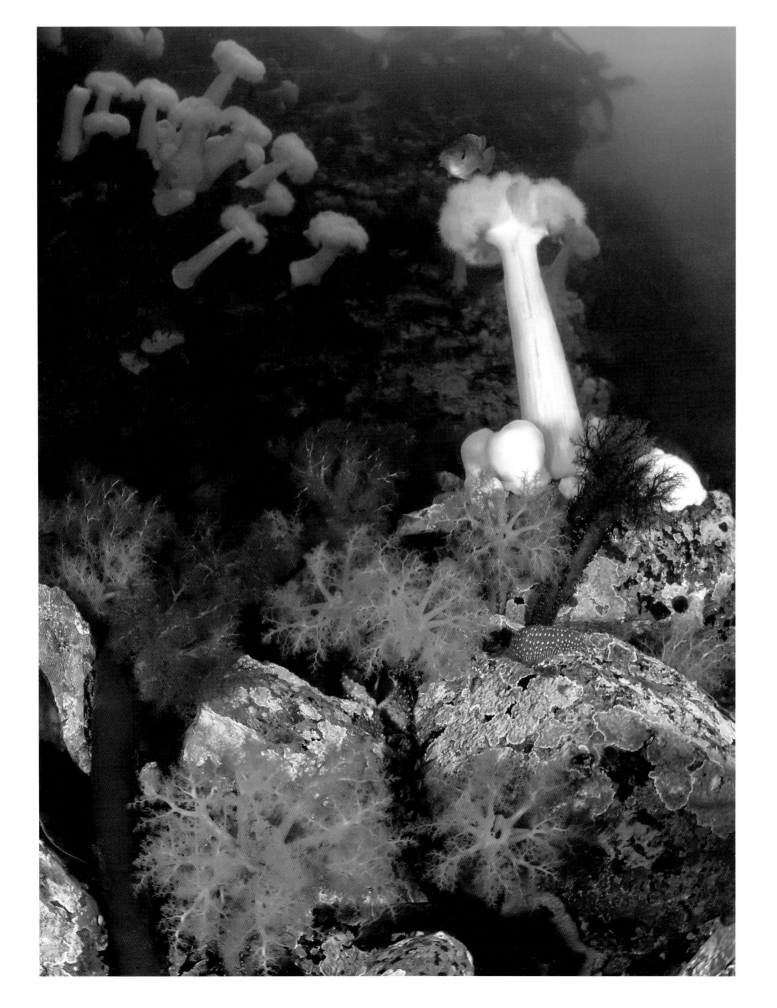

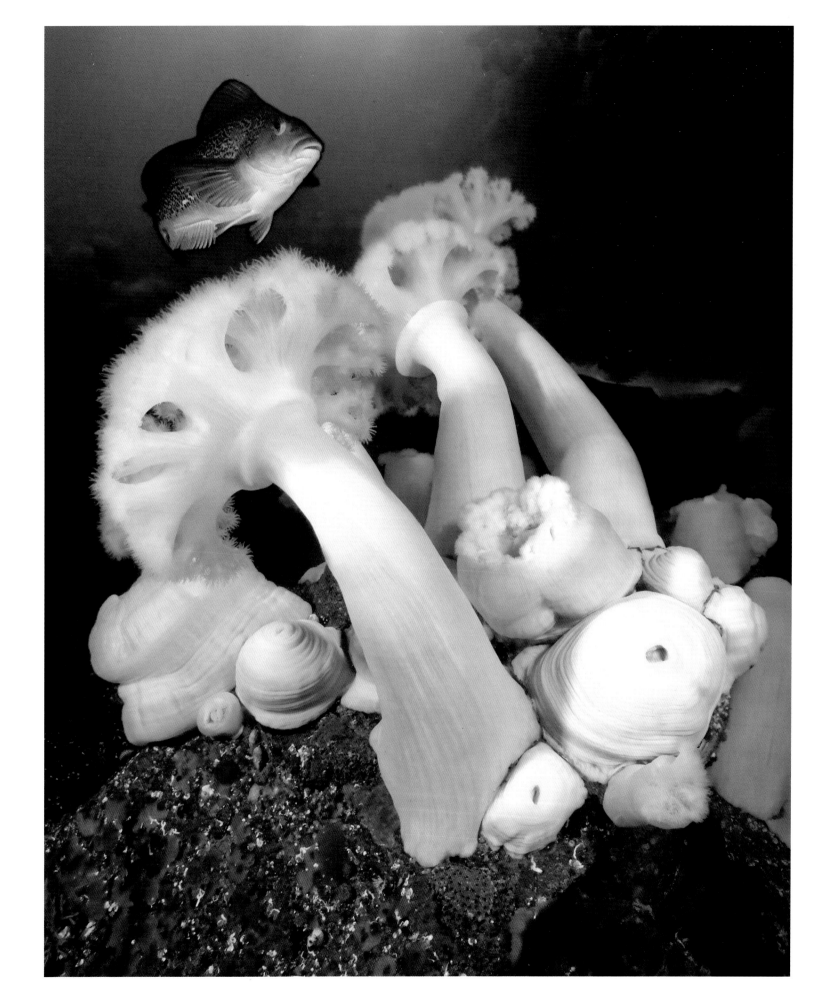

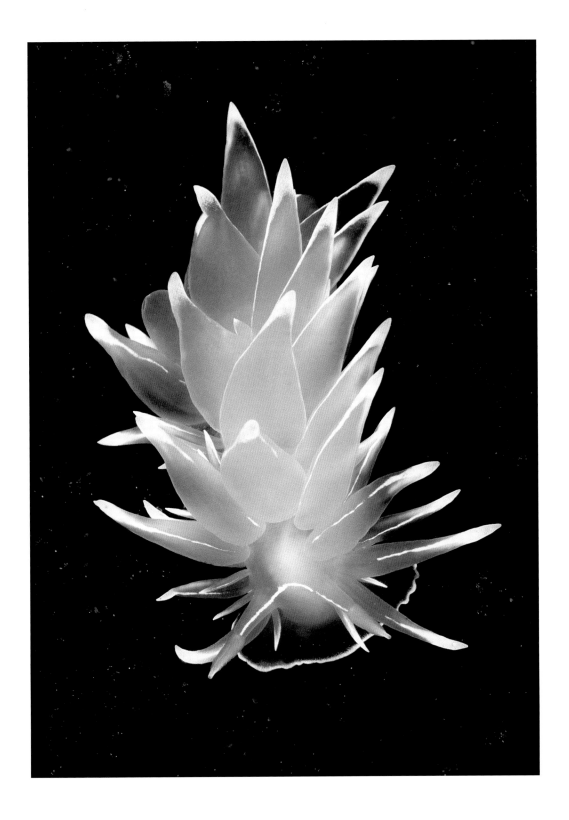

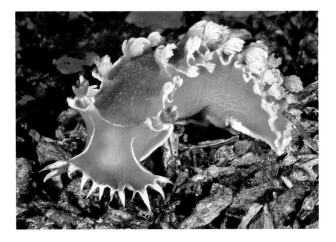

facing page: Plumose anemones
with yellowtail rockfish

left: Frosted nudibranch

above, top: Festive triton nudibranch;
bottom: nudibranch eggs

following spread, *left*: Four nudibranchs;
right: Opalescent nudibranchs

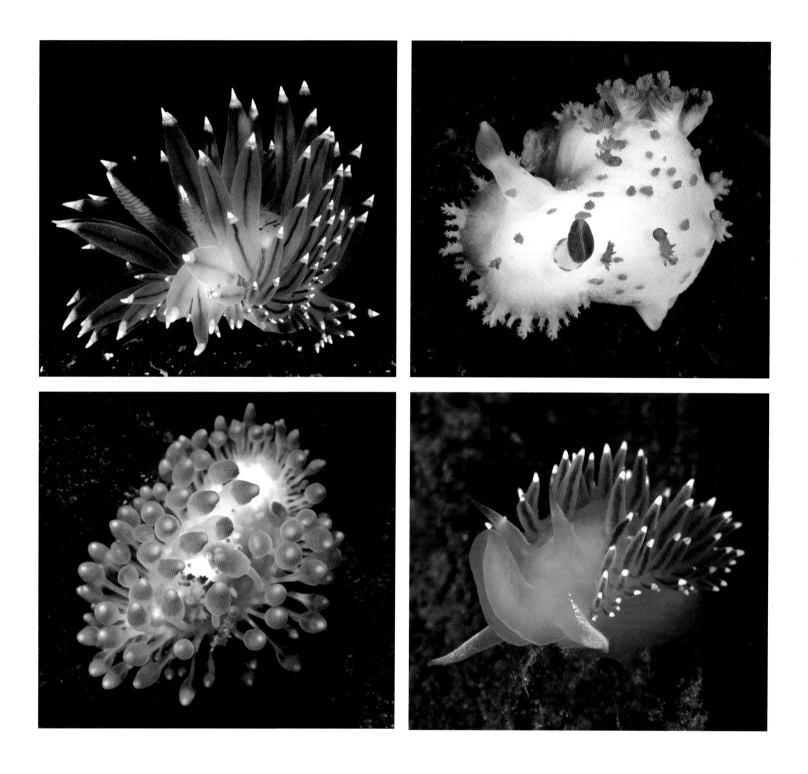

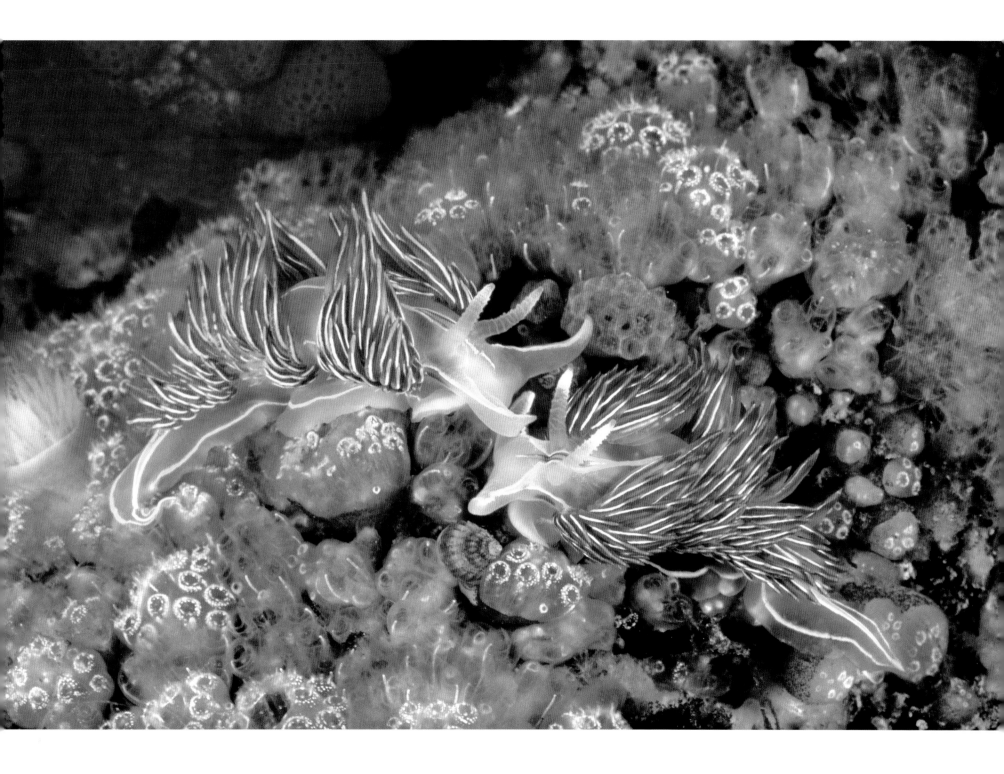

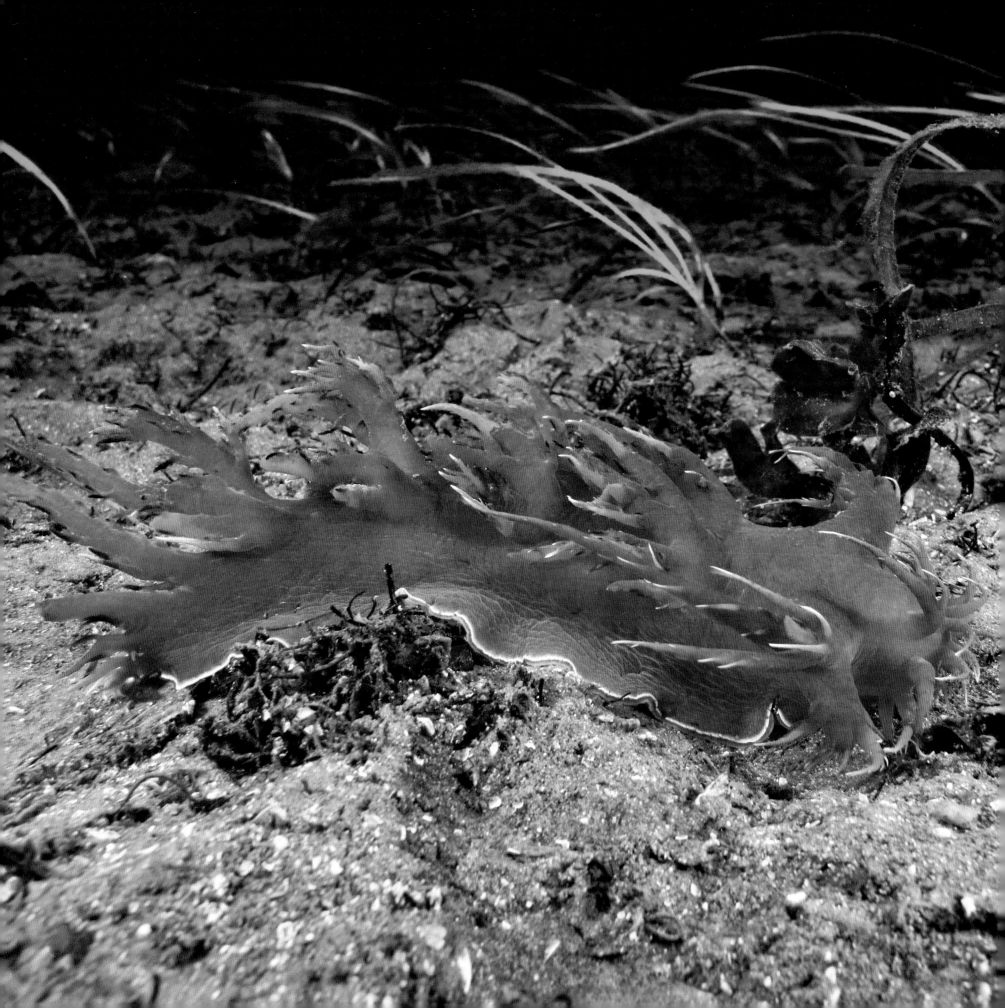

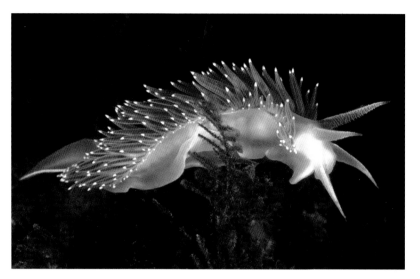

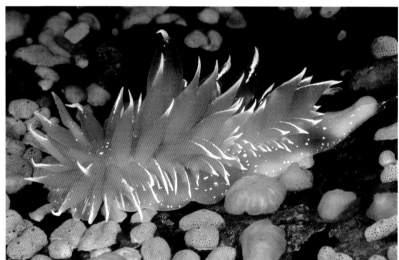

left: Giant nudibranch
top: Red-gilled nudibranch
bottom: Golden dirona nudibranch

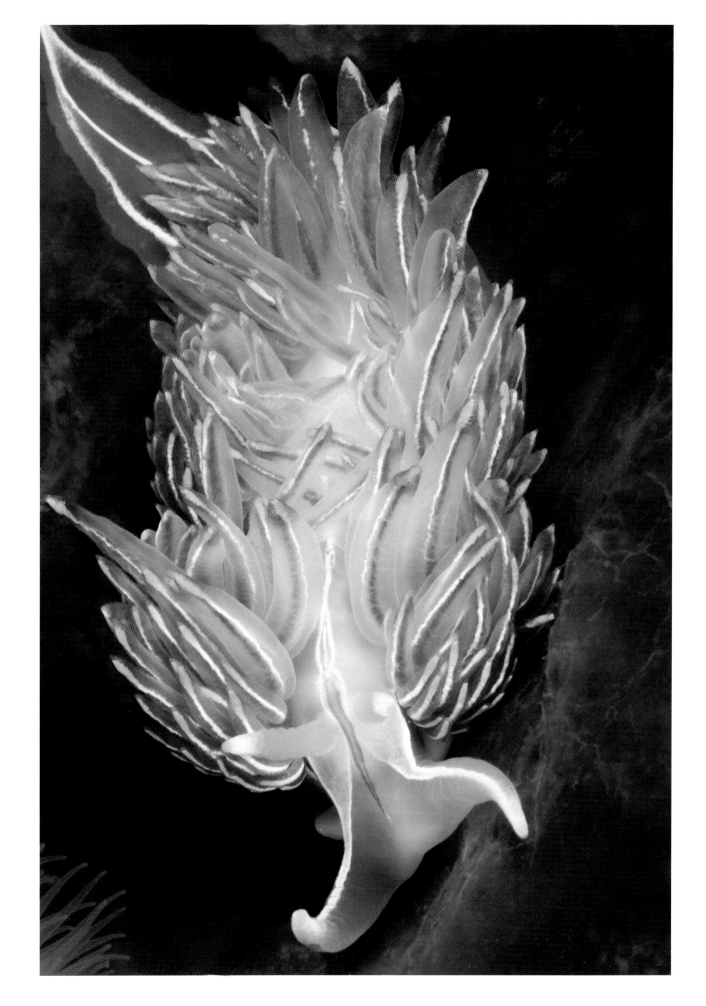

Opalescent nudibranch

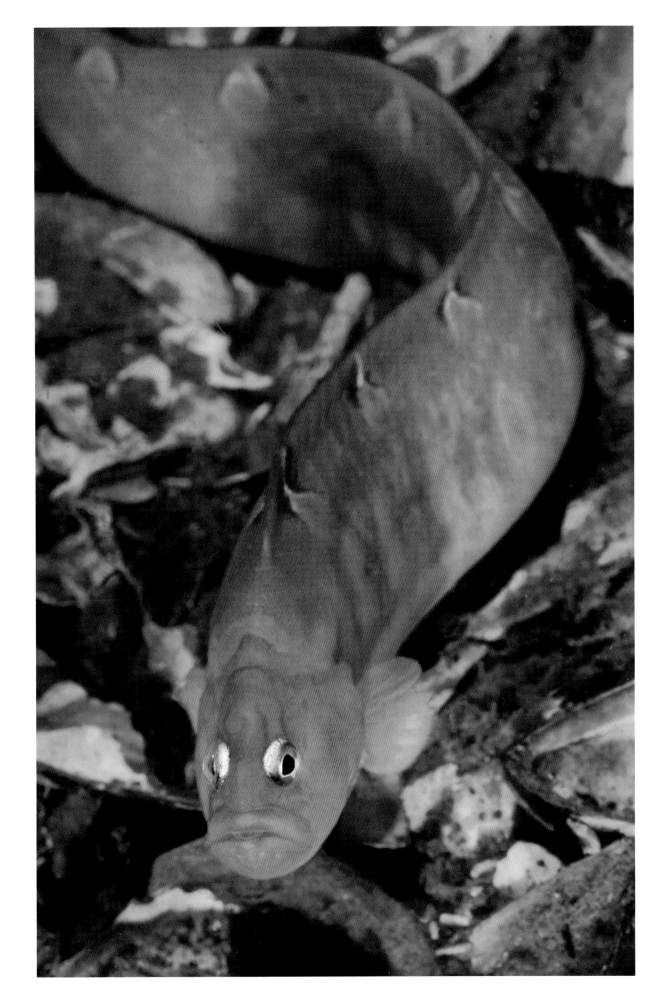

Crescent gunnel

CRABS

MOVED IN slowly. The massive Puget Sound king crab was in perfect position for a photograph, and I did not want to disturb it. I began taking pictures and was relieved when the camera's flash produced no reaction. I circled slowly to one side to capture a different view, and still the crab did not move. Then I noticed that it was missing one of its legs and that another was bent at a peculiar angle. I poked my subject gently with one finger; it was so light that it almost floated away. The embarrassing truth was that I had been photographing a recently discarded, empty shell; the crab itself had departed, leaving its old exoskeleton behind. Crabs do not have skin that stretches as they grow, and so they must periodically molt, discarding their old shell and replacing it with a new, larger one that hardens in place over a period of days.

When I was ten years old I dreamed of a career in entomology, and to this day arthropods—insects and other animals with jointed legs and an outer skeleton—hold a special fascination for me. Insects do not live in the sea, but many of their arthropod cousins do; after mollusks, there are more species of arthropods in the ocean than any other kind of animal. Most familiar among marine arthropods are the crustaceans, particularly those with five pairs of legs, such as crabs, shrimps, and lobsters. Among crustaceans, it is the crabs that I find most appealing.

A crab has a large array of appendages, which, like the tools in a Swiss army knife, serve many different functions, such as feeding, grasping, walking, swimming, and even holding a disguise or protective shell in place. The Puget Sound king crab uses its powerful claws for crushing or tearing its prey; I have even seen one snacking on the severed arm of a large sea star. The Dungeness crab and others in the genus *Cancer*, however, rely more on agility and tenacity than on sheer strength to overcome their prey.

One winter night I made a dive beneath our boat, anchored in a quiet bay. The soft, muddy bottom appeared barren at first, and I began to wonder why I wasn't in my bunk. My slightest movement raised a cloud of fine silt, reducing visibility to less than a foot. In the gloomy darkness my flashlight illuminated a pale, ill-defined object. When the silt had settled a bit, I saw that it was a graceful *Cancer* crab that had found a large clam and was attempting to get at the meat inside.

Like a knight in armor laying siege to a castle, the crab would need strength, skill, and persistence to penetrate the clam's thick shell. The crab repeatedly squeezed the shell halves together in an attempt to create microfractures that would eventually cause the shell to shatter. Should this initial strategy fail, the crab might begin to chip away at the edges of the shell, gradually creating a fatal opening. One can only admire such determination.

Crabs are themselves well defended by a hard shell and powerful claws. Certain fish, mammals, and sea birds can overcome the crabs' defenses, although not without a fight. Once, on a dive in Browning Pass, I came upon a fish—an Irish lord—with a half-swallowed crab in its mouth. I could hardly believe my luck; in most cases a small crab is quickly swallowed by the much larger sculpin, and the event is seldom photographed. Fortunately for me the crab was stuck crossways in the fish's mouth, making it difficult to swallow, especially since the feisty crab was holding onto to the fish's upper lip with one of its legs.

Many crabs use camouflage to hide from their enemies. "Decorator" crabs attach living plants or animals to tiny hooklike projections on their exoskeletons. "Decorations" such as sponges and stinging hydroids disguise the crab and are also distasteful to most predators. The crab *Oregonia gracilis* carries the process to extremes by decorating nearly every part of its anatomy. I am usually unable to spot one of these disguised crustaceans until I see a small clump of sponges or algae move just a tiny bit—a sure sign that a crab is lurking within.

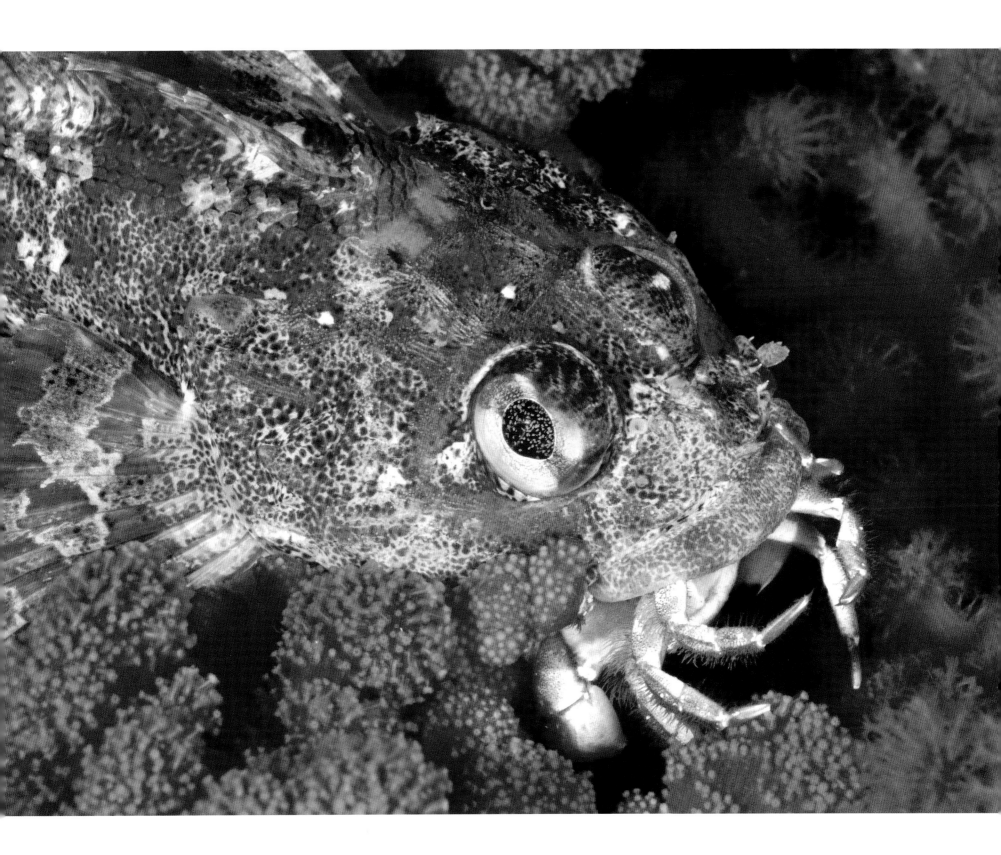

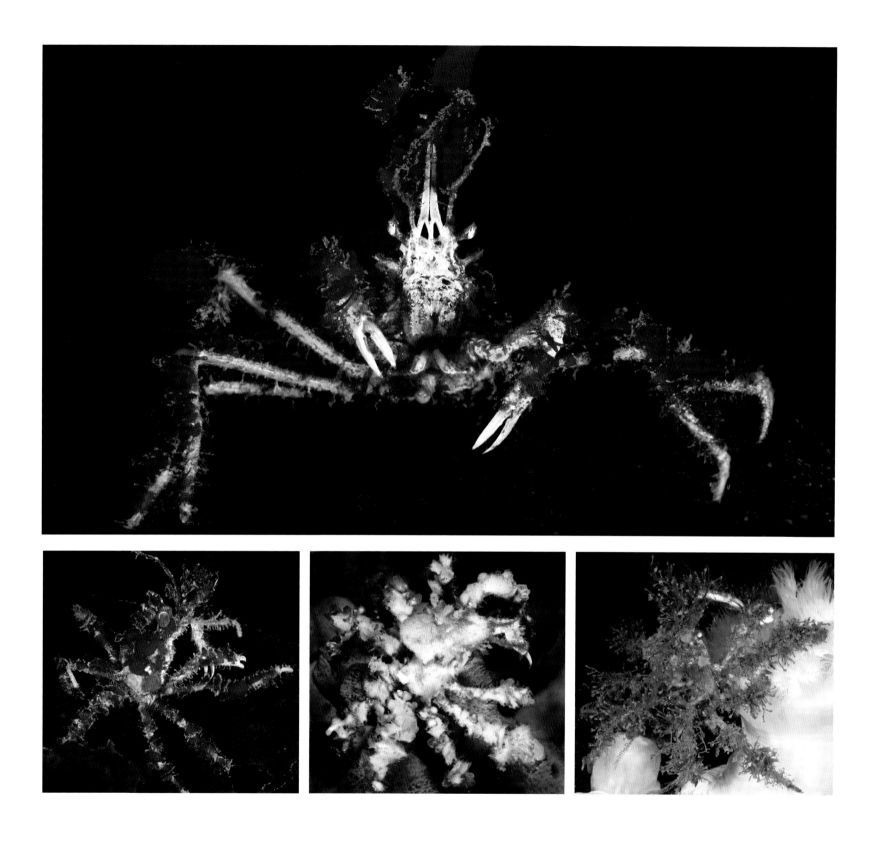

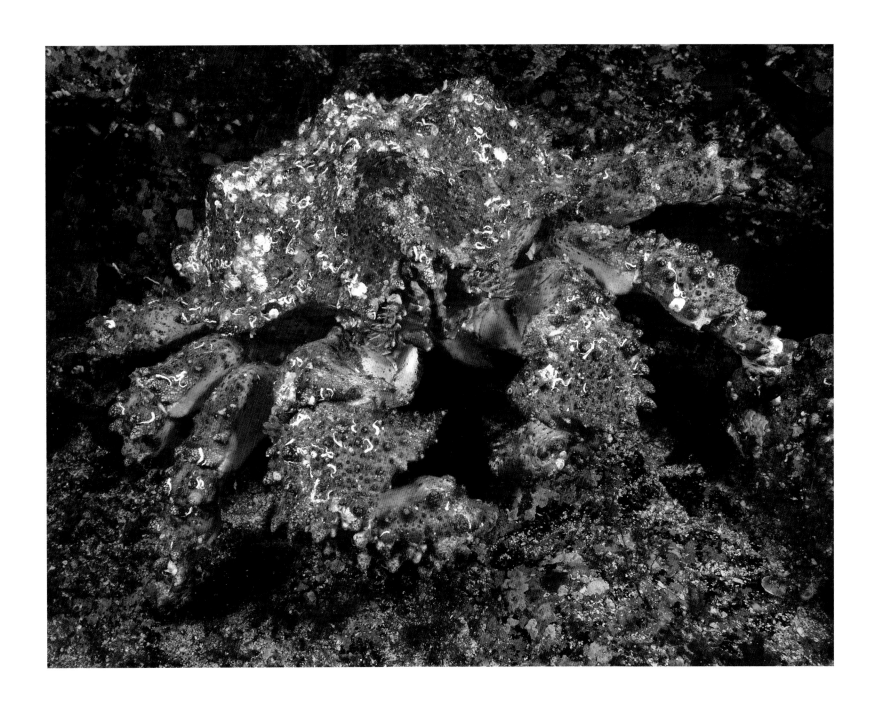

previous spread: Irish lord with pygmy rock crab

facing page: Disguises worn by one kind
of "decorator" crab

above: Puget Sound king crab

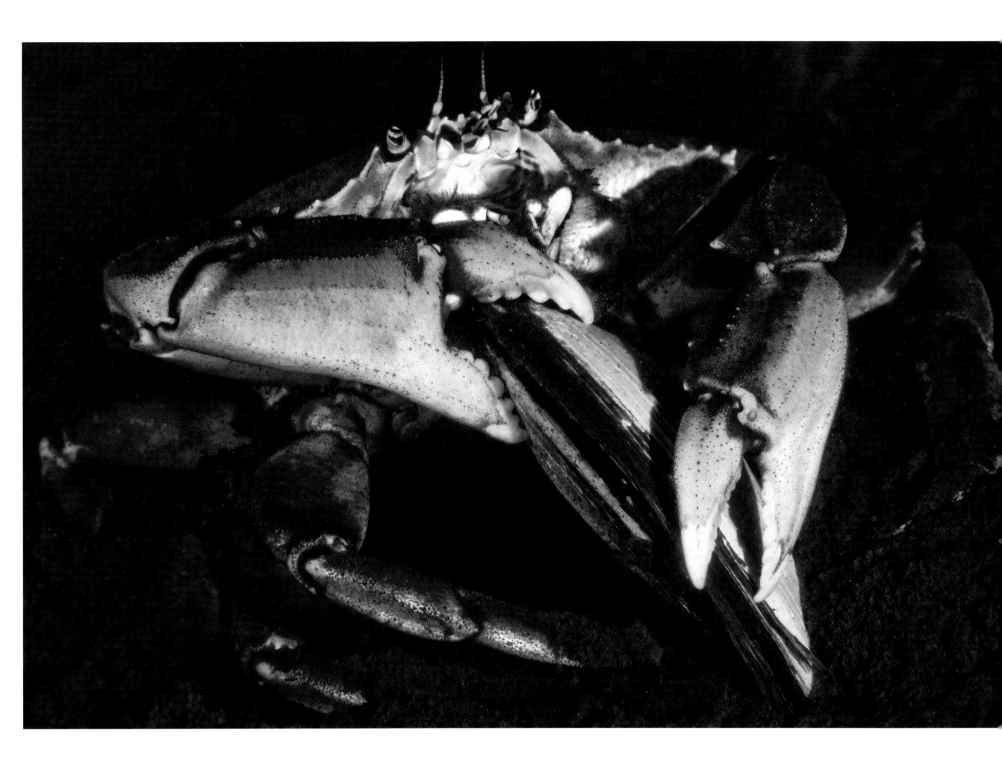

Graceful crab opening a clam

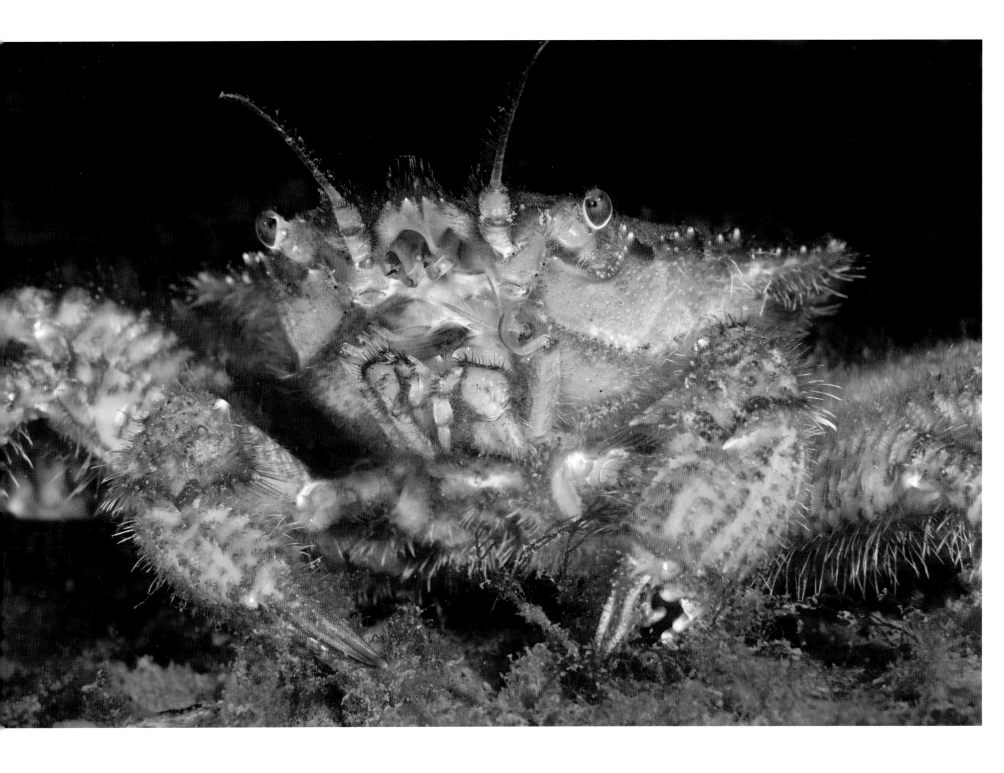

Helmet crab

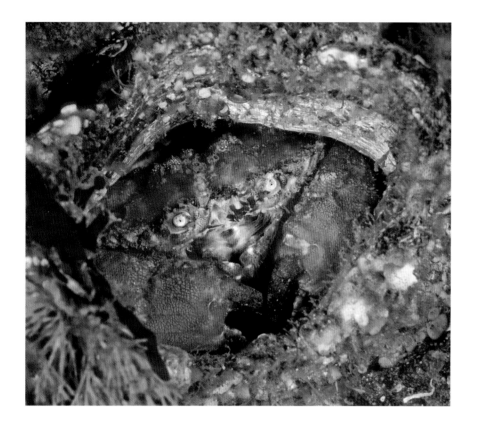

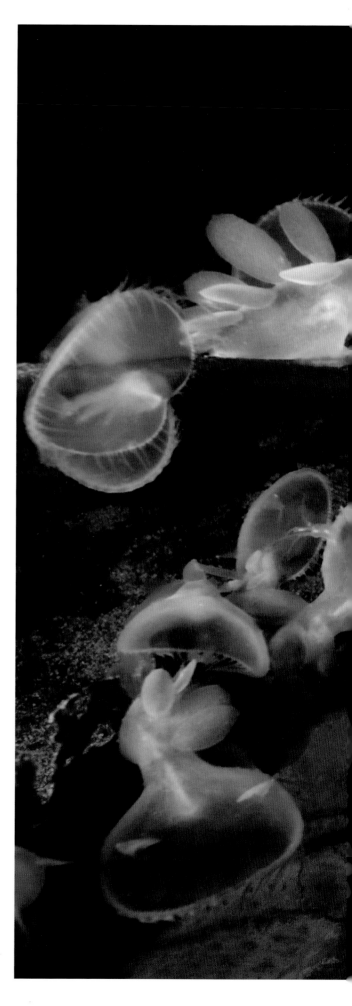

above: Pygmy rock crab inside an
empty barnacle "shell"

right: Helmet crab with hooded nudibranchs

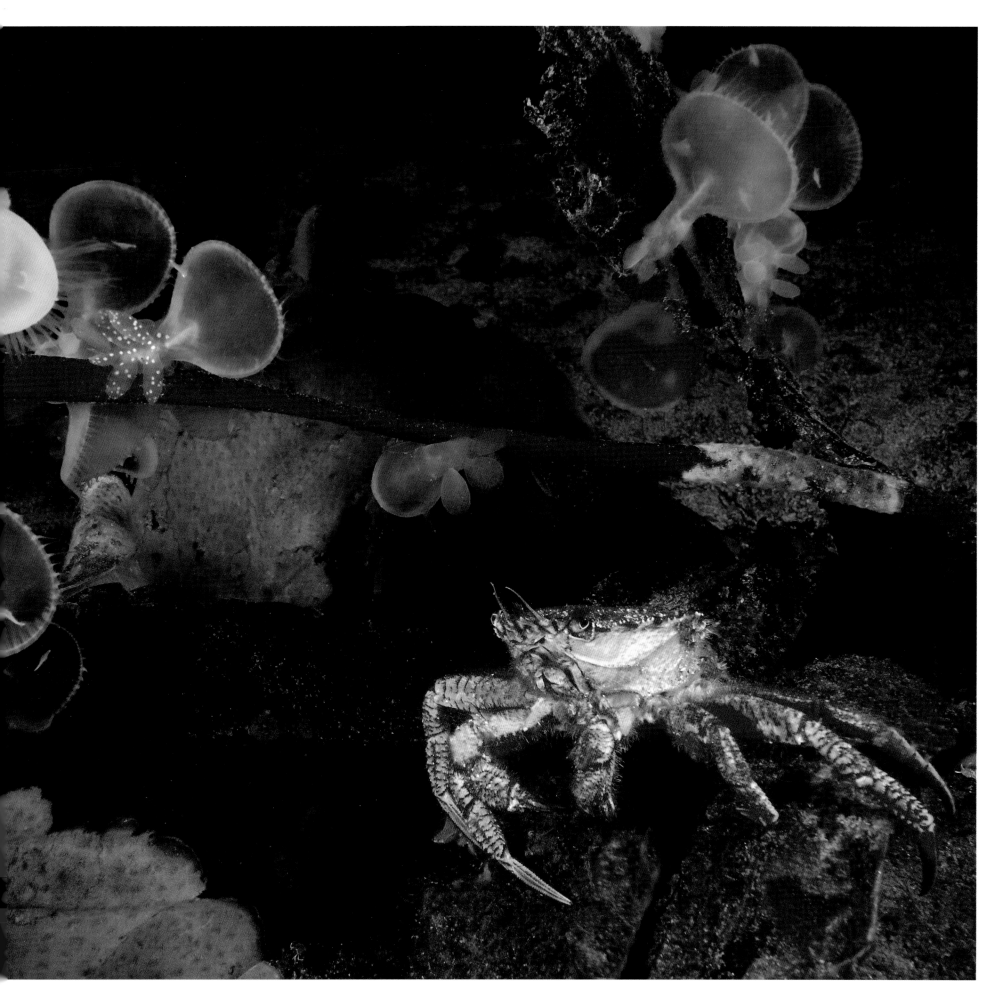

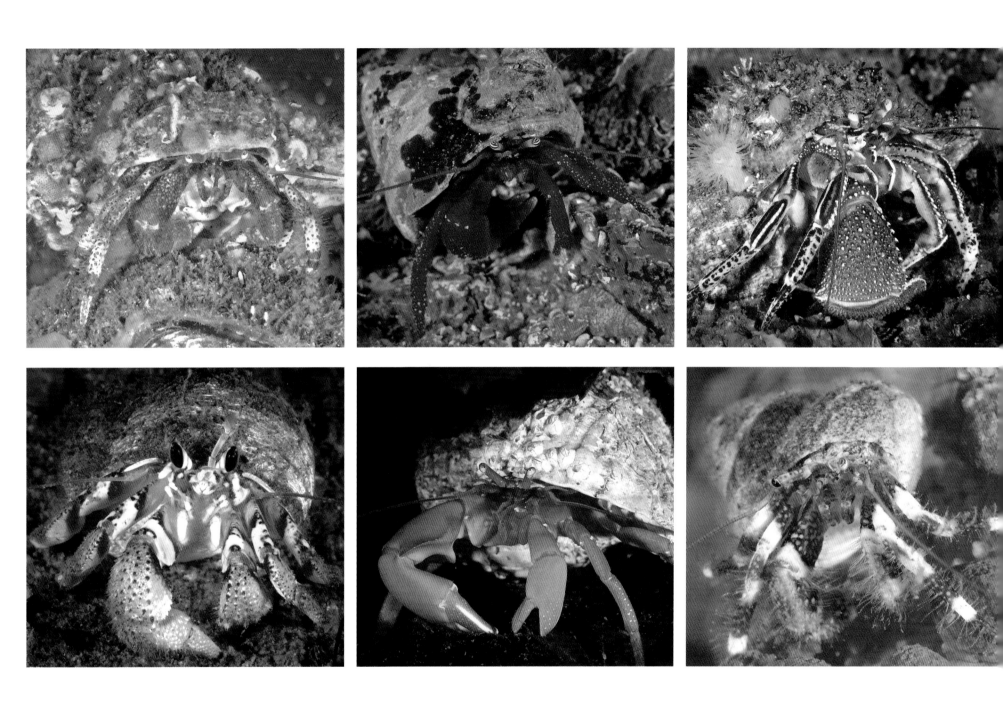

Six kinds of hermit crabs

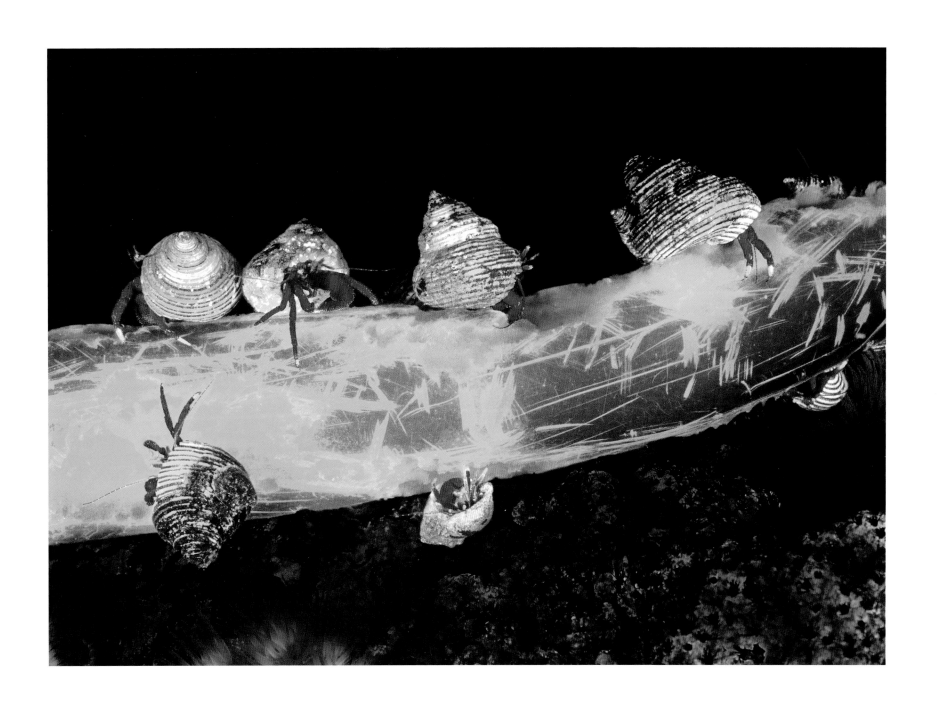

Maroon hermit crabs eating kelp

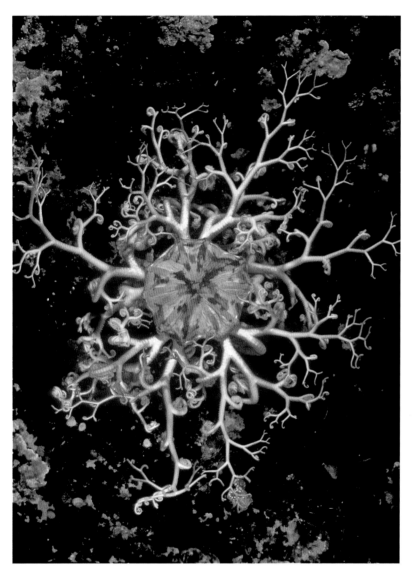
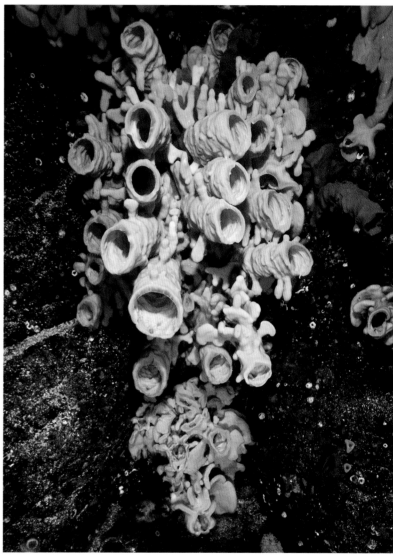

above, left: Basket star;
right: Cloud sponges
facing page: Northern kelp crab

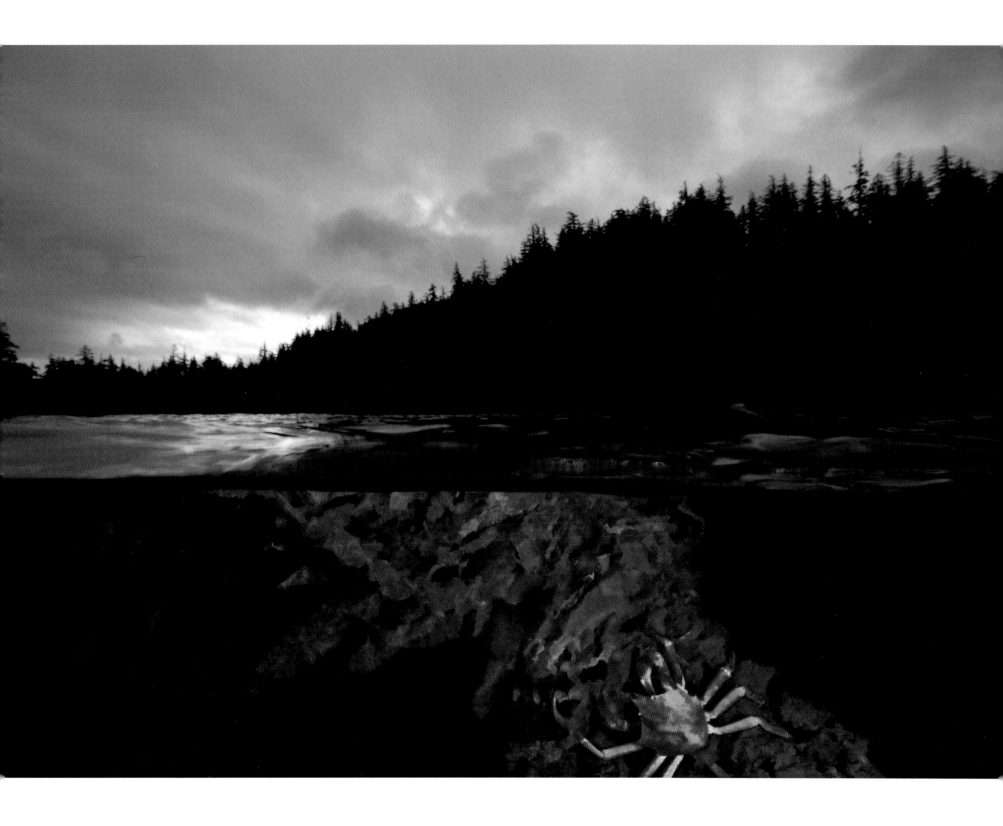

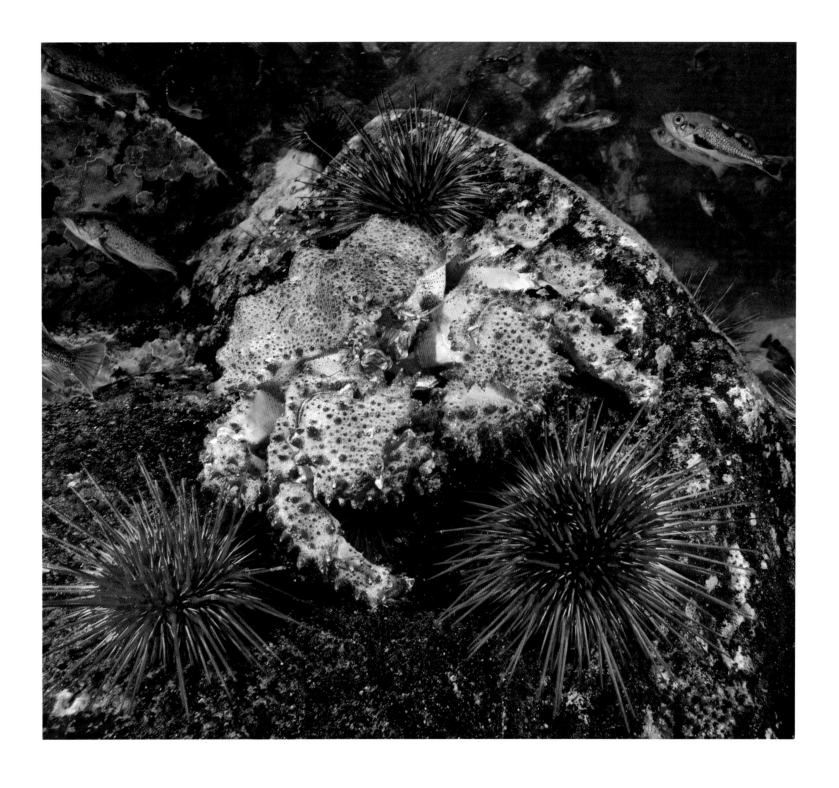

Puget Sound king crab and red urchins

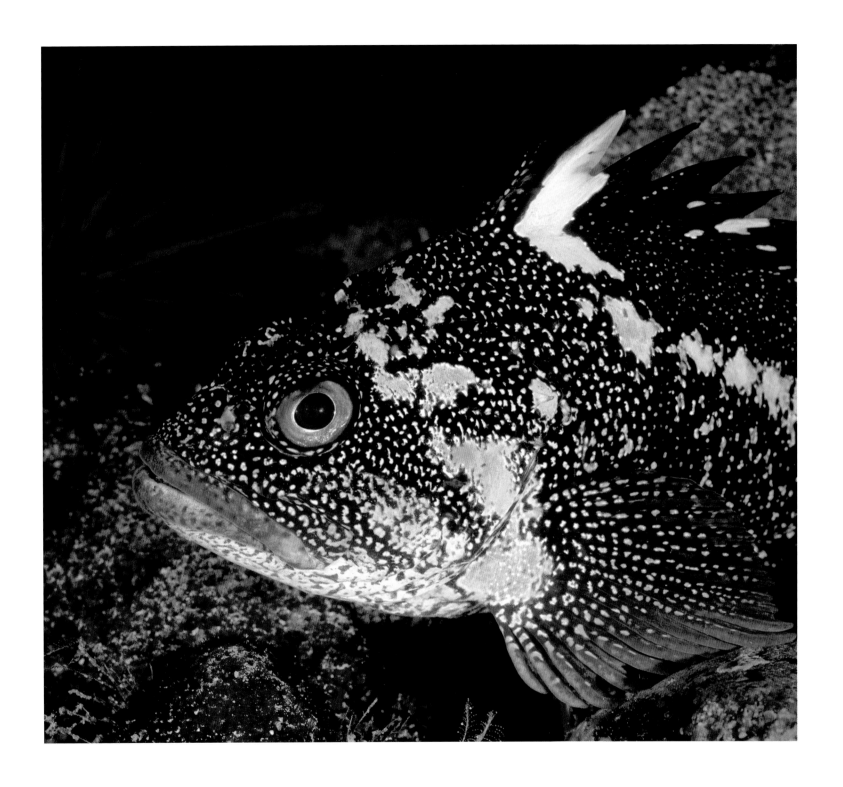

China rockfish

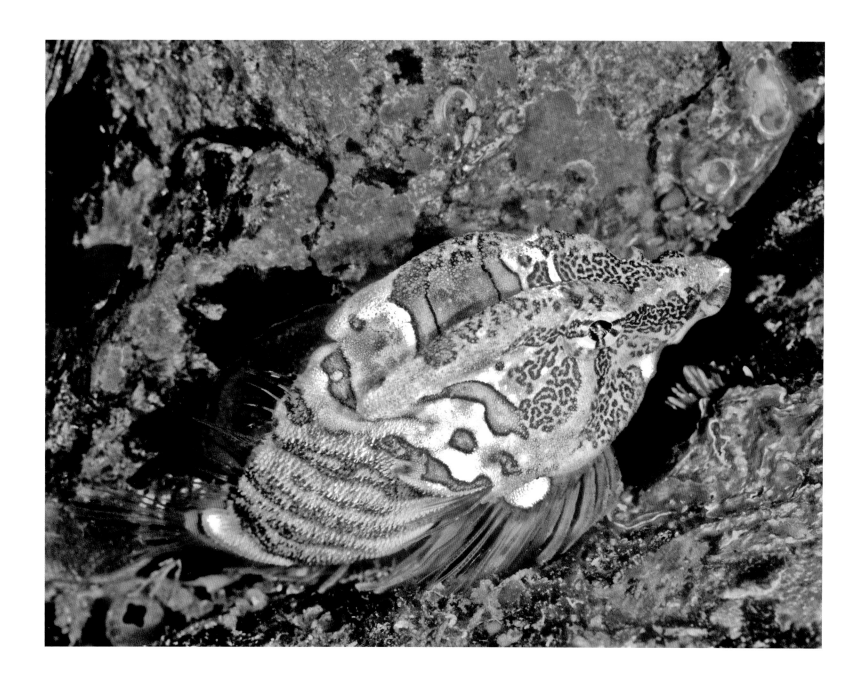

Grunt sculpin

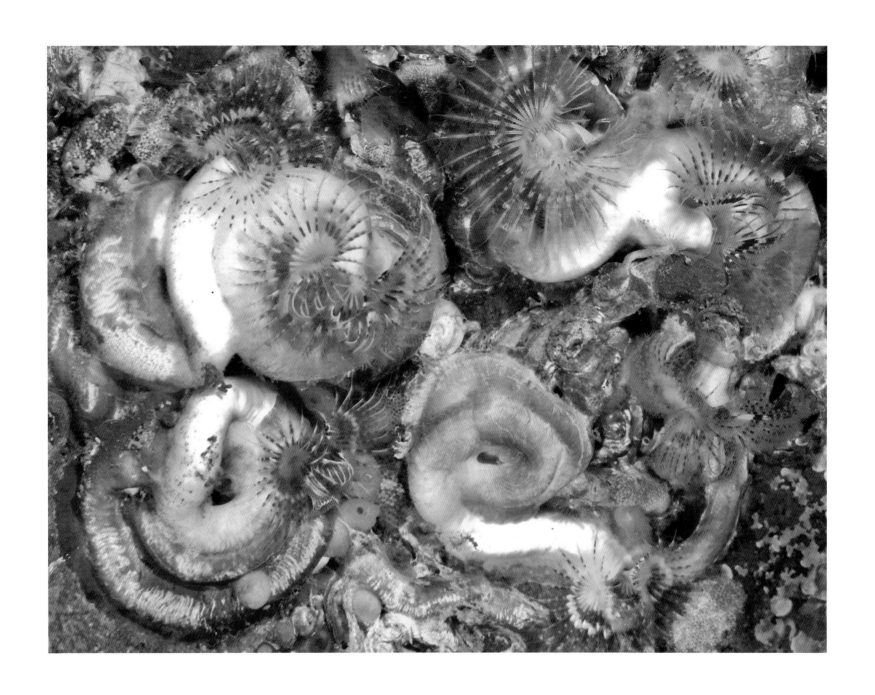

Calcareous tubeworms

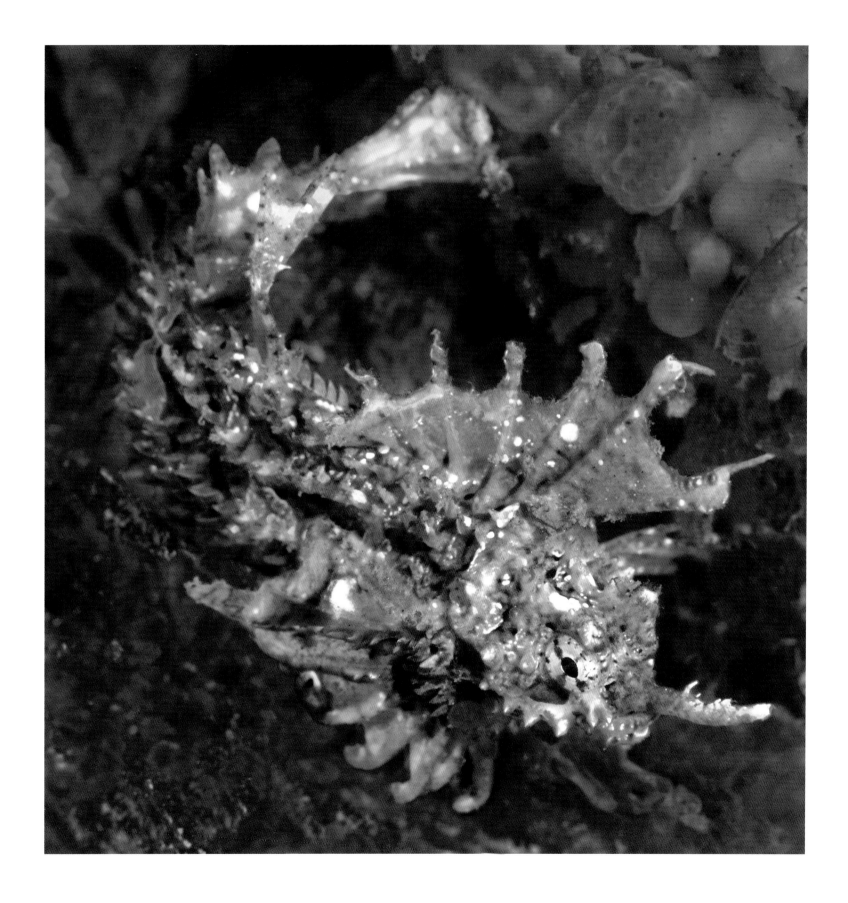

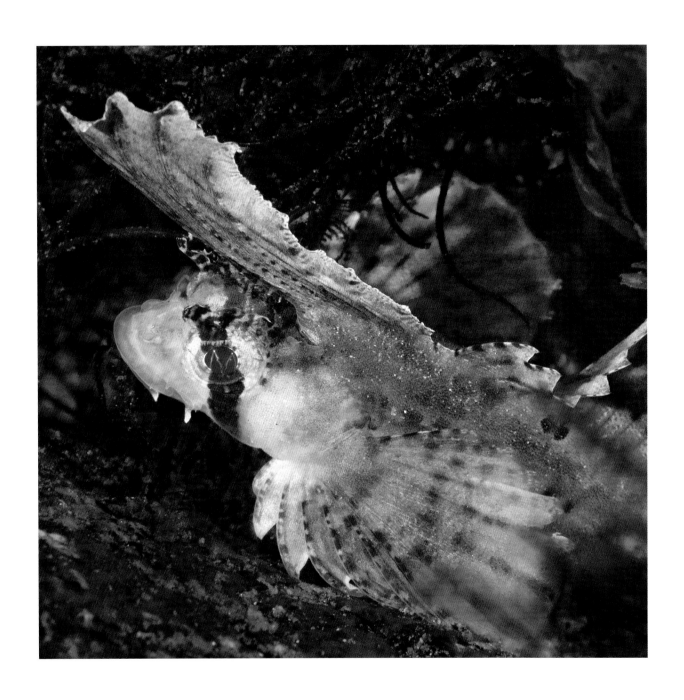

facing page: Kelp poacher

above: Sailfin sculpin

HOODED NUDIBRANCHS
AND JELLYFISH

I HAVE BEEN obsessed with the hooded nudibranch, *Melibe leonina,* ever since my first encounter with it in 1996. Imagine a bull kelp forest in which the plants are completely covered with ghostlike animals expanding and contracting rhythmically, and you will have some idea of what I witnessed. It was like a scene from a science fiction movie, and I knew that I had to find some way to capture it on film. Fifteen years later I am still trying.

Why is it so difficult? For one thing, conveying a sense of movement in a still photograph can be like trying to convey the rhythm of a tango with a single musical note. For another, how can I effectively illuminate these six-inch animals when most of the light emitted by my flash units passes right through their transparent bodies?

If you want to photograph hooded nudibranchs in the Pacific Northwest, timing is critical. In British Columbia's Queen Charlotte Strait, *Melibe* first appear on the kelp in early to mid-September. They grow rapidly, reaching full size and maximum population density within two weeks; yet less than two weeks later they have all but disappeared. Unfortunately, when *Melibe* make their brief appearance, bull kelp, the dominant marine plant in the area, is usually dying back and not very photogenic. Perhaps one year in five or ten the kelp survives in relatively good shape until the nudibranchs have arrived in large numbers. At this time it becomes possible to capture images that are both unique and spectacular.

The transparent and rhythmically contracting *Melibe* may look like jellyfish, but this resemblance is deceiving. Jellyfish are cnidarians—stinging animals related to sea anemones and corals—whereas *Melibe,* a kind of snail with no shell, are mollusks. *Melibe* trap plankton within an expansile "oral hood," whereas jellyfish use stinging cells in their tentacles to immobilize and capture their prey. Like *Melibe,* jellyfish contract rhythmically and are largely transparent, making them difficult to photograph.

Many wonderful jellyfish are found in these cold waters, but one in particular stands out. Once, while photographing rockfish in the kelp bed at Hunt Rock in Queen Charlotte Strait, I became aware of something very large drifting toward me, swept along by the current. It was a huge lion's mane jellyfish nearly three feet in diameter, with ten- to fifteen-foot tentacles trailing behind it. *Cyanea capillata* is the largest jellyfish in the world, and this individual was by far the largest I had ever seen.

I approached the massive animal cautiously. *Cyanea* possesses an especially powerful sting, and the neoprene hood and dive mask I wore left much of my face unprotected. The jelly's many long, transparent tentacles were difficult to keep track of as I approached with one eye glued to the viewfinder of my camera.

I made dozens of photographs of the magnificent animal. The changing pattern of light filtering through the choppy surface and the rhythmic contractions of the jellyfish meant that no two photographs would look the same. None of them would truly convey the grace and beauty of a living jellyfish, but I was determined to try.

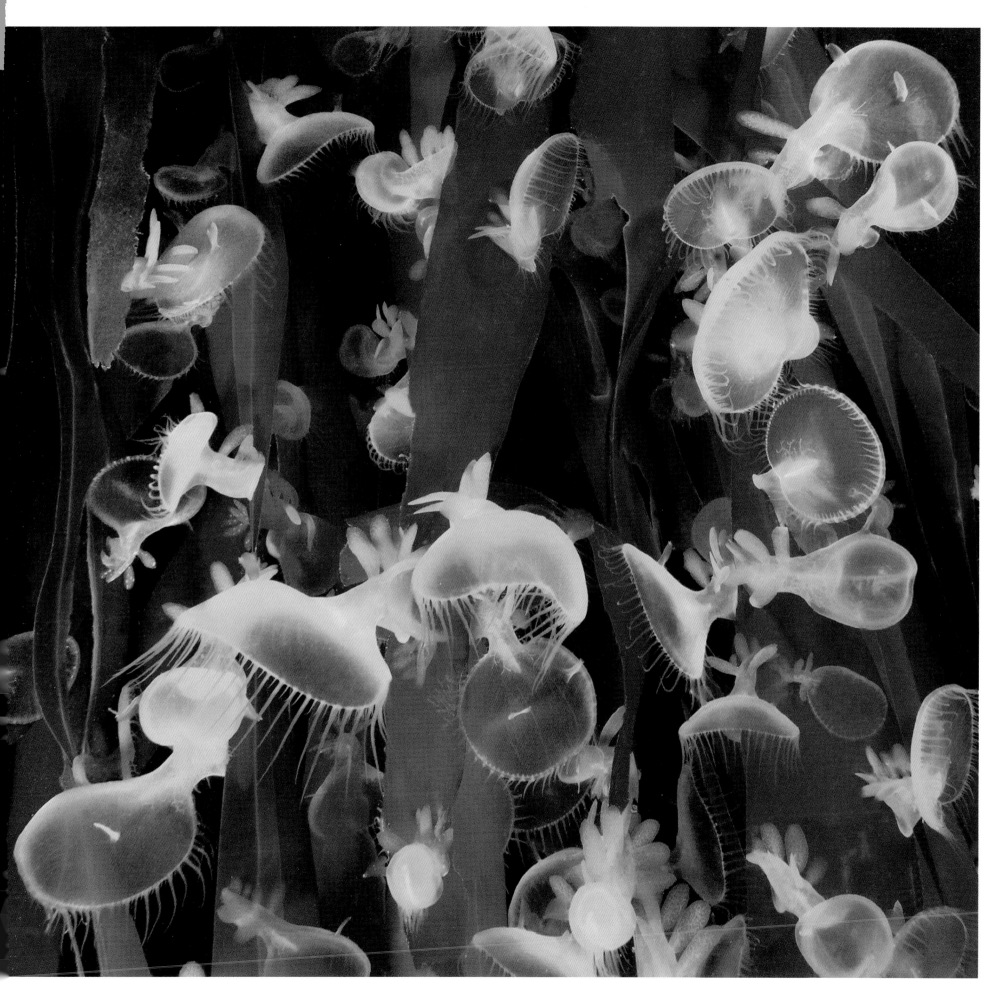

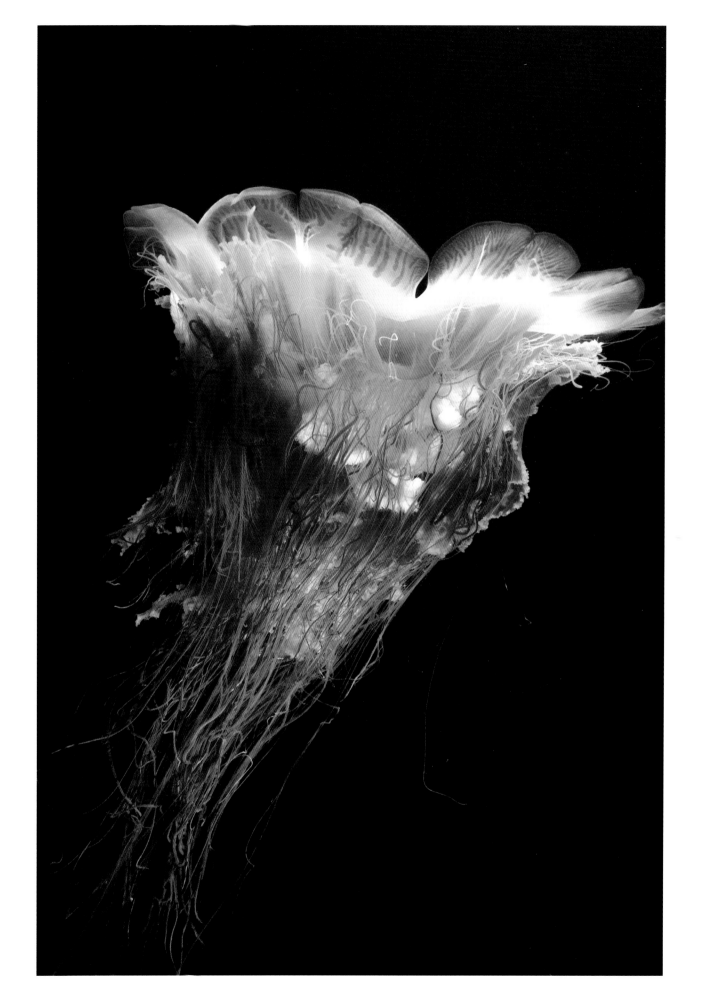

previous spread: Hooded
nudibranchs on bull kelp

right: Lion's mane jelly

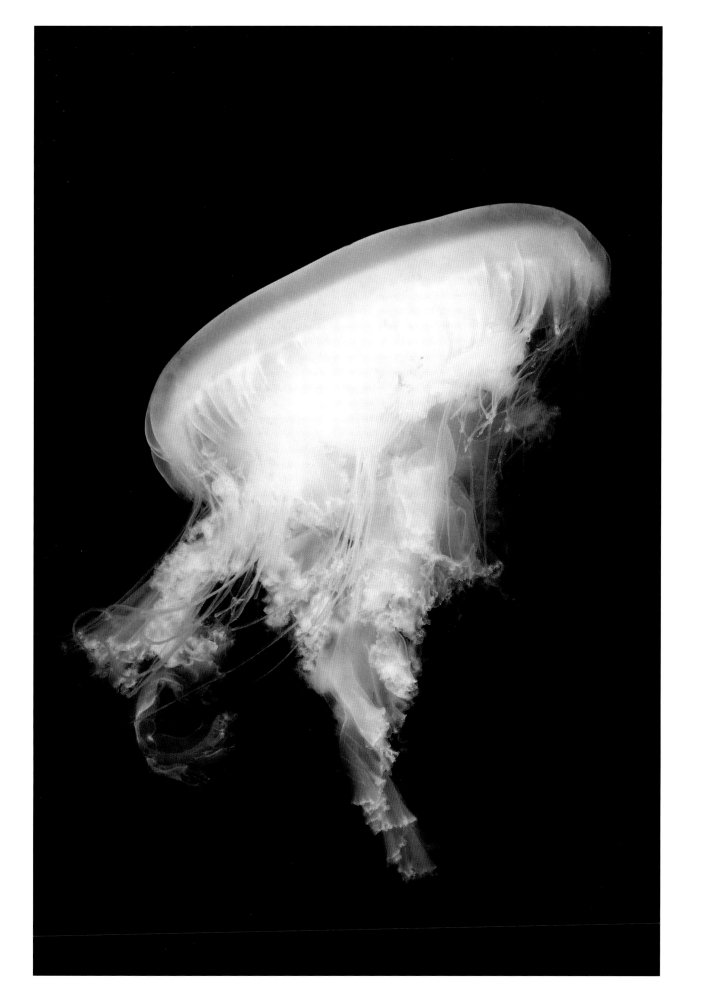

Fried egg jelly

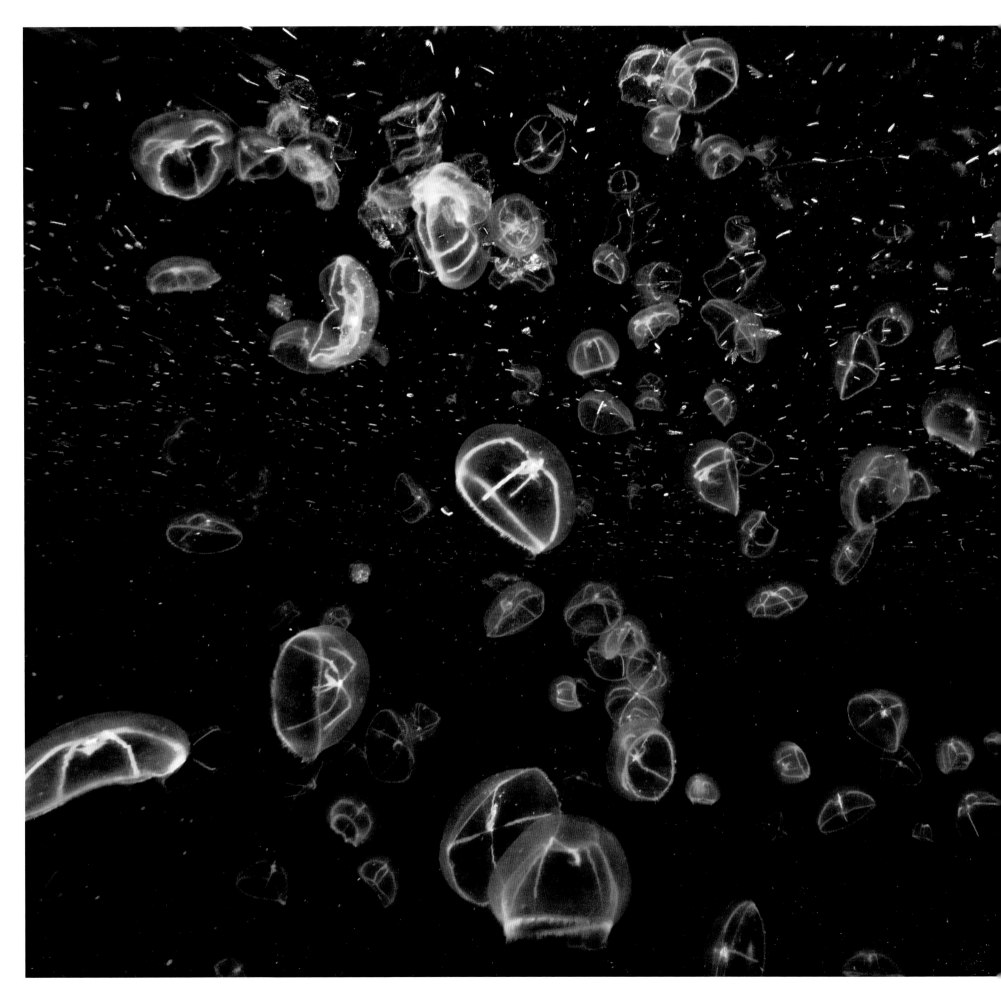

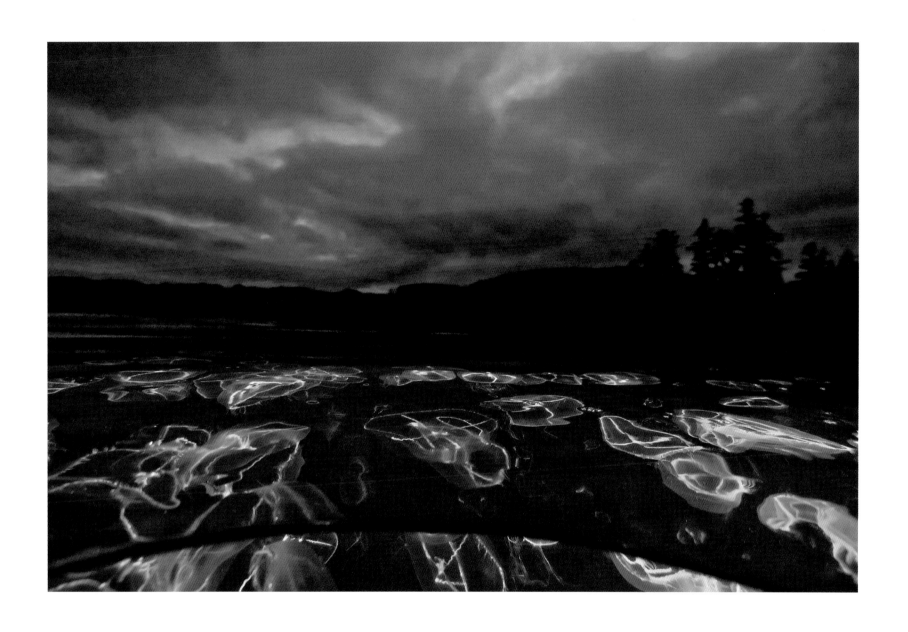

Cross jelly swarm at night

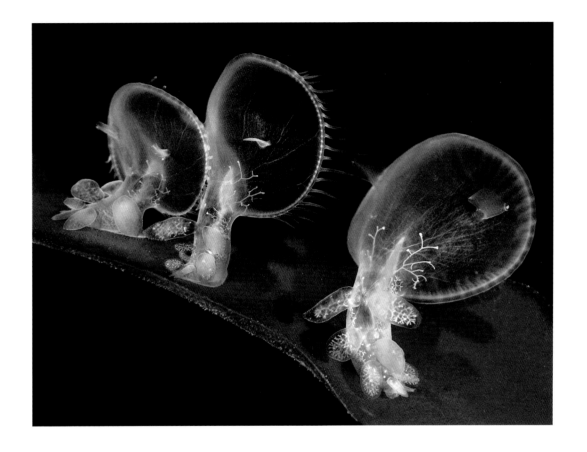

Hooded nudibranchs on bull kelp

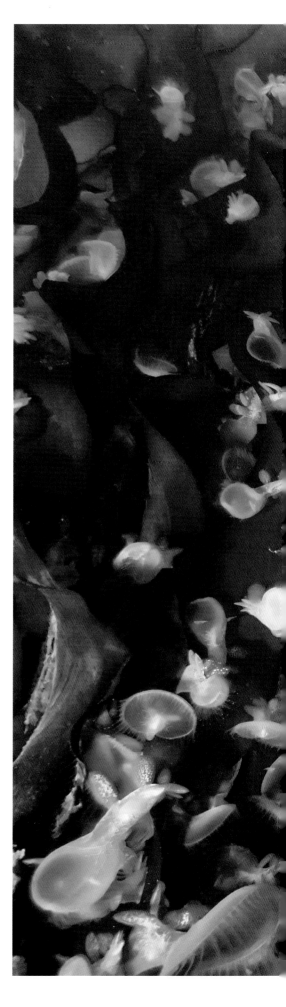

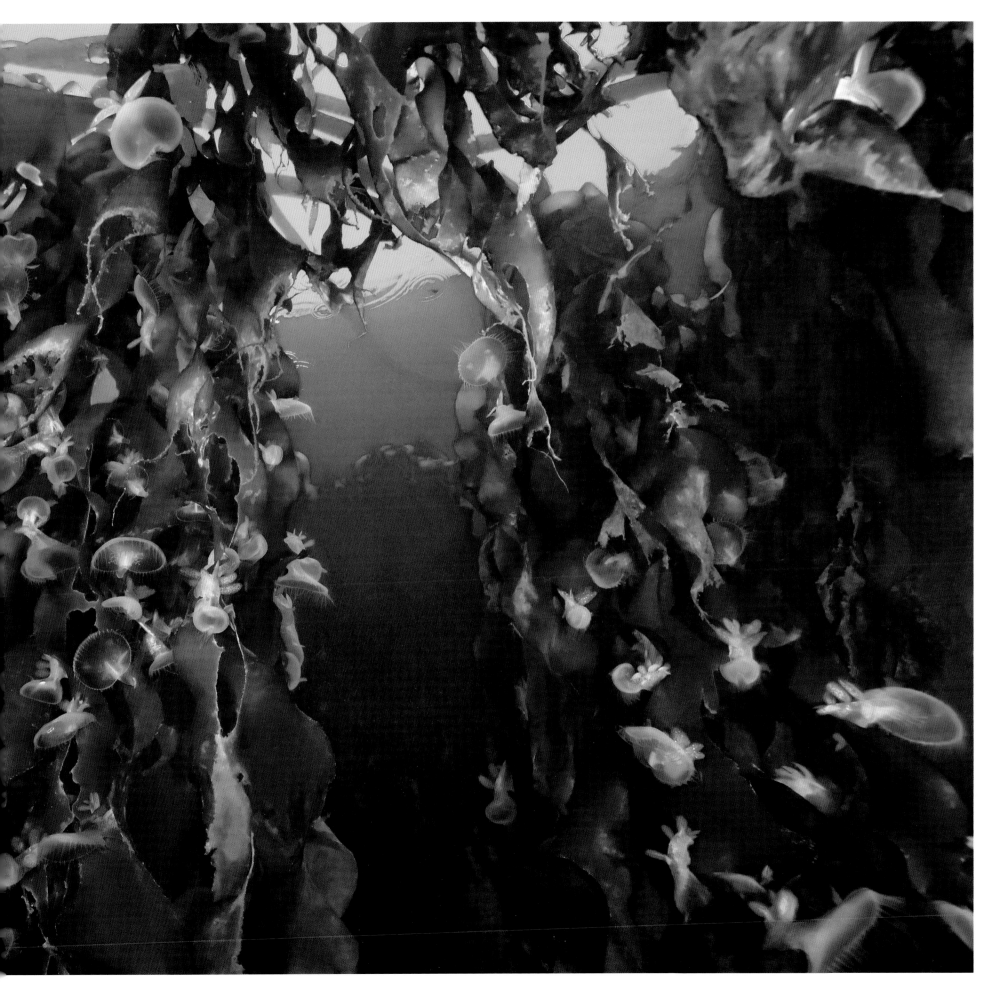

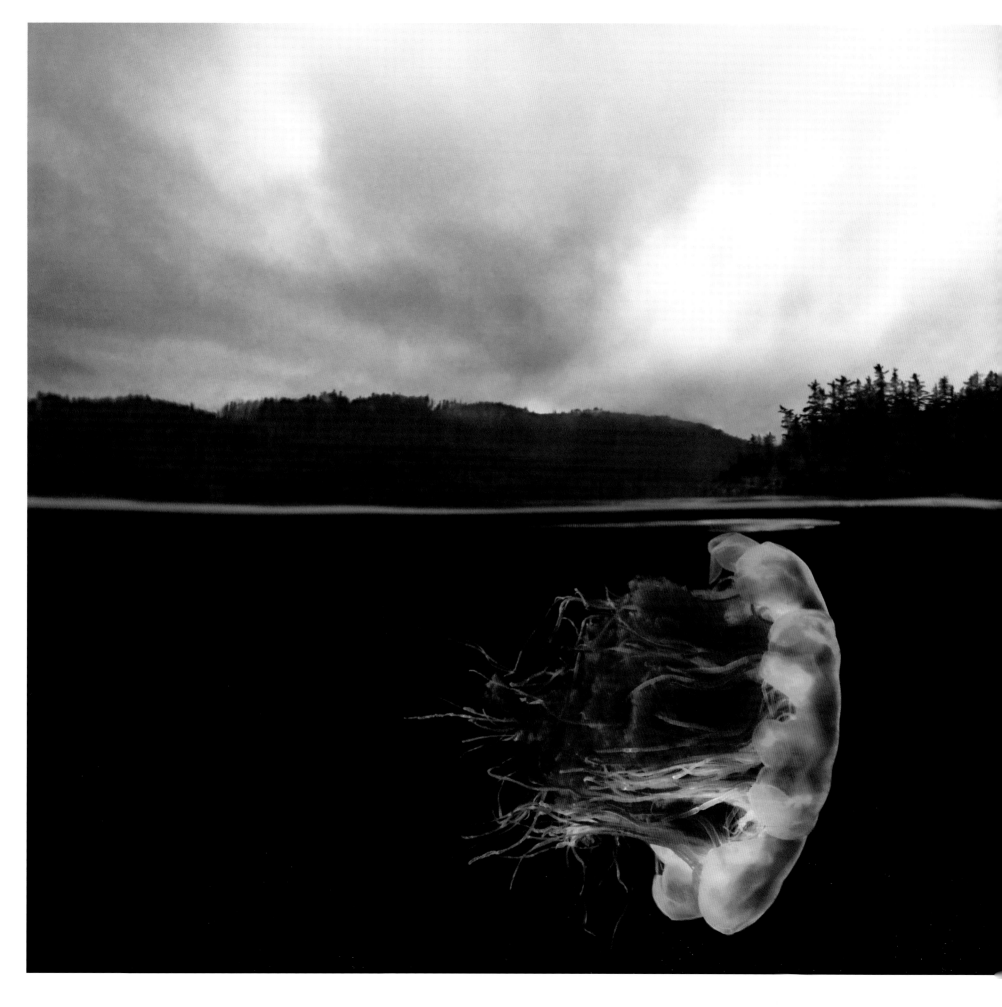

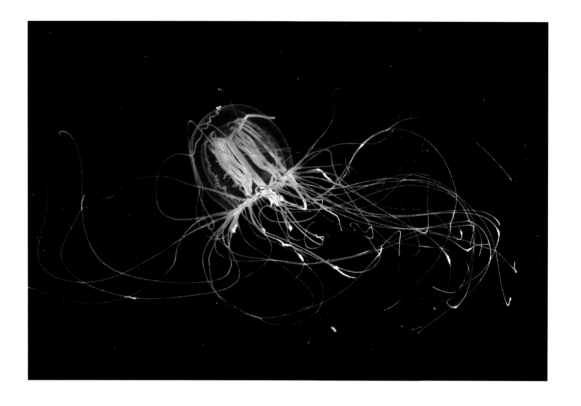

left: Lion's mane jelly
above: Red-eye medusa

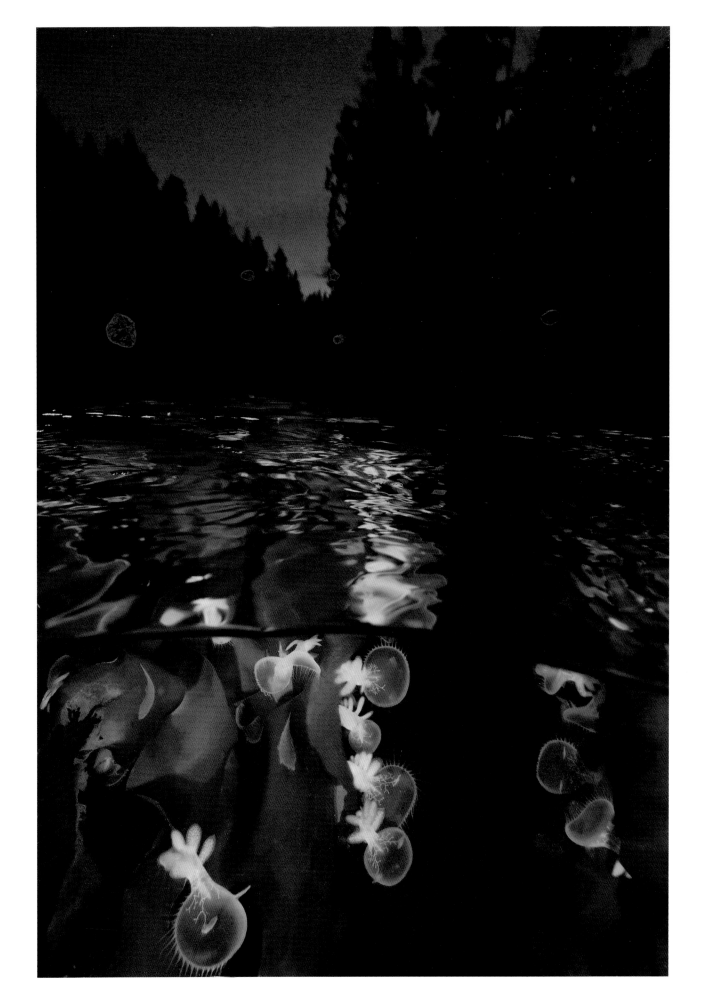

Hooded nudibranchs at dusk

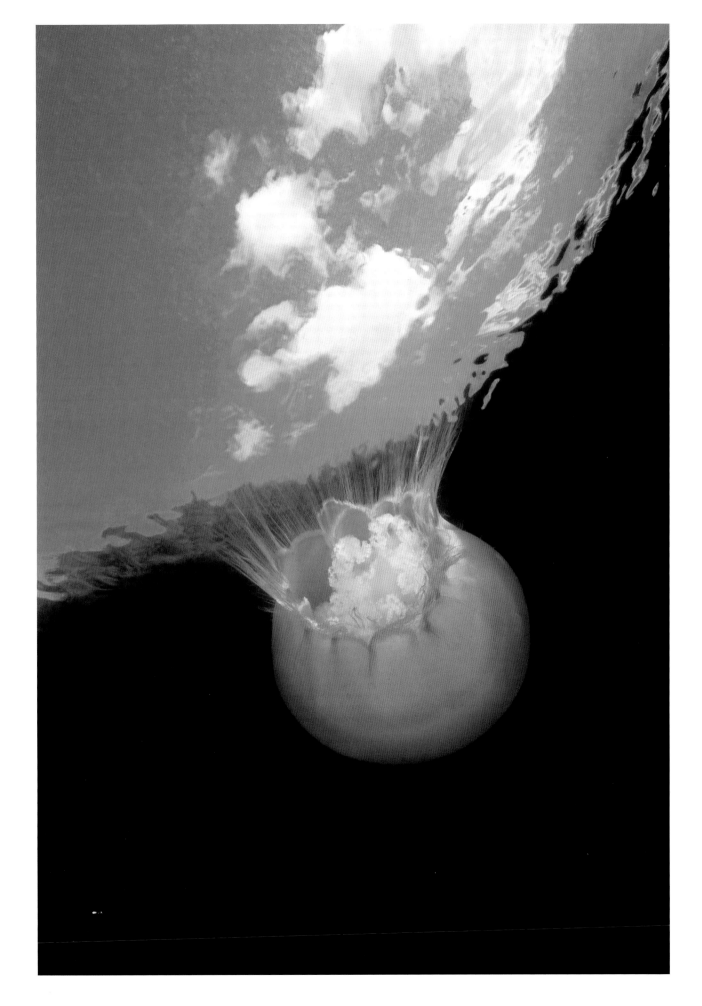

Moon jelly and clouds

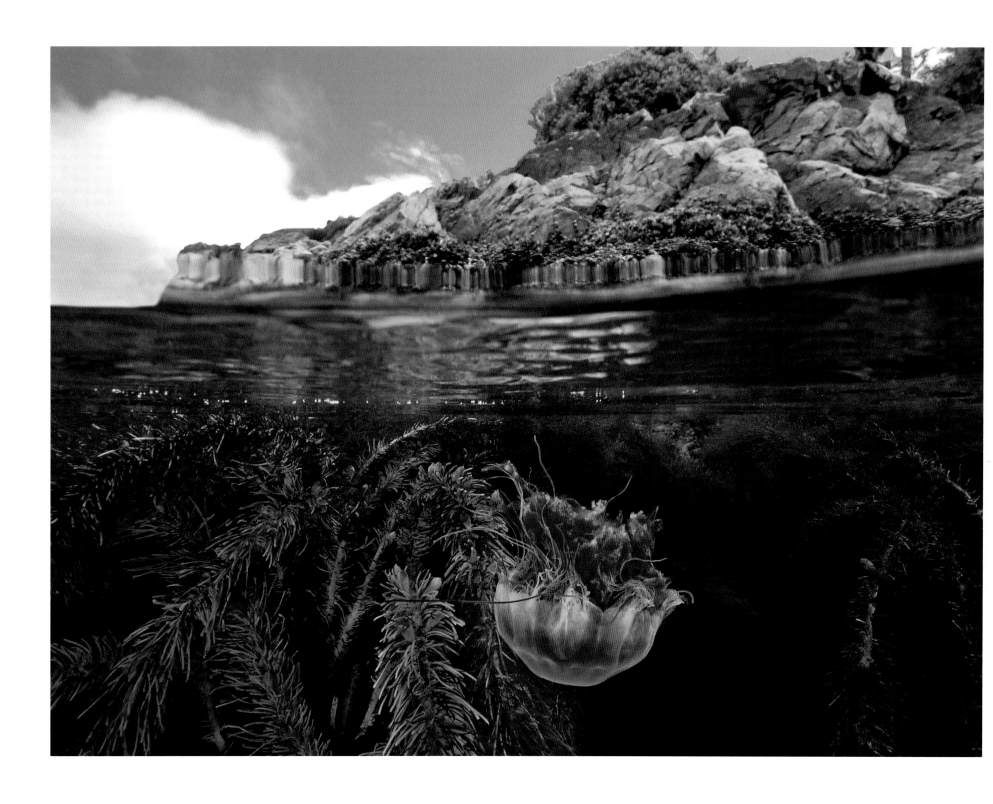

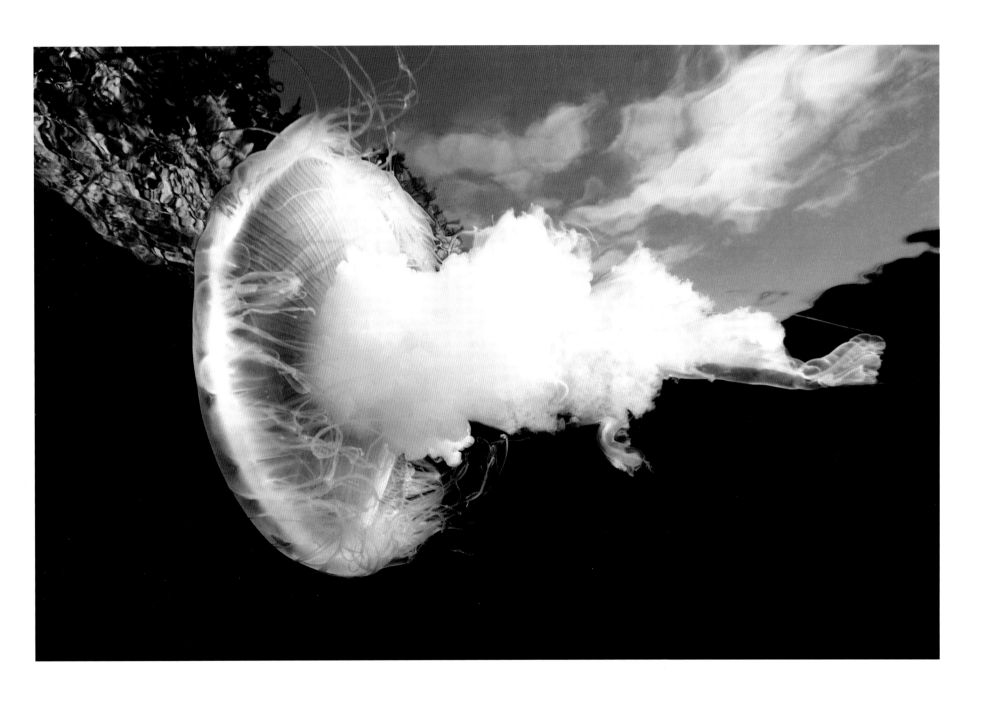

facing page: Lion's mane jelly and feather boa kelp

above: Fried egg jelly

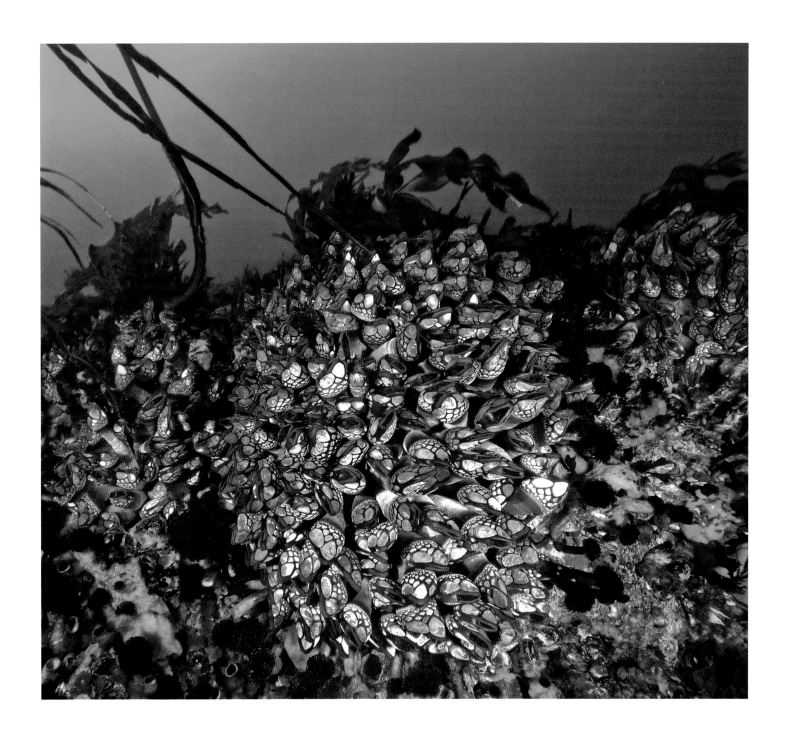

Gooseneck barnacles at Nakwakto Rapids

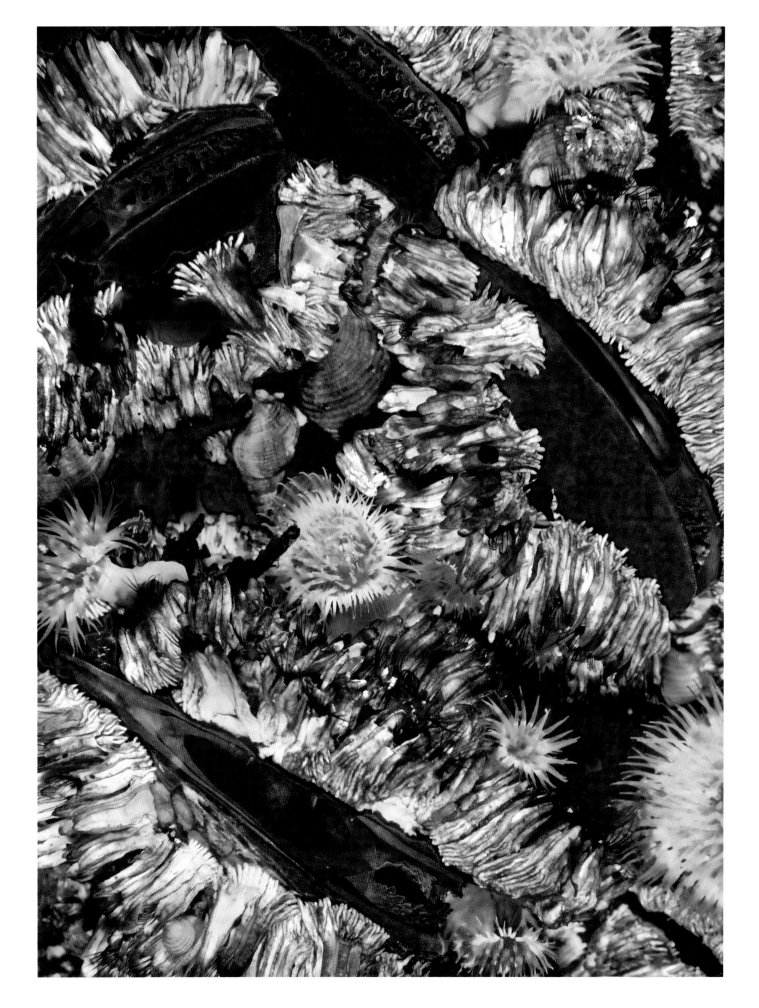

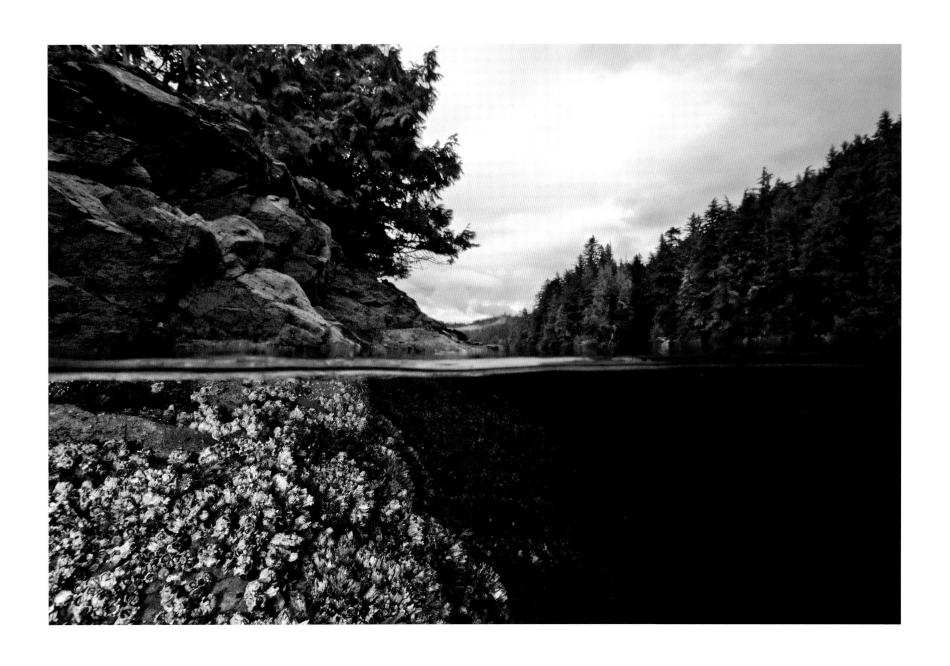

facing page: Acorn barnacles, mussels, and plumose anemones
above: Acorn barnacles in Browning Pass

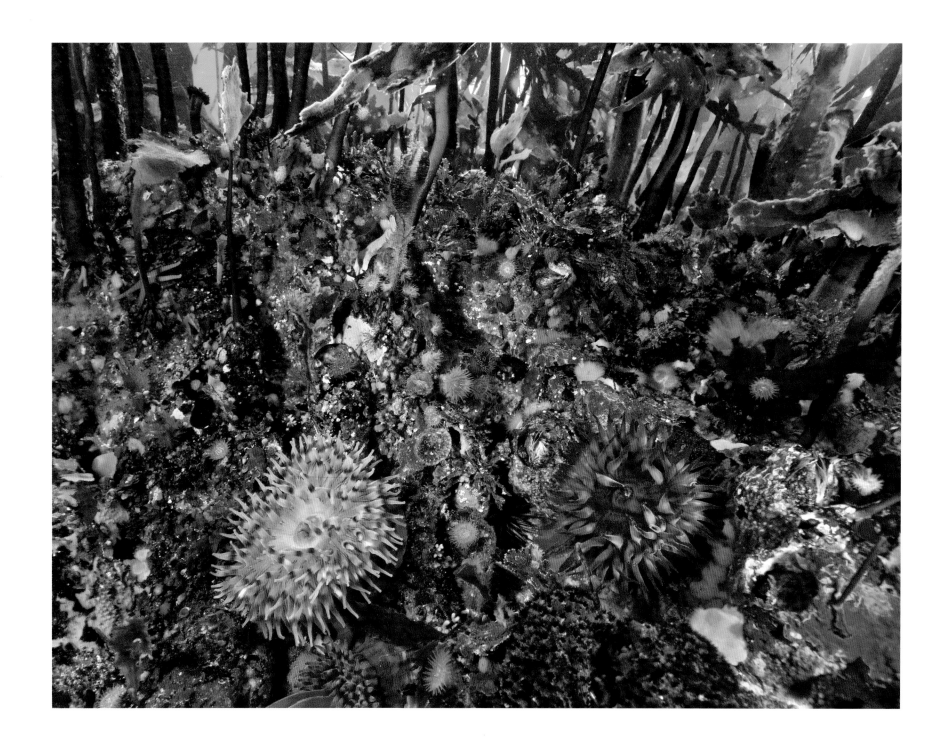

Kelp forest floor with several kinds of anemones

Spawning aggregation of dogwinkle snails

SOCKEYE SALMON

W E WALKED nearly a mile along the riverbank before finding a place where we could easily enter with our heavy equipment. The stench of rotting fish carcasses was overpowering. It was late September 2010, and we had come to photograph the largest run of sockeye salmon in a century. We had already photographed individual fish or small groups arriving at their final destination in quiet, shallow streams, hundreds of miles from the sea. Today our goal was more ambitious: to capture underwater images of the huge aggregation of salmon battling the swift current of the Adams River.

Like other Pacific salmon species, sockeye return to the same freshwater stream in which they were hatched to spawn. During a long and arduous journey upstream, they stop feeding. Their entry into freshwater triggers extensive anatomic and metabolic changes. Silvery blue in the ocean, the sockeye become bright red with yellow-green heads. The males develop sharp, curved teeth, a prominent hooked upper jaw, and a humped back. Guided to her destination by an acute sense of smell, the female excavates a shallow nest in the gravel bottom. She and her mate release eggs and sperm into the nest, then move a bit farther upstream to repeat this process one or more times. Battered and exhausted, both parents die within a day or two. Their decomposing bodies are then consumed by various organisms, bringing significant nourishment to the surrounding forest.

Snug in our dry suits, marine biologist Conor McCracken and I entered the chilly water, underwater cameras in hand. The swiftly flowing river was 150 feet wide at this point, with a slippery gravel bottom. Near shore weaker salmon hugged the shallows, some bearing wounds from collisions with sharp objects and encounters with predators or from infighting among pugnacious males.

As we moved into deeper water, the current grew stronger, tugging at us and our cameras until I could barely stand. Dozens of fish flashed by in a fleeting hint of red glimpsed through the bright reflections on the water's surface. Cursing silently, I thought of the Polaroid sunglasses I had left behind in our cabin. I tried to photograph the sockeye as they swam past but repeatedly mistimed the exposure because I could not see them clearly. To make matters worse, the rushing current was playing havoc with the two electronic strobes attached to my camera housing, shoving them out of position. This approach was clearly not working, and the sun would soon drop below the horizon.

I noticed that Conor had found shelter in the lee of a huge cedar tree trunk lying in the middle of the river. I moved toward him but soon found myself in water up to my waist. The pull of the current was now overpowering and gradually pushed me downstream. Barely able to stay on my feet, I imagined being swept head over heels and carried downriver. Conor quickly anchored himself with one arm wrapped around a sturdy branch and pulled me into the shelter of the great tree trunk, a pool of relatively calm water in the middle of the swiftly flowing river. It was an odd feeling, perhaps akin to being in the eye of a hurricane.

I was now surrounded by salmon. I could not see them clearly in the rapidly fading light but felt them brushing past my legs as they swam upstream. One fish leaped out of the water, striking me in the chest and almost knocking me off my feet. I pointed my camera downstream and made a test exposure. The image that came up seconds later on the back of the camera showed a virtual wall of sockeye facing me from just inches away. The sky had turned purple and pink, and the flash units lit up the surface of the water, turning it a deep red, like an intricate oriental carpet. I began to photograph and did not stop until the light had all but disappeared.

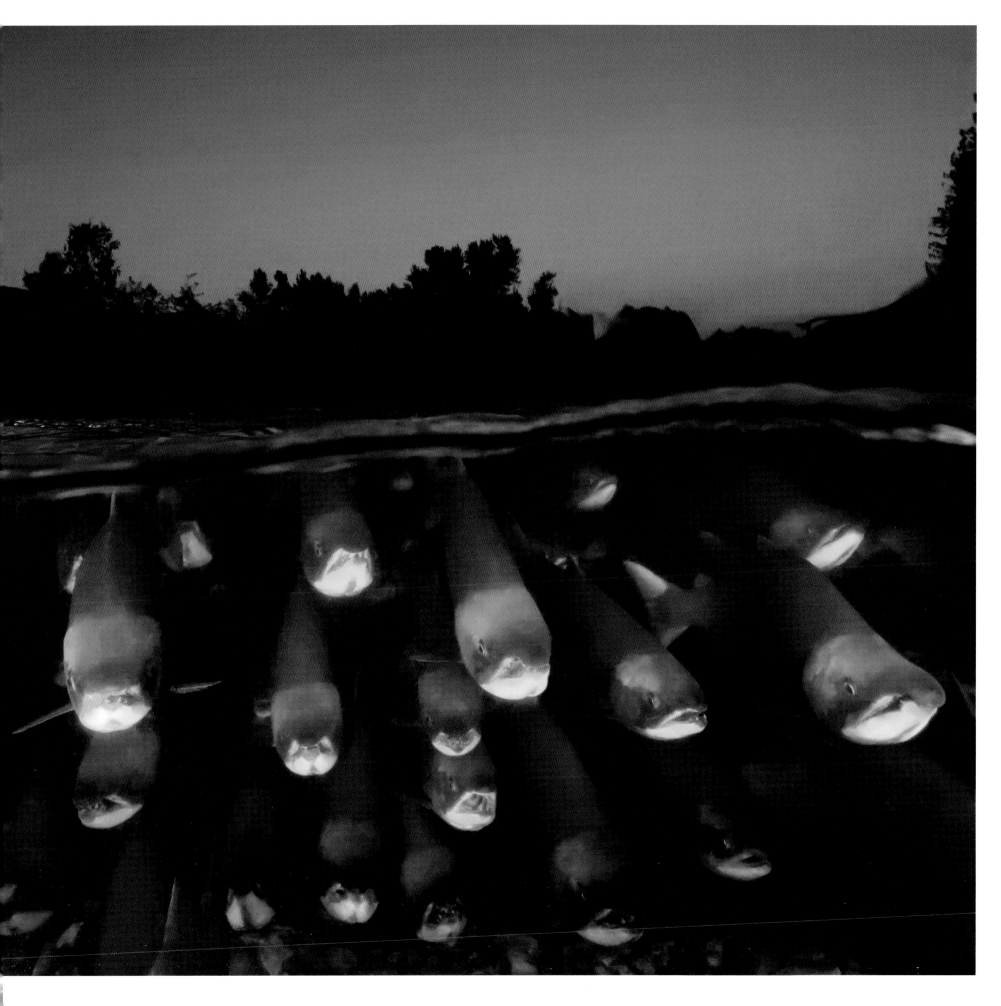

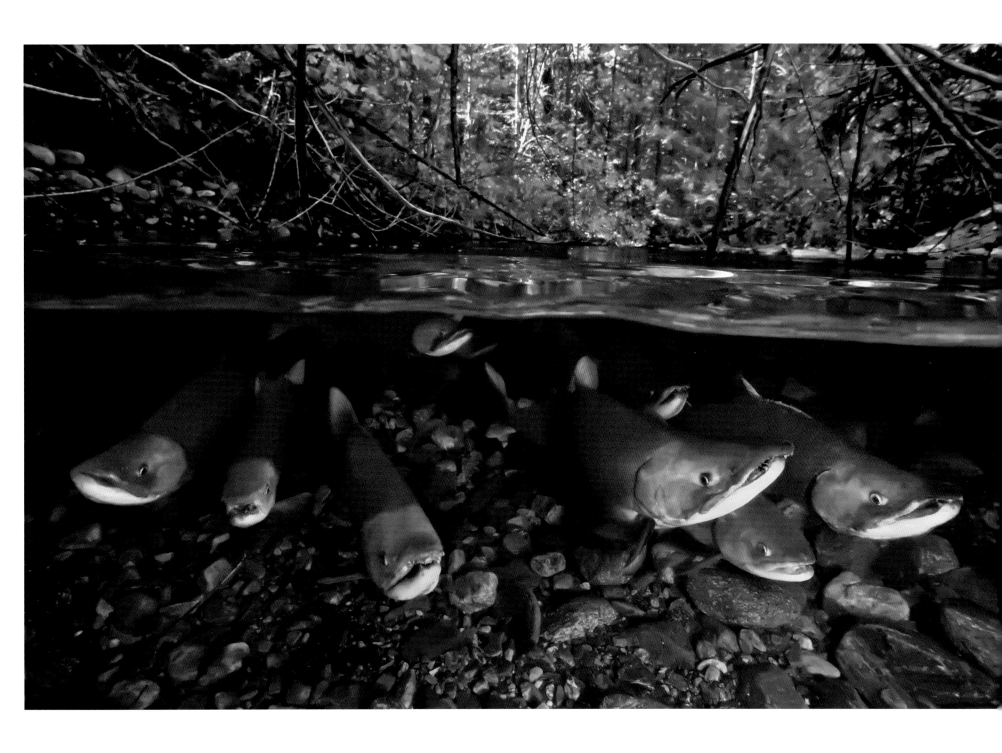

previous spread: Migrating sockeye salmon at dusk

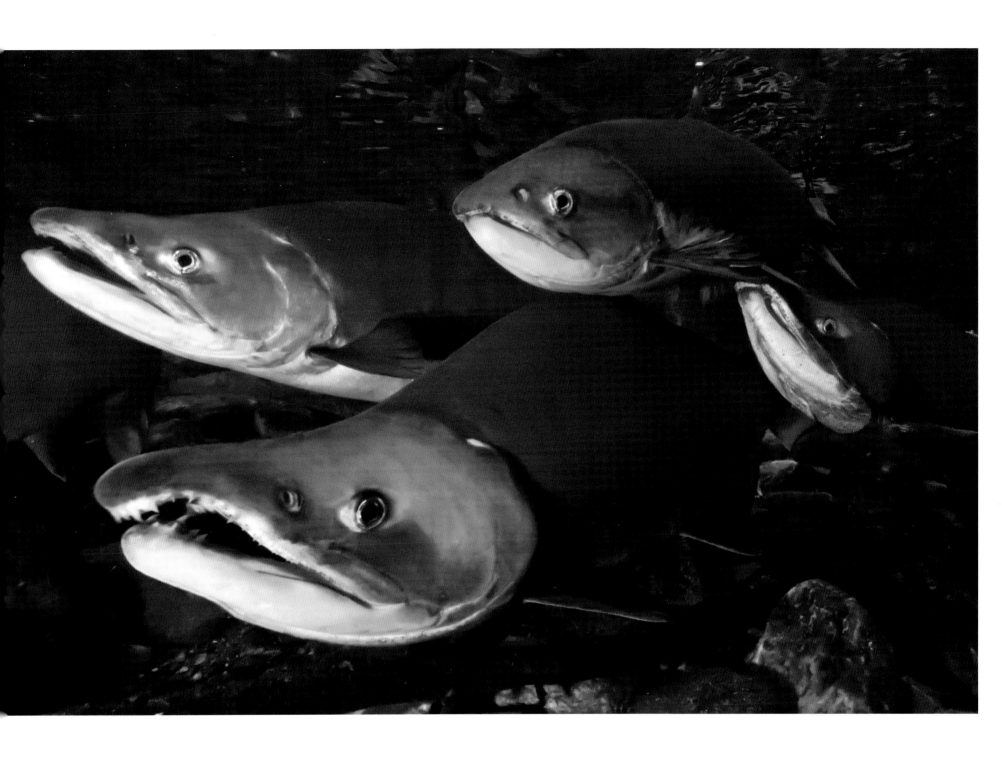

both pages: Migrating sockeye in small stream

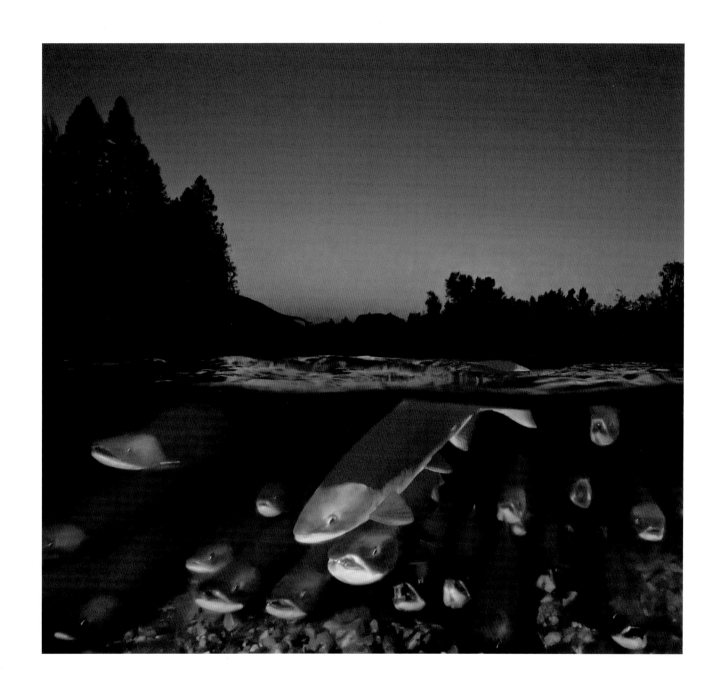

above: Migrating sockeye in the Adams River

facing page: Male and female sockeye preparing to spawn

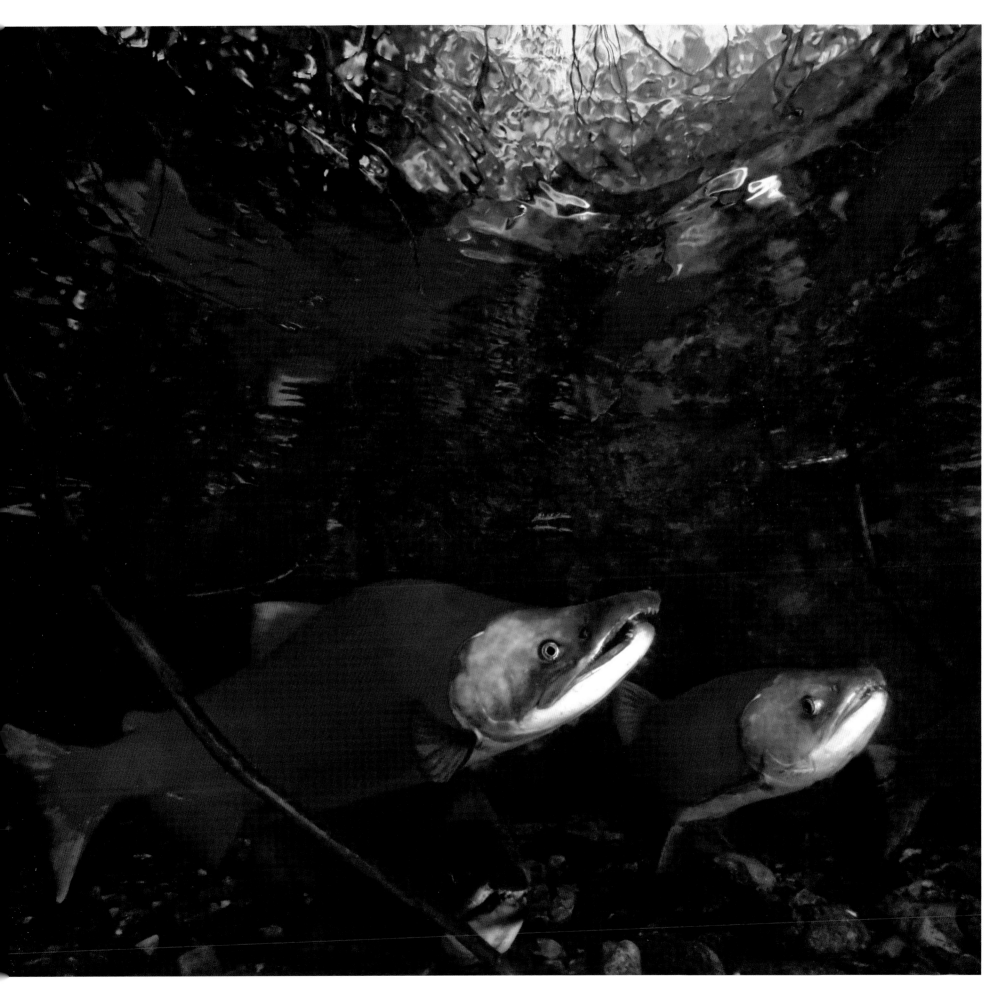

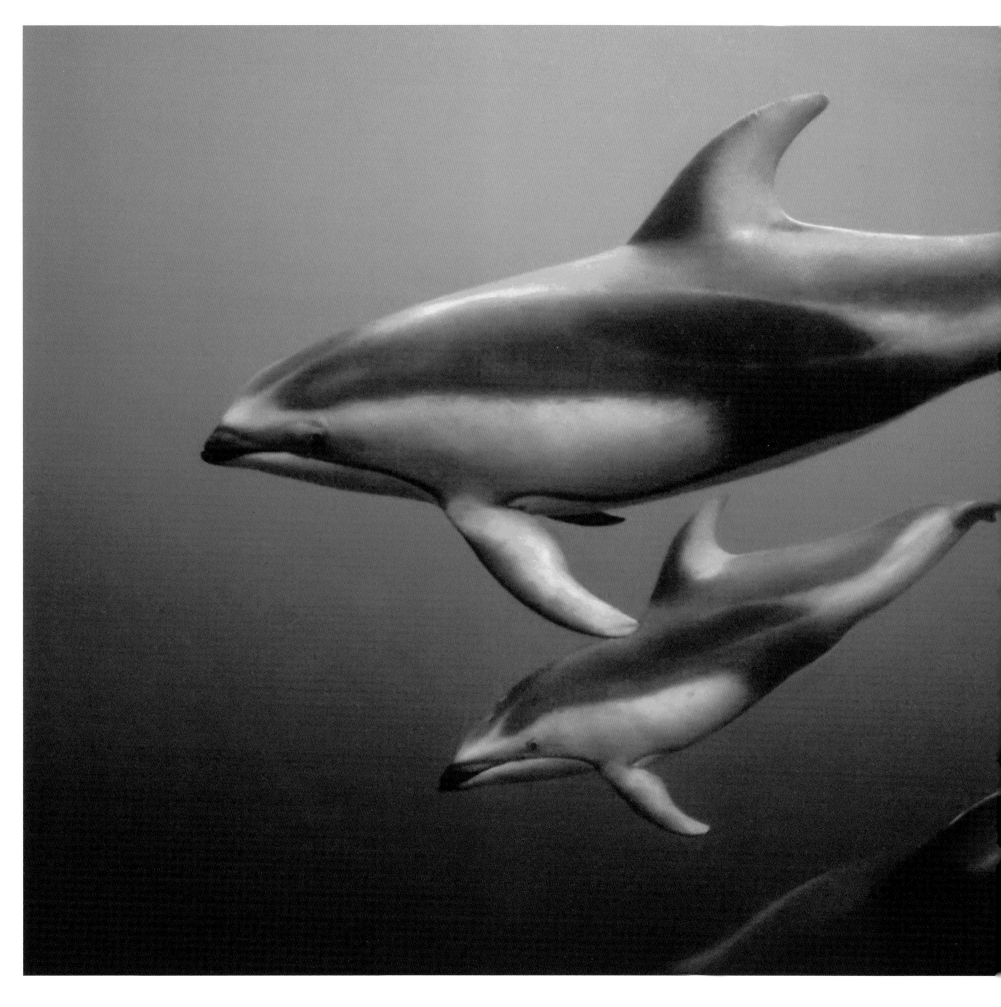

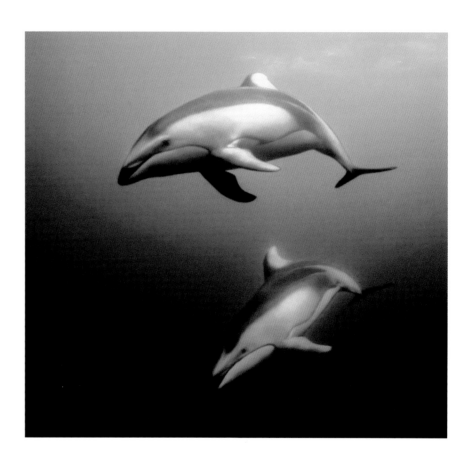

Pacific white-sided dolphins

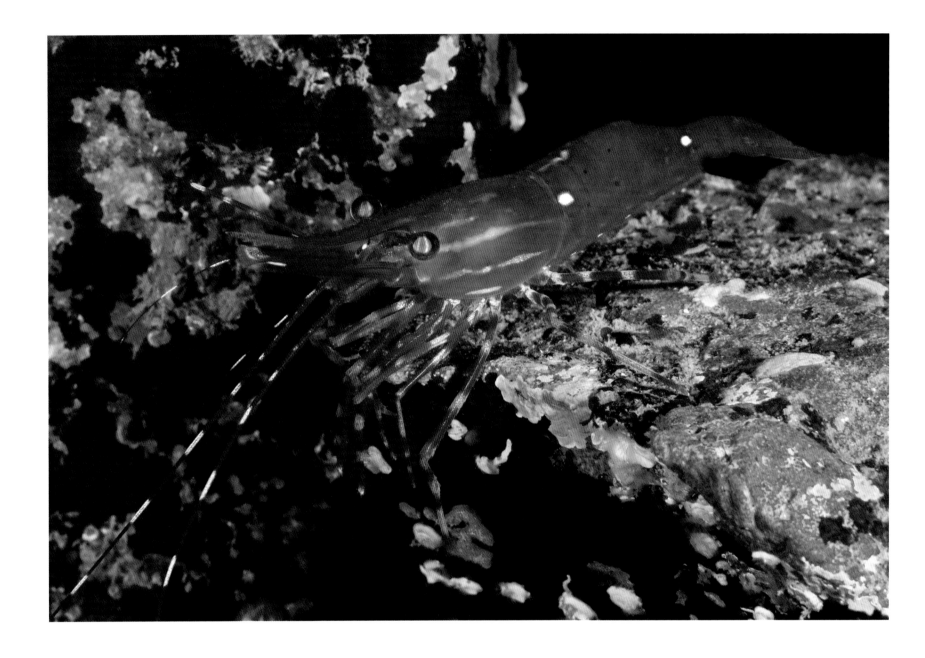

Pacific prawn

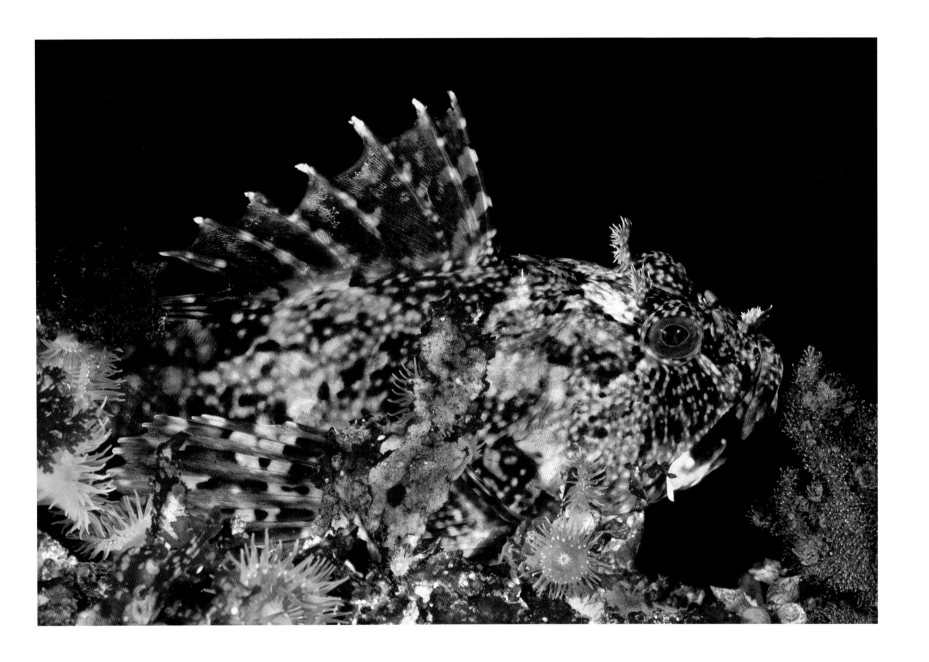

Cabezon

STELLER SEA LIONS

DAN FERRIS, skipper of the *Mamro,* maneuvered our skiff to within fifty yards of the small, rocky island. Dozens of sea lions watched us intently; others dove into the water with a loud splash. From this distance they looked much like the playful California sea lions I had dived with many times before. These intelligent mammals were familiar with dive boats and presumably took to the water in anticipation of visiting divers.

I rolled off the skiff backward and hit the water headfirst. I felt an icy chill on my face; it was February in British Columbia, and the water temperature was 45°F. The normally green water was milky today, filled with the sperm of millions of spawning herring. This annual event was no doubt appreciated by the sea lions, who would be having no trouble finding food lately. Thanks to the amorous herring, underwater visibility near the surface was no more than a couple of feet; if conditions at depth were similar, the camera I carried would be all but useless. Fortunately, the visibility improved as I descended. At a depth of thirty feet, I knelt on the sandy bottom and waited for the local reception committee to pay me a visit.

I didn't have to wait long. A large object materialized in the gloom less than ten yards away and came barreling toward me at incredible speed, veering off only at the last possible instant. I felt small and woefully overmatched at this display of power and agility. The animal was huge, much larger than I had previously realized. It was a Steller sea lion, the third-largest member of the pinniped family; only walruses and elephant seals are bigger. Female Stellers weigh several hundred pounds, and males may exceed a ton.

Now more wary, I moved closer to the rocks. I managed to snap a few quick photographs as an occasional sea lion zoomed past me, usually sneaking up from behind. Then several sea lions appeared around the same time from behind a large boulder. They swam up to within ten feet of me and remained there for a moment. They seemed to be sizing me up.

Less than a minute later, there were many more of them, shoving one another in their effort to examine me up close. I looked over my shoulder and realized that I was surrounded, dozens of expressionless, whiskered faces staring at me from every direction. I was alone, and these huge sea lions were becoming bolder as their numbers increased. I began to photograph instinctively, pointing my camera here and there without looking through the viewfinder, both strobes firing in unison. I felt like a lone warrior surrounded by enemy soldiers, firing my weapon at random in an effort to keep them at bay.

The rapidly flashing strobes had no effect. I was now heavily pressed, pushed around roughly by these powerful animals. Every few seconds I felt a heavy tug on an arm or leg as another sea lion examined me with a mouth full of long, sharp teeth. I began to imagine various unpleasant scenarios: regulator hose bitten through, dry suit punctured, camera damaged or torn away from me. I believed that my antagonists meant no harm, but how could they possibly know that a human diver was so vulnerable to their enthusiastic probing? I felt I had to leave, and soon.

I swam away from the rocks and began to ascend, the sea lions close behind me. When I reached the surface and scanned the horizon, the skiff seemed very far away. The sea lions surfaced close by, protesting loudly at my hasty exit. They were still protesting several minutes later, as I climbed aboard the skiff.

Safely back on the *Mamro,* I finally had time to reflect. I had been diving for more than thirty years and had photographed many large and potentially dangerous animals. Yet never before had I voluntarily left the water during a highly productive shoot, with a loaded camera and plenty of air in my tank. Had I exaggerated the potential danger? Should I have stayed down longer and continued to photograph?

Later that night I lay in my bunk, unable to sleep. In the surrounding darkness, I could still see many pairs of eyes staring at me.

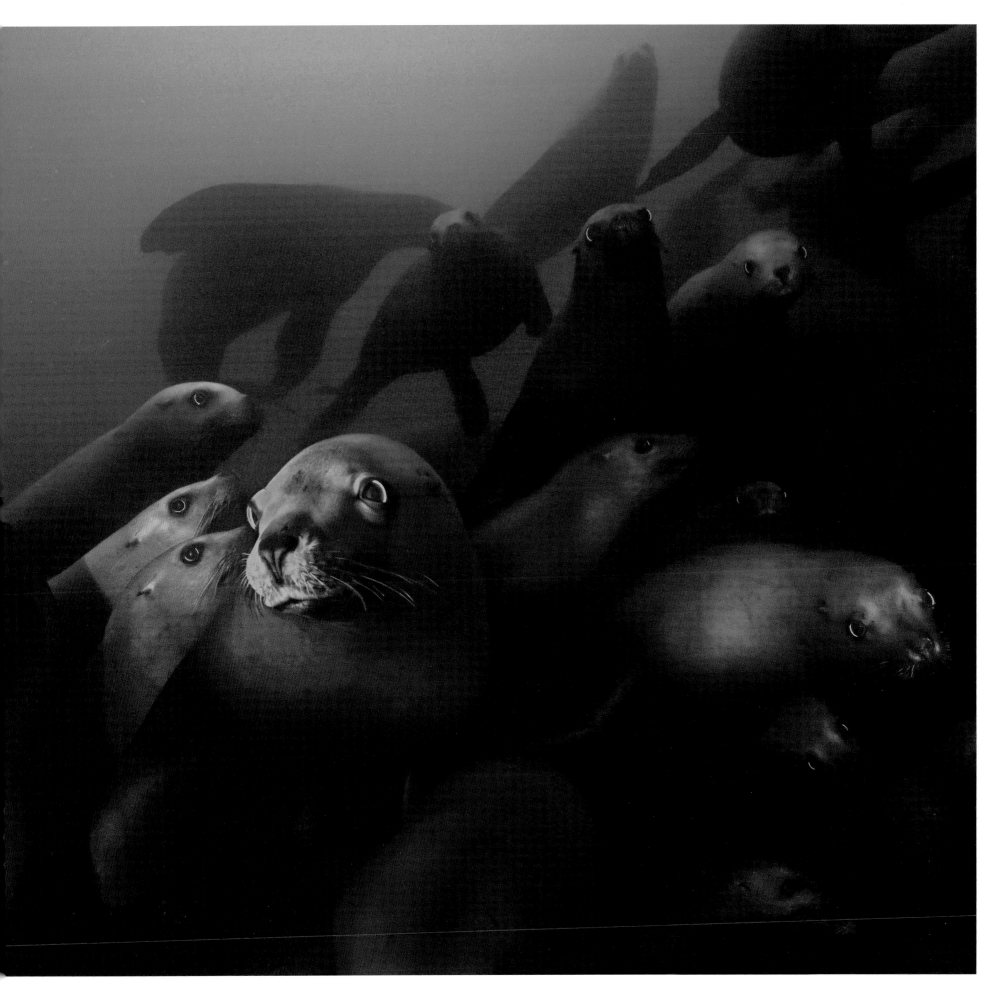

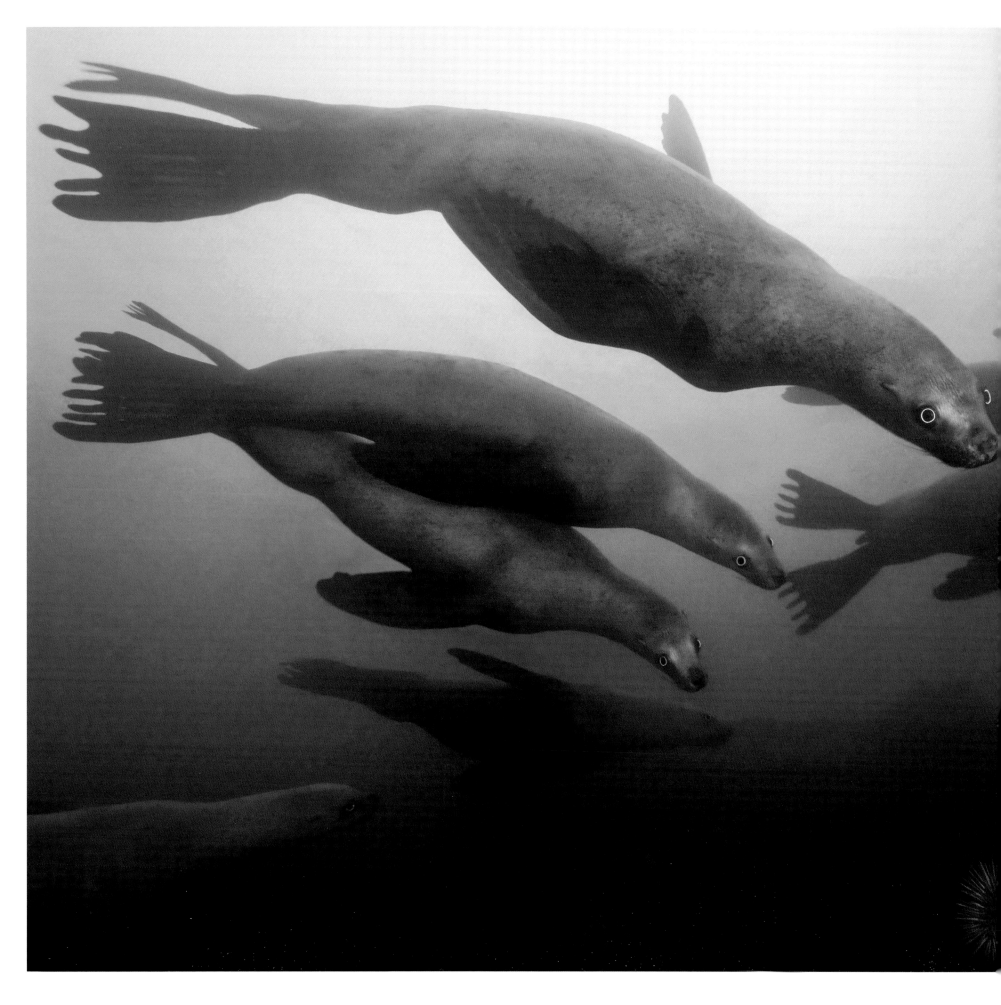

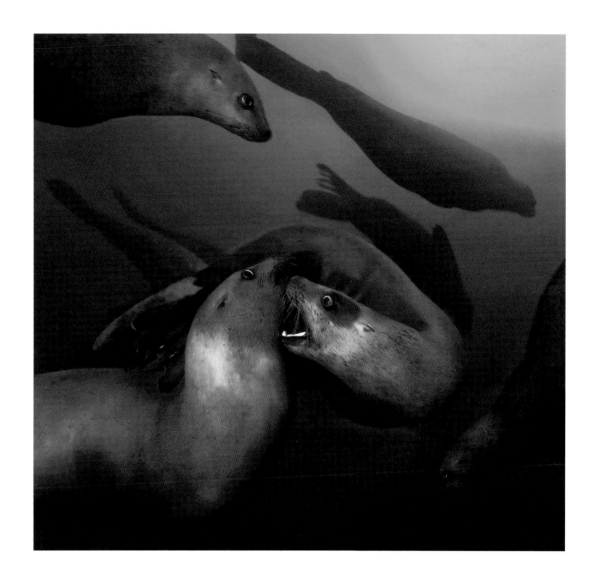

previous spread: Steller sea lions gather
to investigate an intruder

left: Steller sea lions

above: A dispute over a front row seat

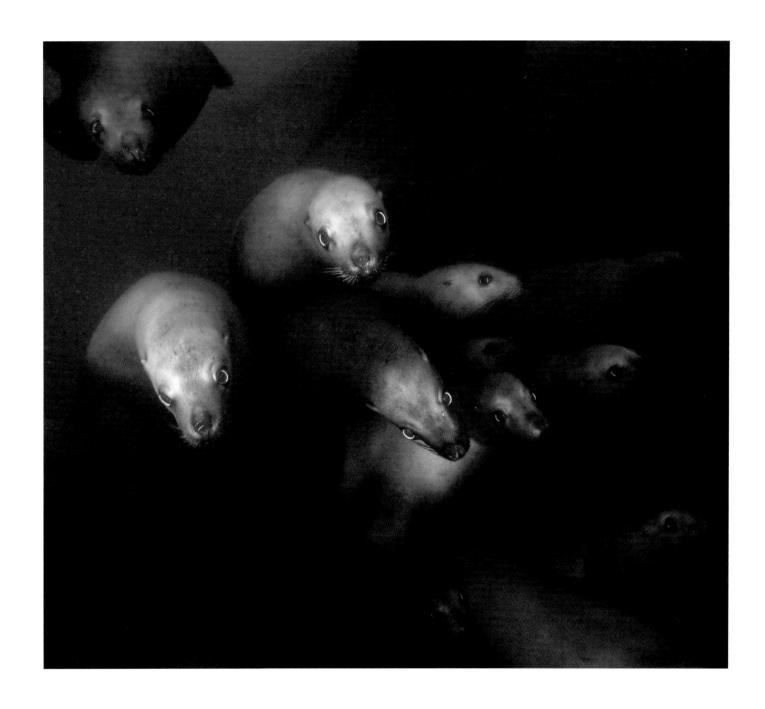

above: The sea lions study me at close range

facing page: A large school of Pacific sand lance

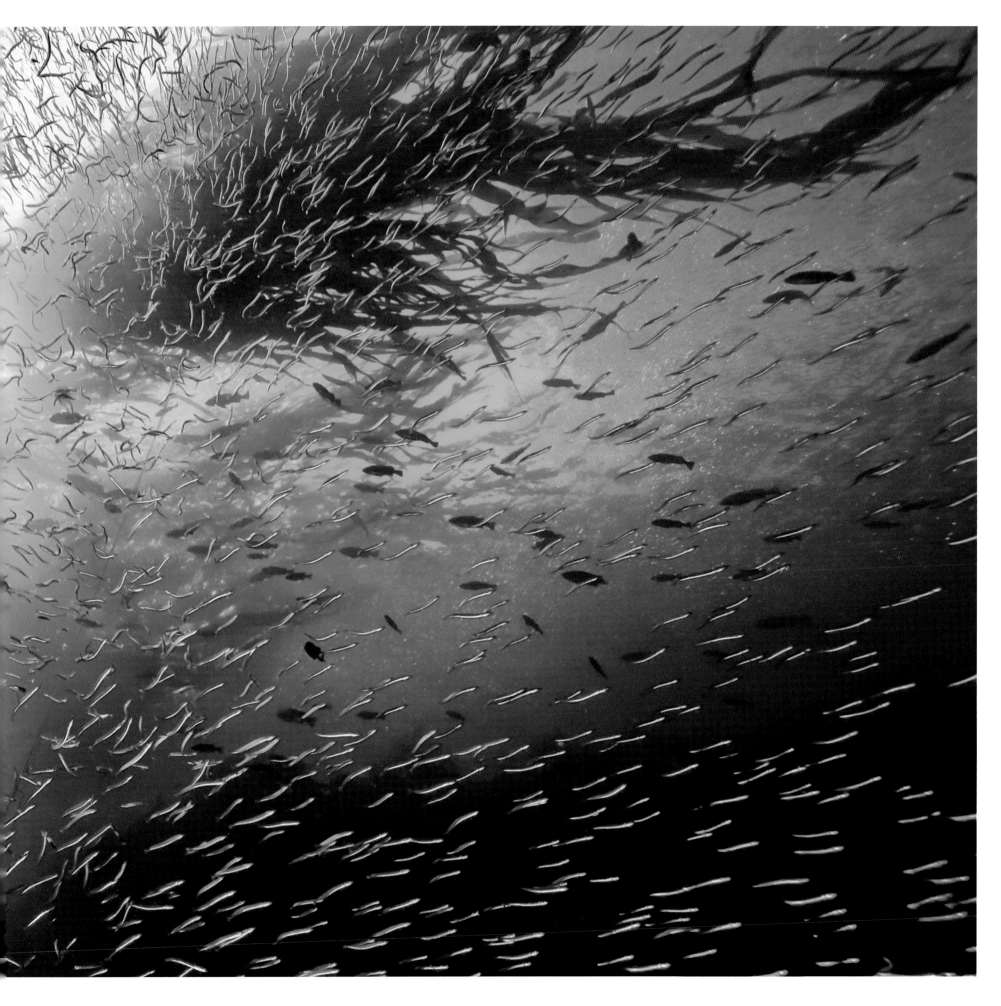

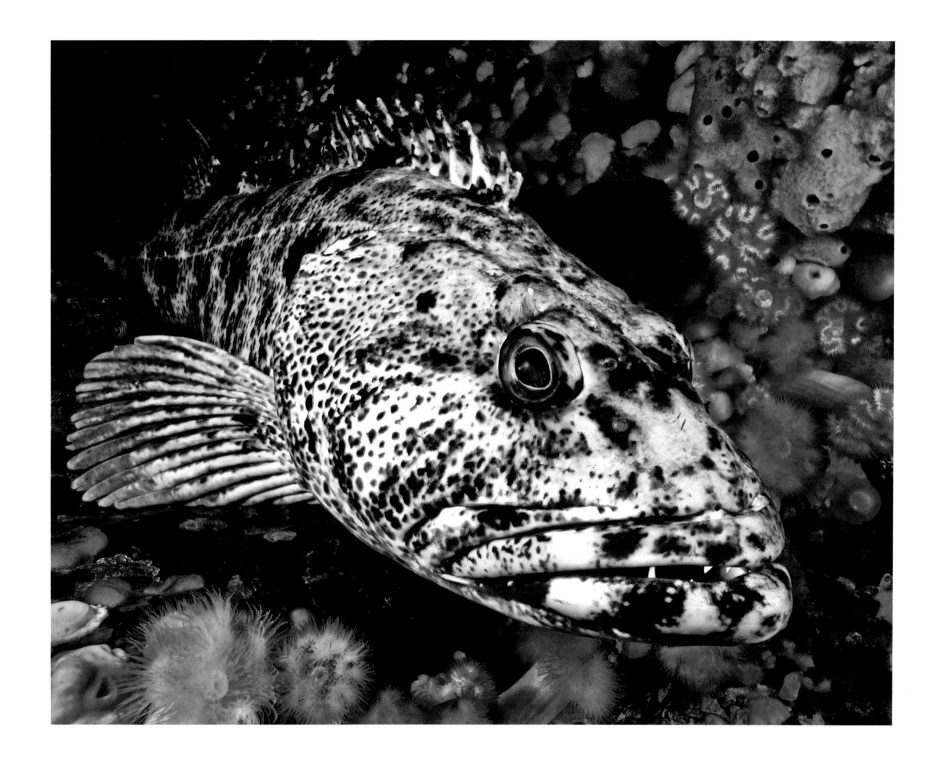

A large lingcod

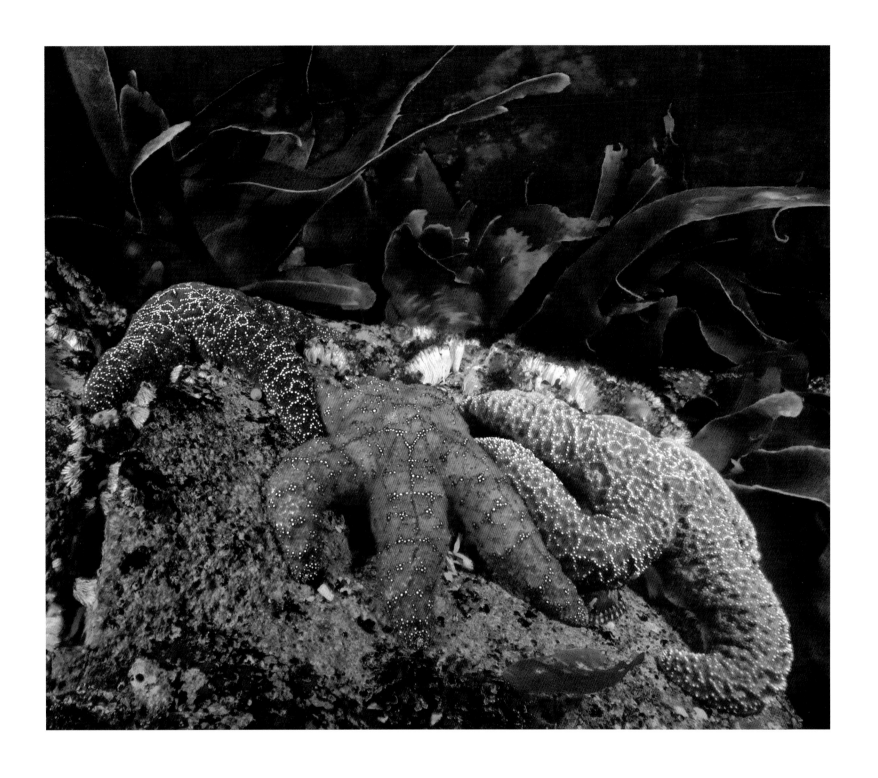

Purple and ocher sea stars

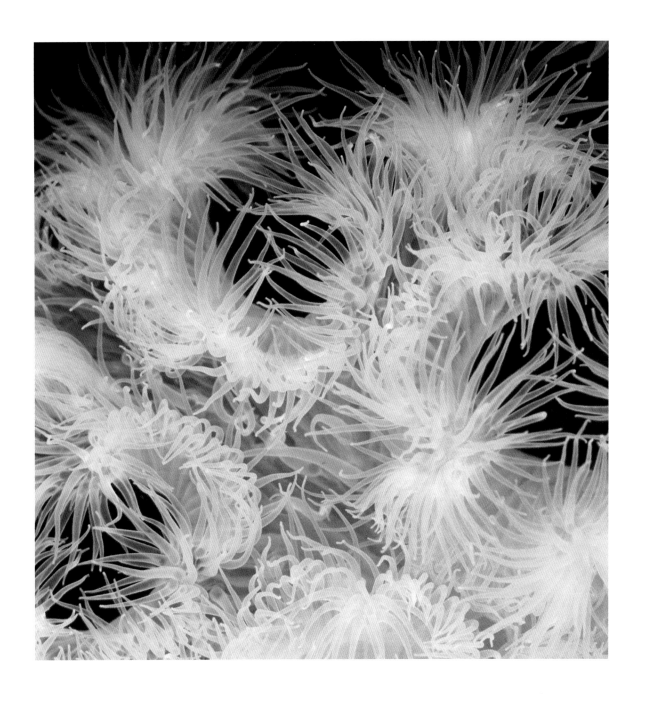

above: Plumose anemone detail

facing page: Spotted ratfish and red urchins

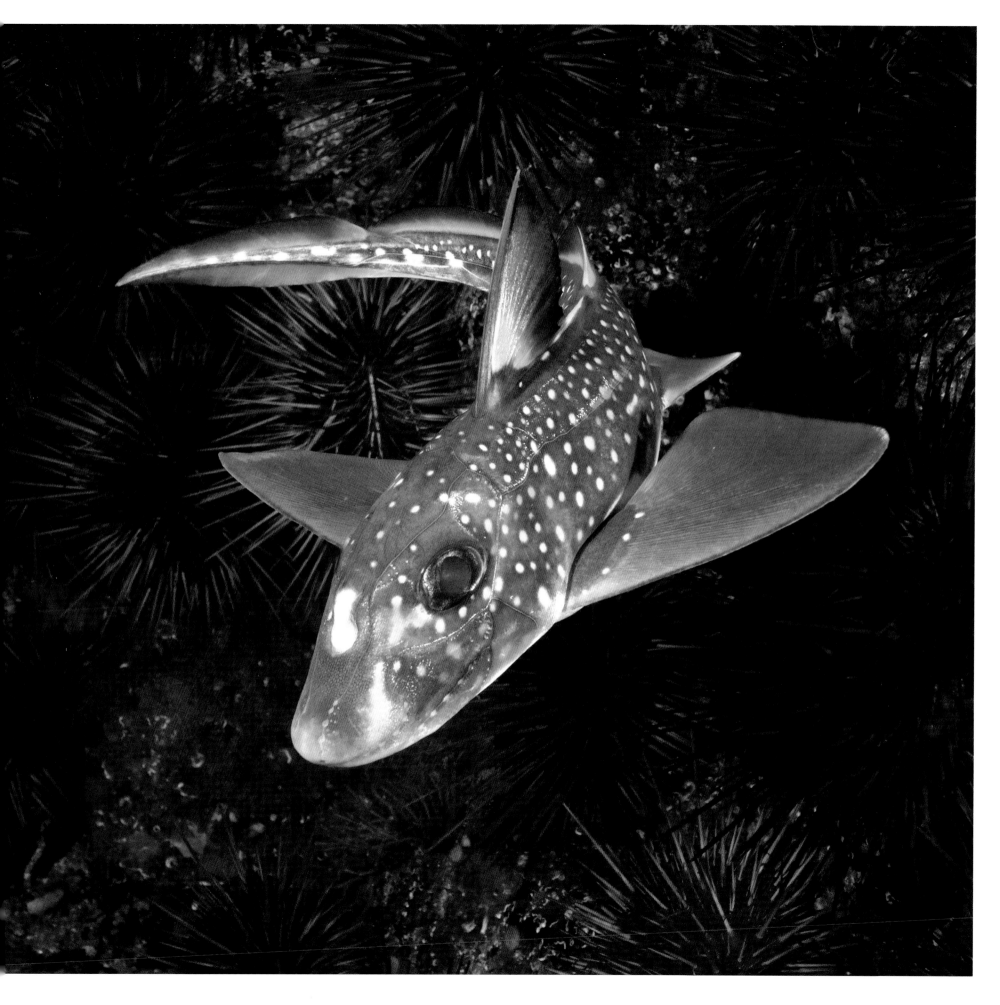

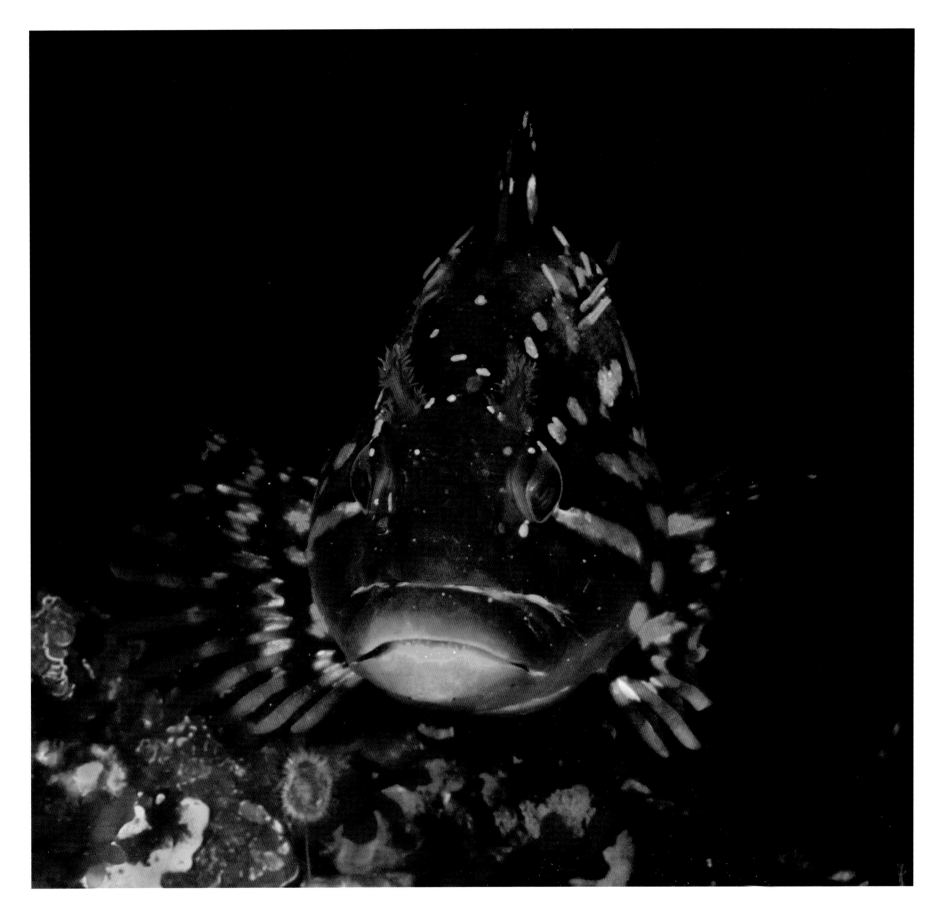

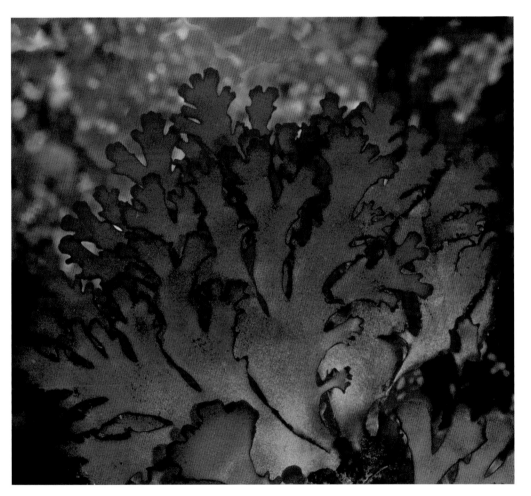

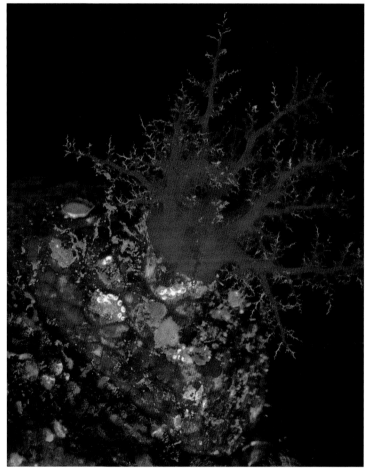

facing page: Rock greenling

above, left: Blue branching seaweed;
right: Armored sea cucumber

WOLF-EELS AND HARBOR SEALS

WE WERE diving on the wreck of the *Themus*, a 270-foot freighter that struck a rock and sank near the north end of Browning Pass in December 1906. The barely recognizable wreckage is scattered over a considerable distance and largely overgrown with sea-weeds, sponges, anemones, and other invertebrate life. Divers visit this site mostly for its resident wolf-eel population, but the residents did not seem to be cooperative on that day. One adult male stared out at me from the entrance to his den among the wreckage, while his mate remained hidden inside.

In spite of their large size and fearsome appearance, these eel-like fish are quite shy in the presence of divers. Fortunately, their shyness can be readily overcome by breaking open a sea urchin with a dive knife and placing it within sight of their den. This tasty offering is seldom refused, and over time a wolf-eel can become so habituated to urchin handouts that it will emerge from its den and swim right up to any nearby diver.

A few moments later, the male came out and swam over to me. He was over six feet long and looked me over expectantly. Unfortunately for him there were no urchins in sight, and his only reward was to have his picture taken. His more timid mate appeared at the entrance to the den but remained inside.

The wolf-eel soon returned to his den, and I decided to try my luck in the kelp bed near the surface, where there was a large aggregation of black rockfish. I glanced upward into the kelp canopy and saw the unmistakable silhouette of a harbor seal at the surface. Curious yet shy, these small seals have unpredictable reactions to divers. Wariness usually prevails over curiosity, however, and I had never been able to capture a really good photograph of one before. I did not know it yet, but my luck was about to change.

Moments later the seal appeared just a few feet away, keeping one eye on me as it swam past. It weighed no more than one hundred pounds and was probably a young female. She returned a minute later and then again for a third time. Did she think I was a sick or wounded seal, in need of assistance? Or had she simply concluded that whatever I might be, I was far too slow and clumsy to pose any threat.

Steve Redding soon joined me, and his presence did not seem to bother the seal, who continued to visit us. At one point Steve reached out to her, and she responded by gently touching his hand. I thought how unlikely it would be for a wild terrestrial mammal to respond to a human in this manner. Hominids have lived on land for millions of years, and we are usually seen by other animals as predators or prey. But under the sea we are clumsy, bubble-blowing newcomers, and marine mammals do not appear to be guided by the same instincts as their terrestrial kin.

The young seal continued to return every couple of minutes, staying for a short while to visit with us. One time she stopped less than two feet away and stared intently into the dome port of my camera housing, perhaps seeing her own reflection for the first time.

Having waited many years for my first good opportunity to photograph a harbor seal, I did not have to wait very long for the next one. A few months later, I was diving near Quadra Island when I spotted a pair of harbor seals in the distance. They were hanging out just below the surface, near a large boulder. I moved slowly toward them, hoping for an opportunity to get more photographs.

As I approached the boulder where I first saw them, something unexpected happened. One of the seals began to rub its back vigorously on the large rock, all the while keeping one eye on me. The boulder was covered with small barnacles, making it a perfect scratching post for an animal with thick fur. I photographed for several minutes as the seals took turns rubbing different parts of their bodies against the rock. Fifteen minutes later I climbed back aboard the skiff, hardly able to believe my good fortune in capturing this interesting behavior with a camera.

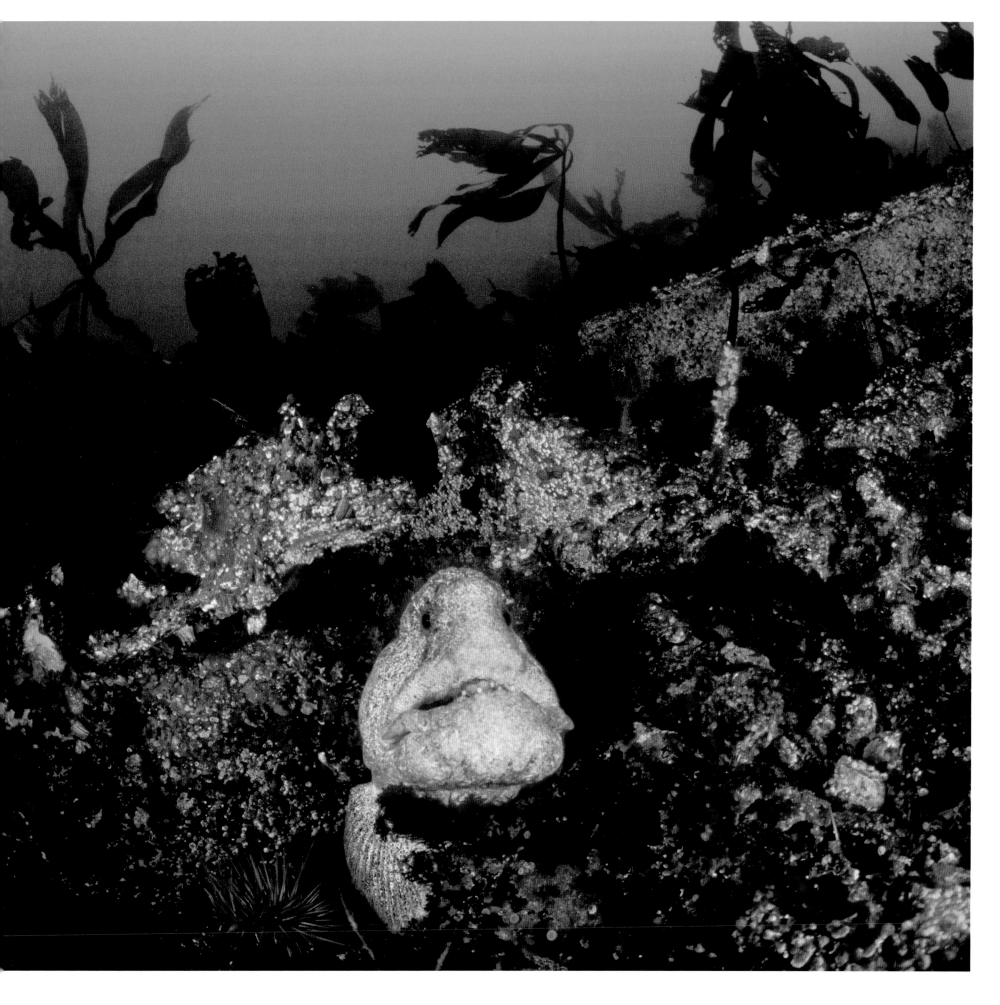

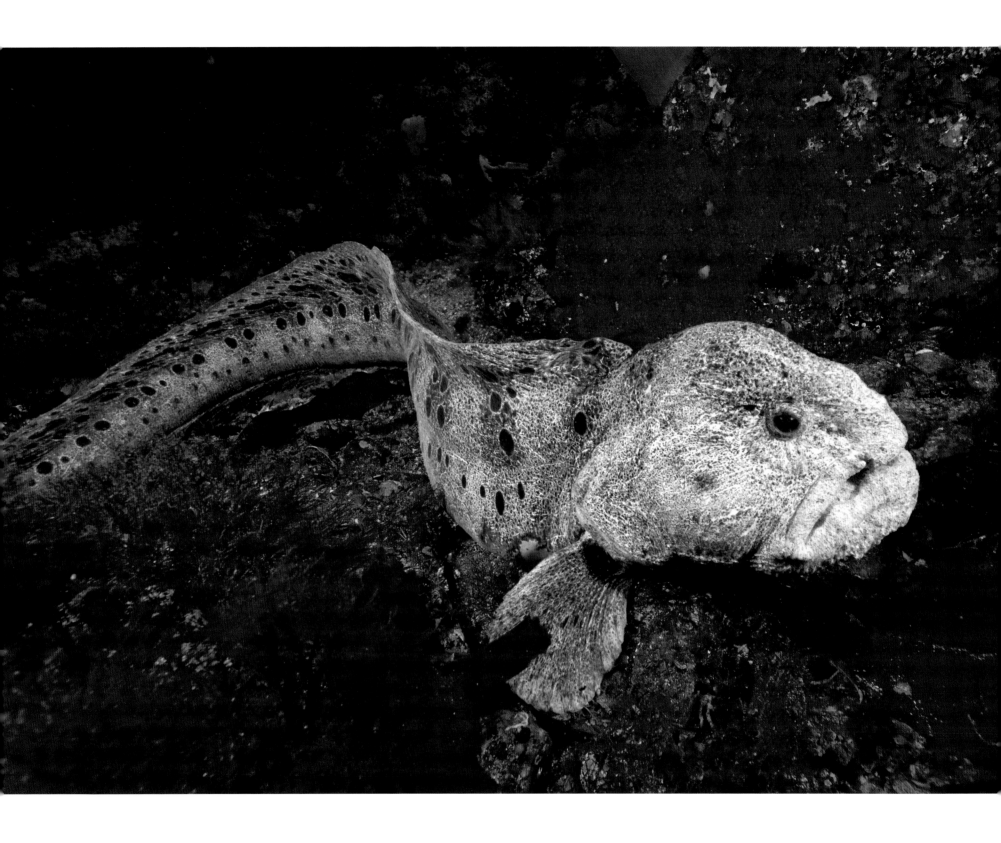

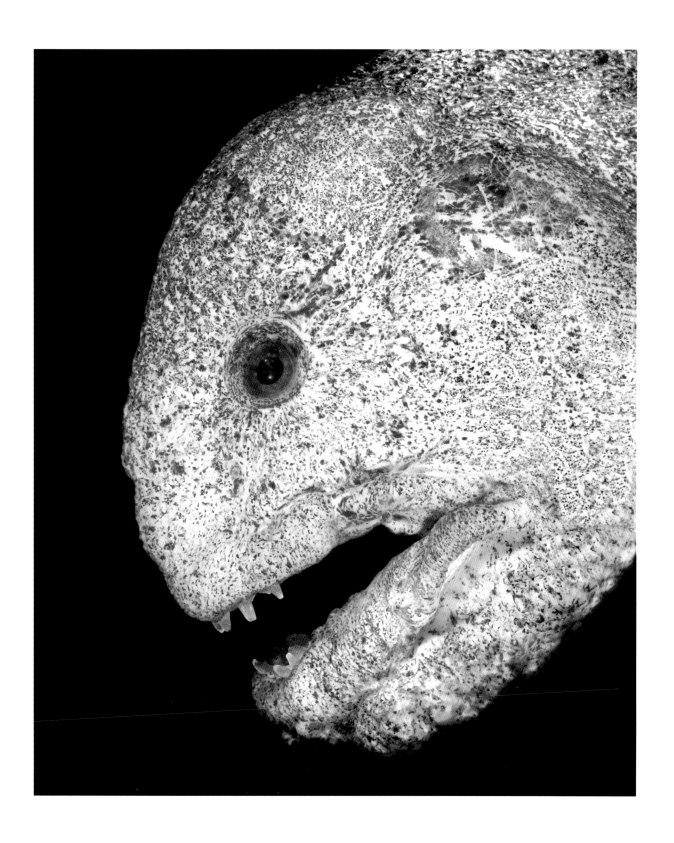

previous spread: A wolf-eel in
the wreckage of a sunken ship
both pages: Adult male wolf-eels

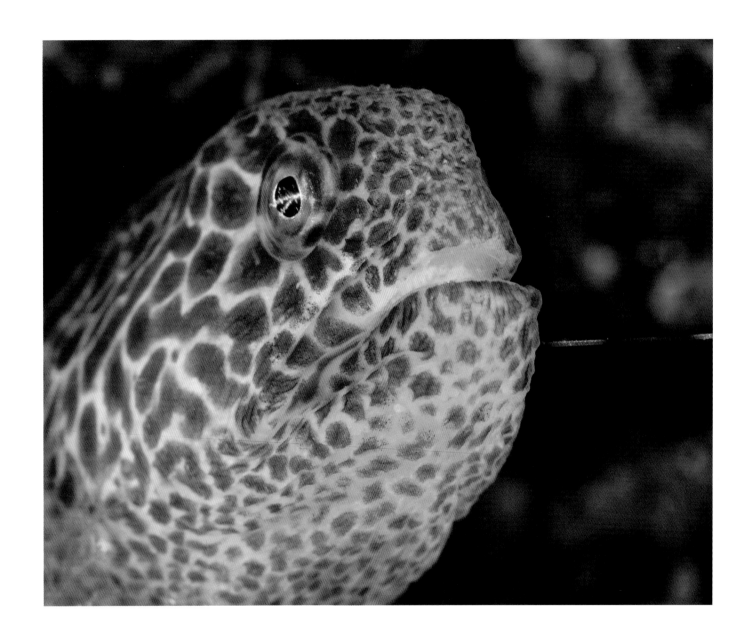

above: Juvenile wolf-eel with antenna
of a recently swallowed prawn

facing page: Juvenile wolf-eel

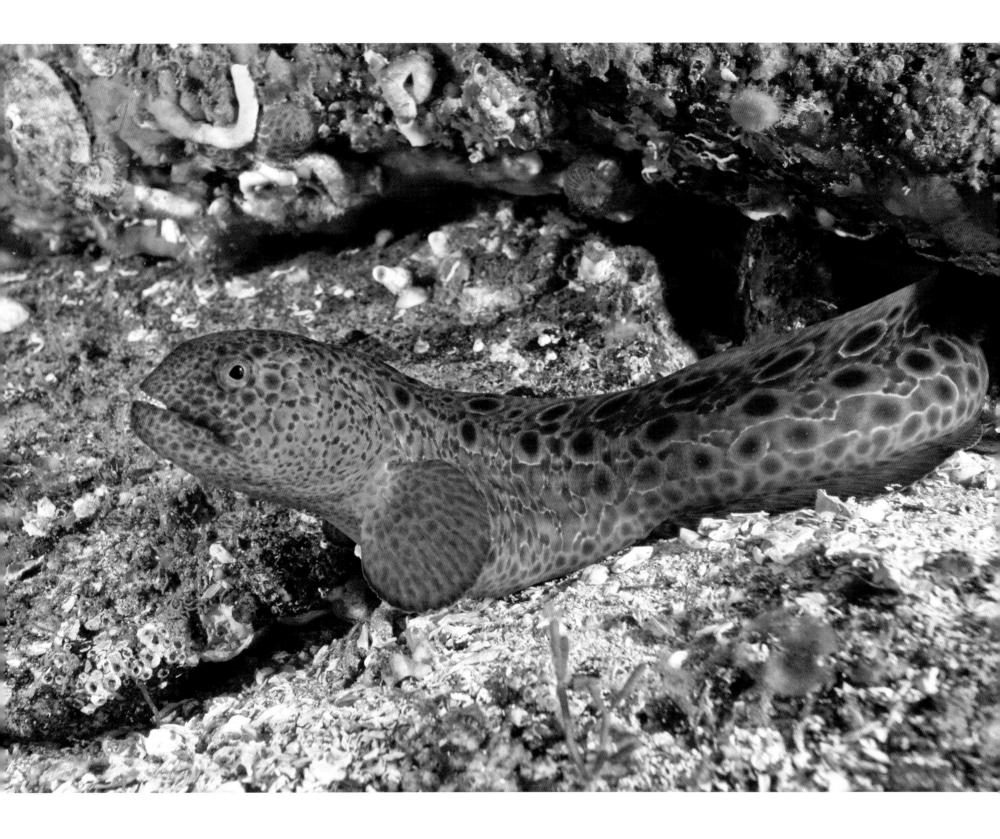

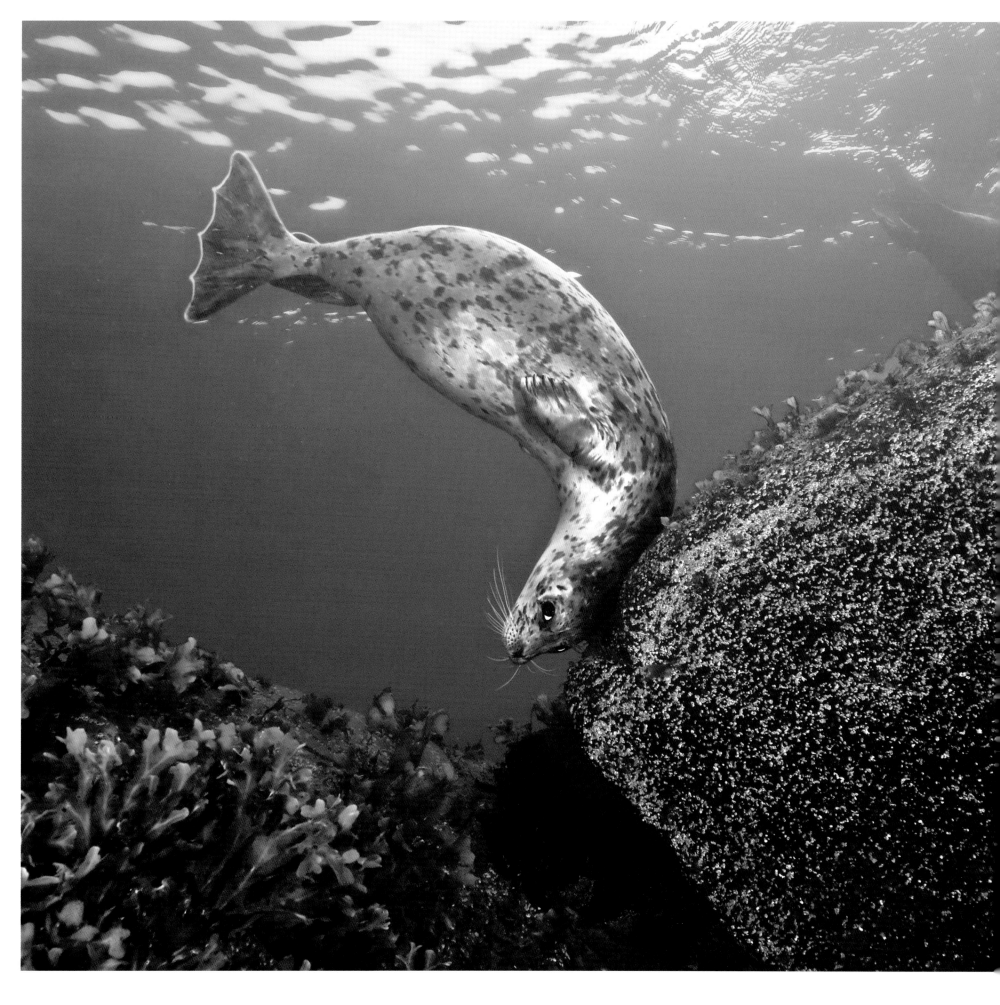

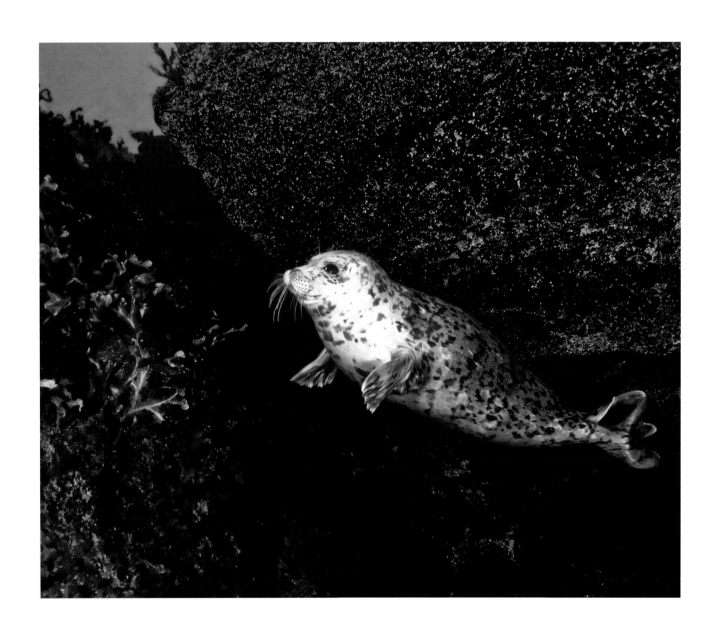

A harbor seal scratching its back

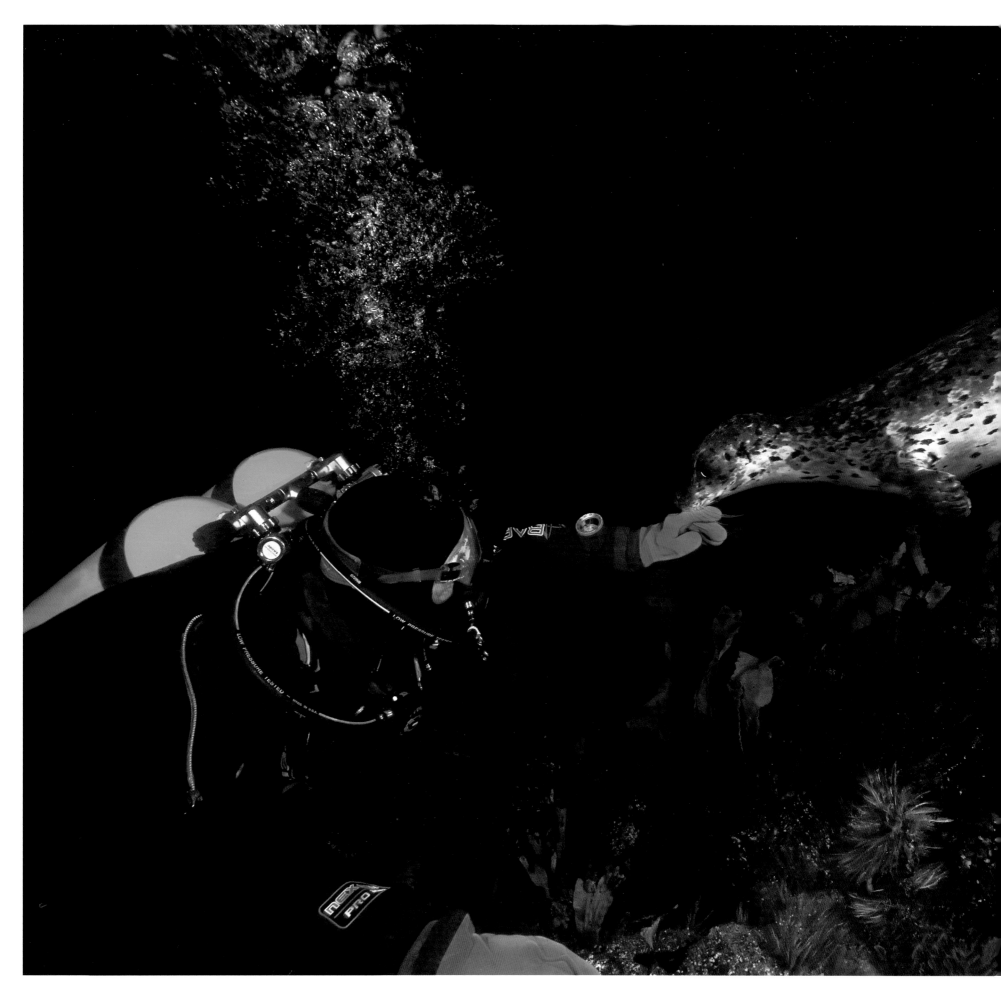

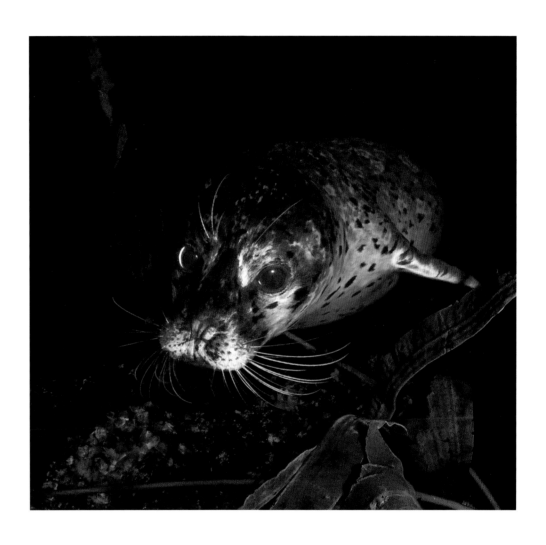

left: An interspecies greeting

above: A friendly harbor seal

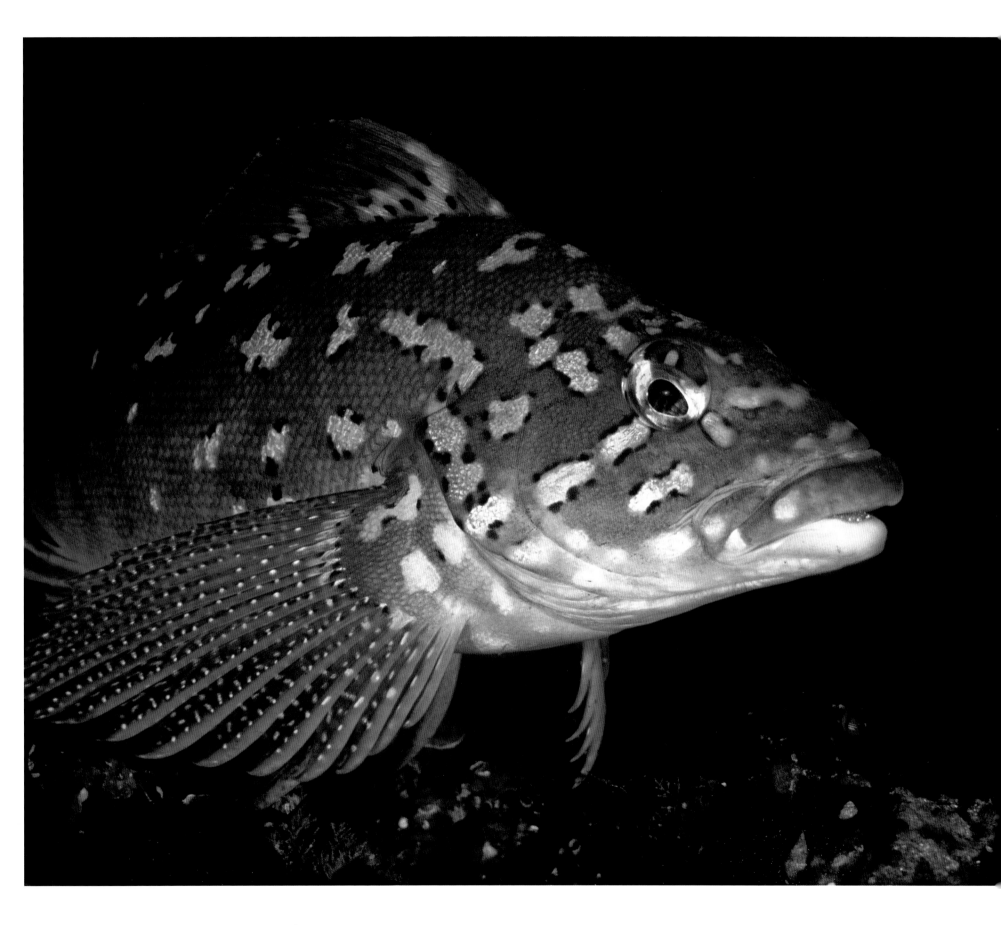

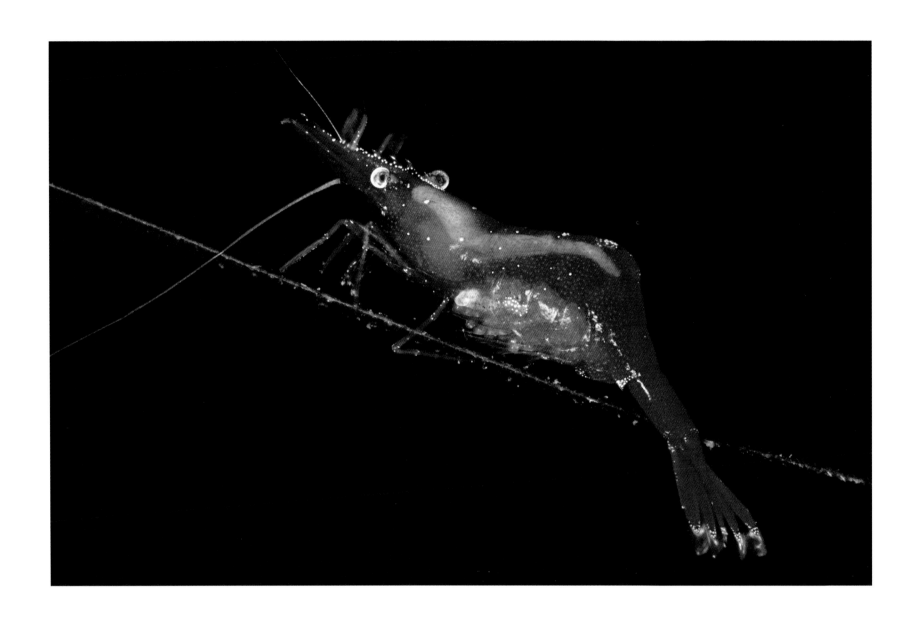

facing page: A male kelp greenling

above: A female stiletto shrimp with eggs

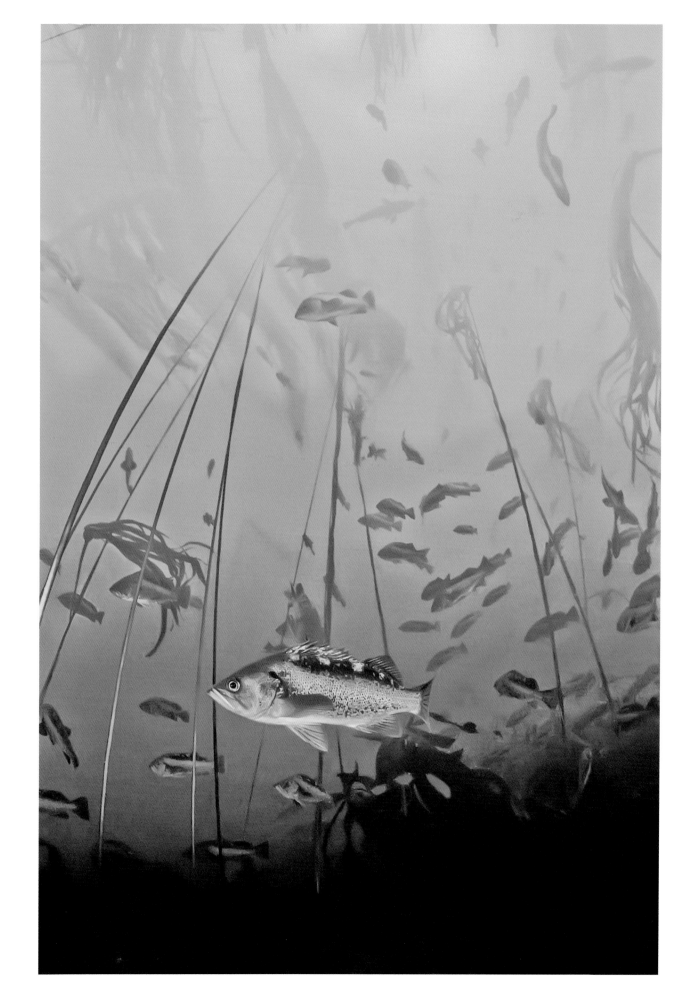

Black rockfish and bull kelp

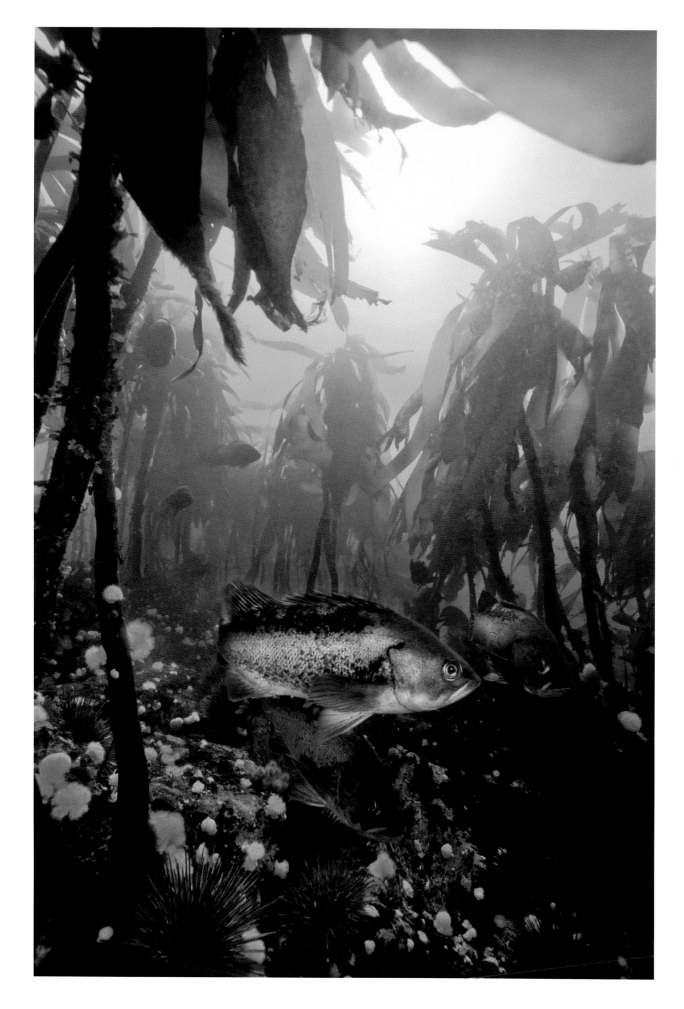

Black rockfish with old-growth kelp

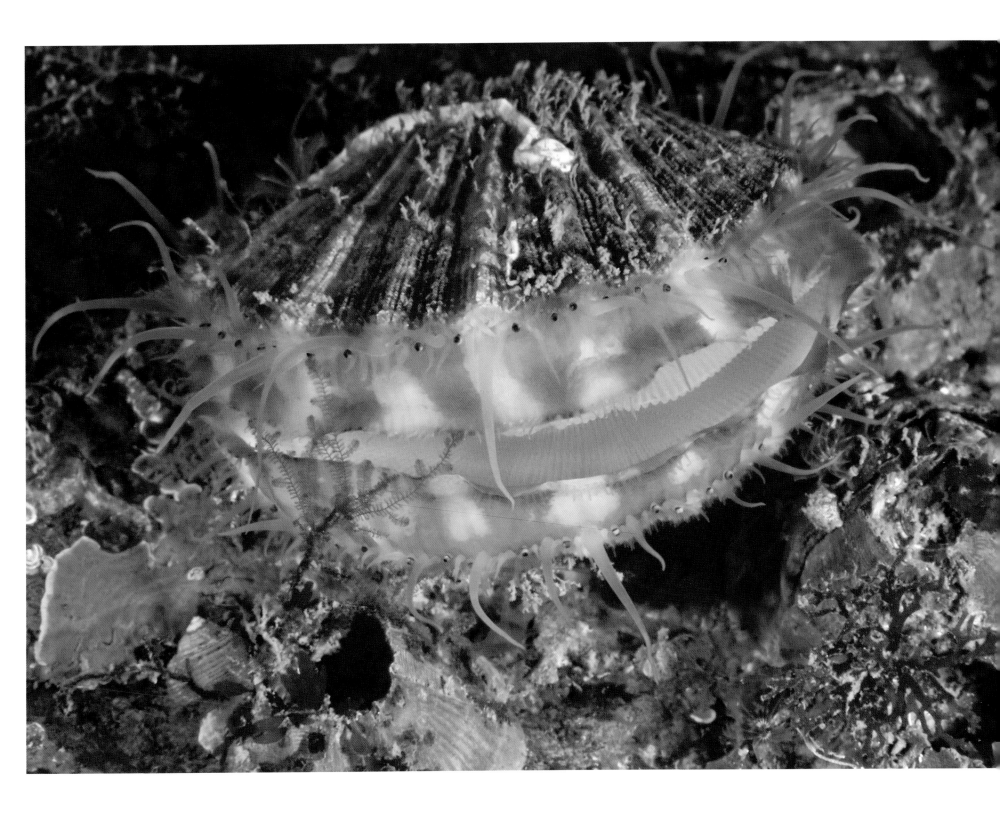

facing page: Spiny pink scallop

above: Lined chiton and orange social tunicates

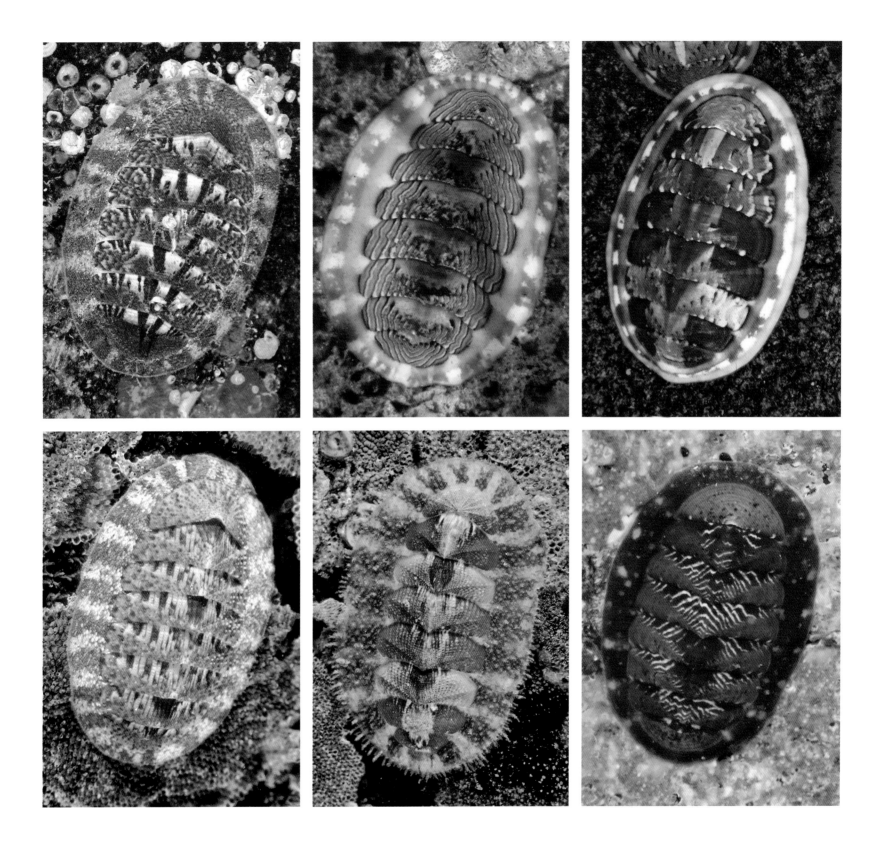

facing page: Six chitons of the Pacific Northwest

above: Orange-peel nudibranchs and red soft coral

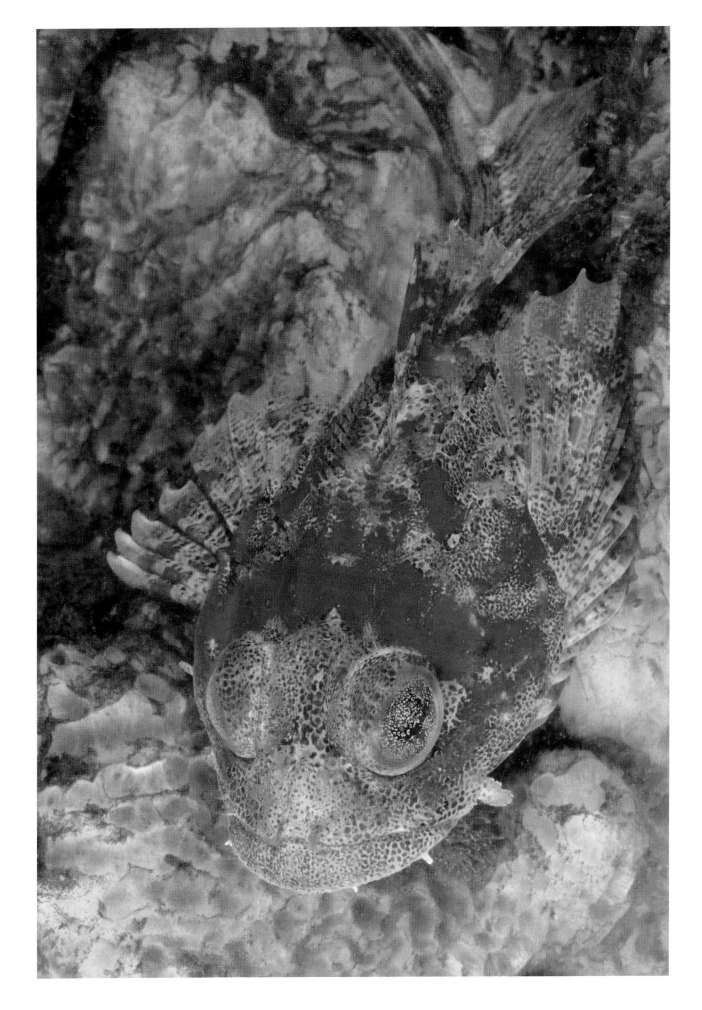

Red Irish lord with
sulfur sponge

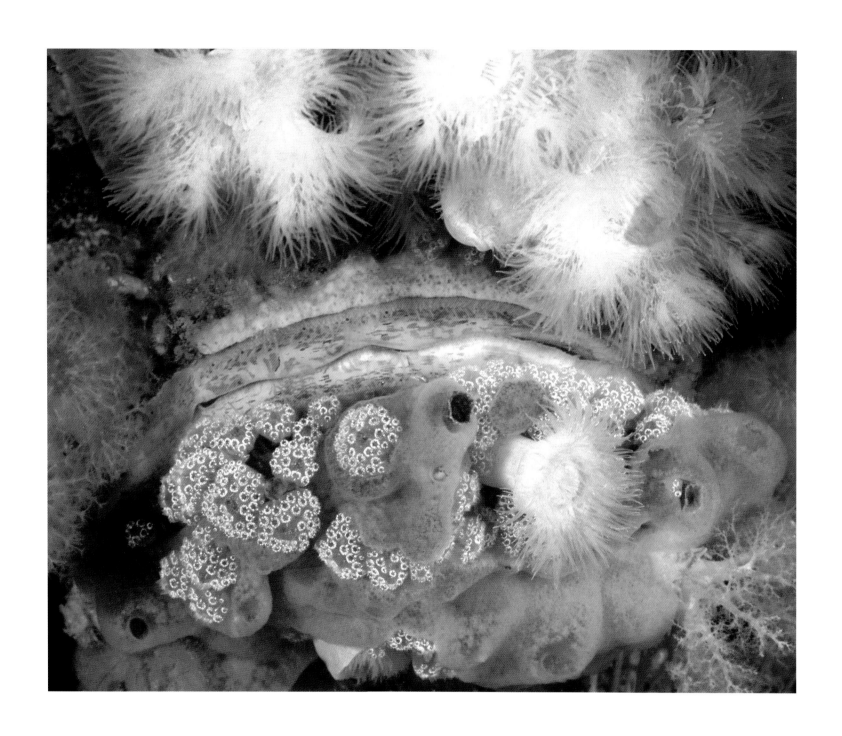

Giant rock scallop with anemones,
sponges, and ascidians

THE WARBONNET AND THE OCTOPUS

FOR MANY years I had rotten luck finding and photographing decorated warbonnets. I did somewhat better with mosshead warbonnets, but their larger cousin, *Chirolophis decoratus,* always eluded me. These spectacular fish have long, slender bodies and a remarkable coiffure, from which their common name is derived. They are also exceptionally reclusive.

After several years of bad luck, I became an underwater beggar, shamelessly soliciting the help of other divers in my quest for a warbonnet. Tom Sheldon was a frequent recipient of my begging, because he seemed to have a special knack for spotting these elusive fish.

Several years ago Tom and I did a dive together at Seven Tree Island in Browning Passage. As is often true for underwater photographers, "together" meant only that we had entered the water in the same place at approximately the same time, a buddy system sarcastically described as "same ocean, same day." Fifteen minutes into the dive, I was suddenly enveloped in a cloud of rising bubbles. Looking down, I saw Tom motioning forcefully for me to follow him.

I followed as Tom descended to eighty feet and then stopped and pointed to a rocky ledge protruding from the wall. Perched there in all of its glory was a handsome warbonnet. It was completely out in the open, posing as if auditioning for the lead role in the latest IMAX underwater movie. Having performed his charitable service, Tom departed, leaving me alone to immortalize his discovery.

I preset my camera and strobes for a shooting distance of about three feet. (Long telephoto lenses are useless underwater, where high-quality photographs require a close approach that leaves as little water as possible between lens and subject.) I approached my quarry cautiously. When I reached the correct distance, I slowly brought the camera up to my eye, prepared to compose a photographic masterpiece. But when I looked through the viewfinder, I saw nothing but a bare rock. The bashful fish had vanished into its hole at the last moment, leaving me muttering expletives into my regulator mouthpiece.

I waited two years for another benefactor to come along. Steve Redding, first mate and cook aboard the *Mamro* that summer, offered to show me a warbonnet he had found on a previous dive. Embarrassing though it was to receive a handout from a young Aussie who had made relatively few dives on my side of the Pacific, I eagerly accepted the offer. I followed Steve as he descended Browning Wall to a depth of one hundred feet and turned his flashlight on a rocky ledge. The narrow beam of light illuminated a large warbonnet out in the open, resting on a sponge-covered rock.

I decided to employ piscine psychology and approach the warbonnet nonchalantly, as though photography was the last thing on my mind. I turned both my gaze and my camera everywhere except toward my quarry. The strategy appeared to work, and I started photographing from about three feet away. I exposed a couple of frames, moved a bit closer, and exposed a couple more. The warbonnet eyed me intently but did not move. As I prepared to move in still closer, I became aware of movement out of the corner of my eye.

I turned and saw a very large octopus moving steadily toward the warbonnet. The fish quickly disappeared, while the octopus settled in front of me like an unwelcome party crasher.

How ironic! The only other animal I had hoped to photograph on this trip was a large octopus. Unfortunately, I did not have a wide-angle lens on my camera, the kind required to photograph an octopus with an arm spread of ten feet or more, so I grabbed a few frames of portions of the huge animal's body. The octopus paid no attention to me and began probing recesses in the rocky wall in search of a meal. A minute or two later, I began my gradual ascent to the surface.

Later that day, when I reviewed the images I had captured, I was amazed to discover that I had photographed not one warbonnet but two. In the dim light one hundred feet below the surface, I had not noticed the second, much smaller warbonnet, probably a male, peeking out from beneath the body of his mate.

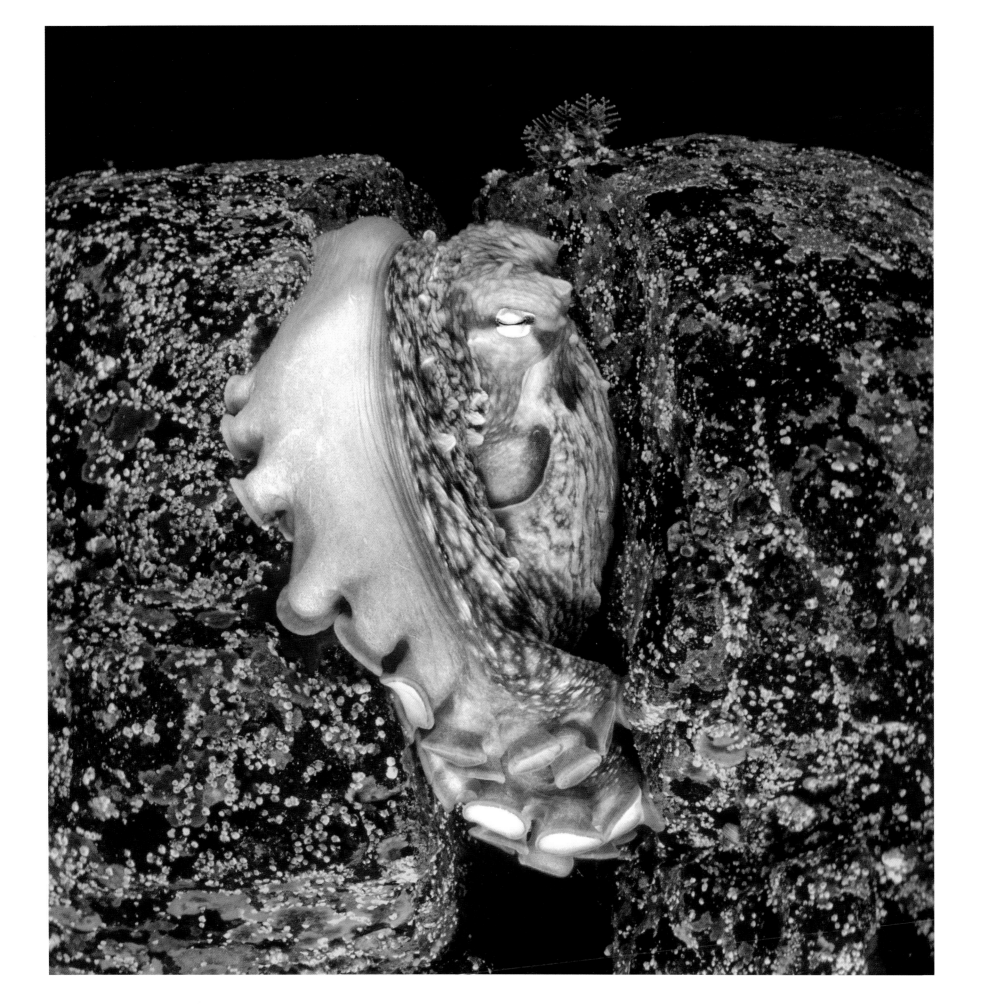

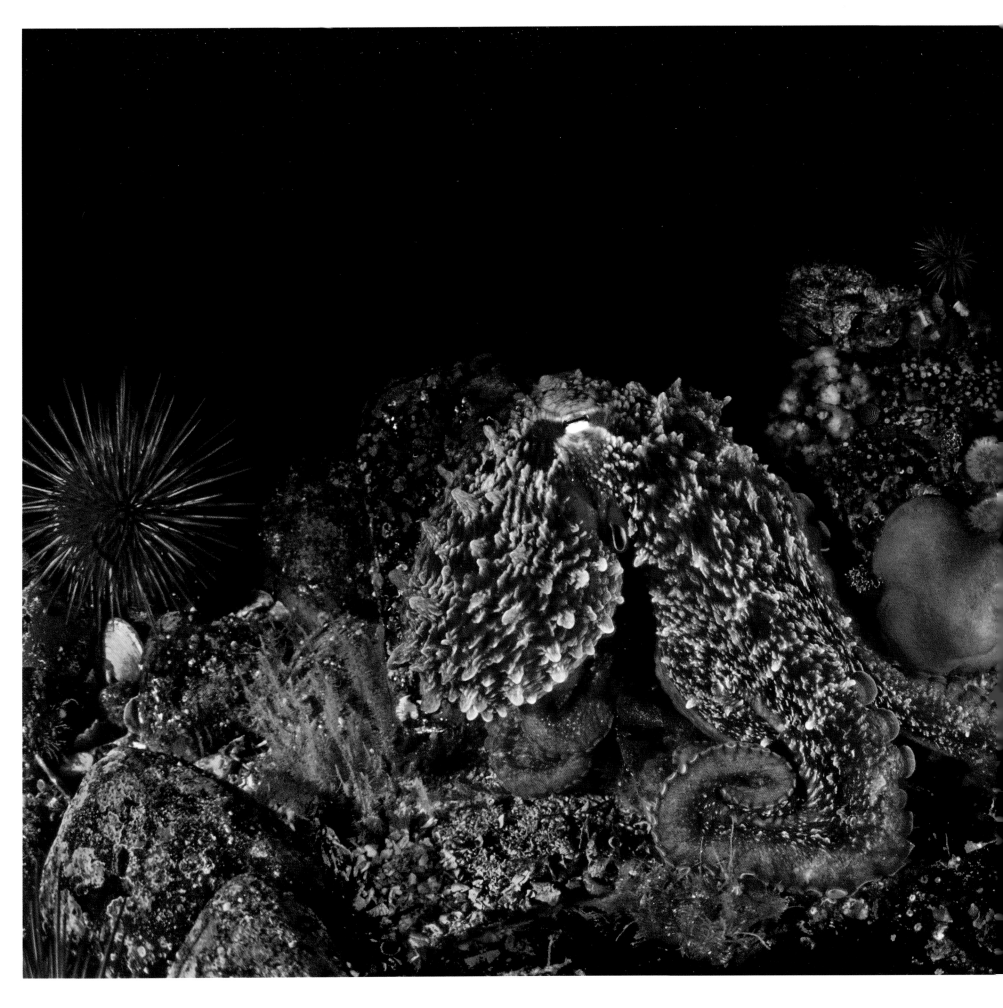

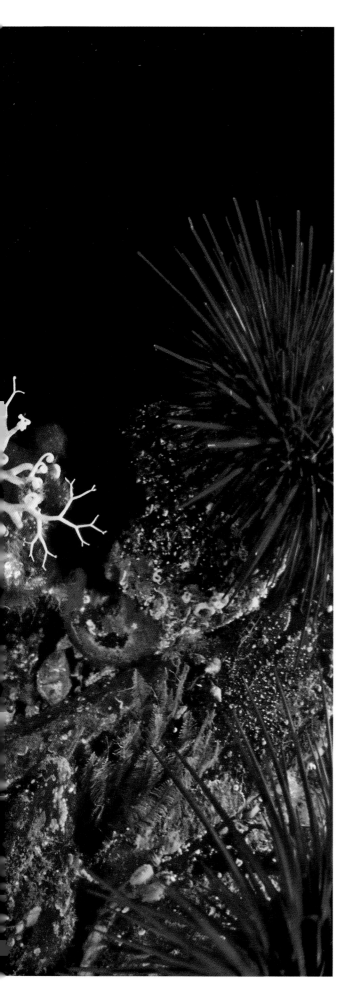

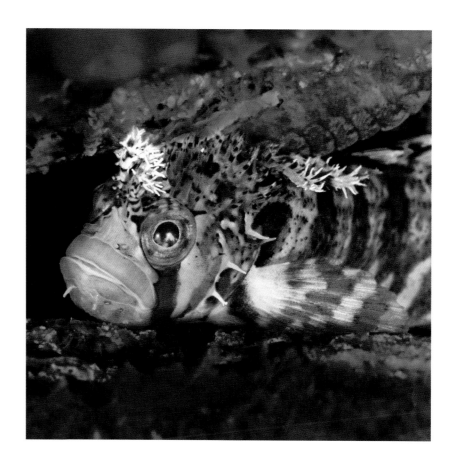

previous spread: A giant Pacific octopus emerges from its den.

left: An octopus out in the open attempts to blend in with nearby rocks.

above: Decorated warbonnet

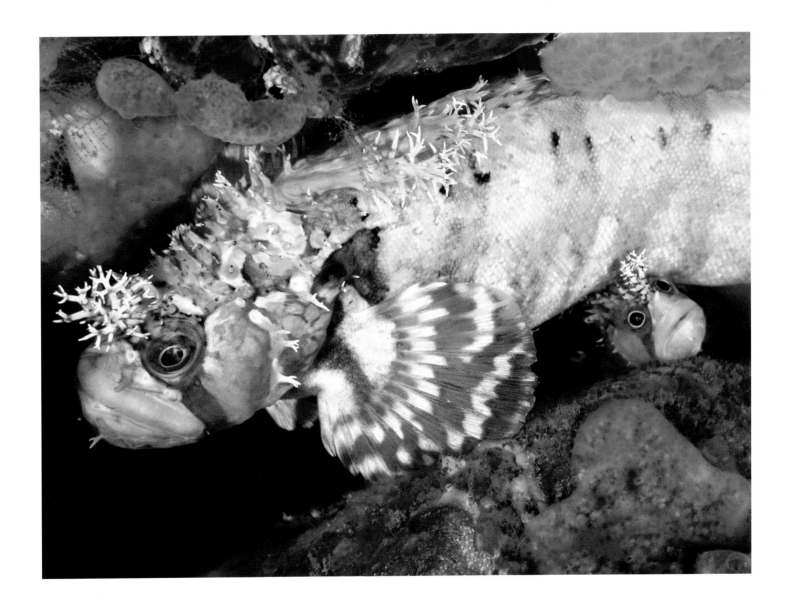

above: Decorated warbonnets

facing page: The giant Pacific octopus is the largest in the world.

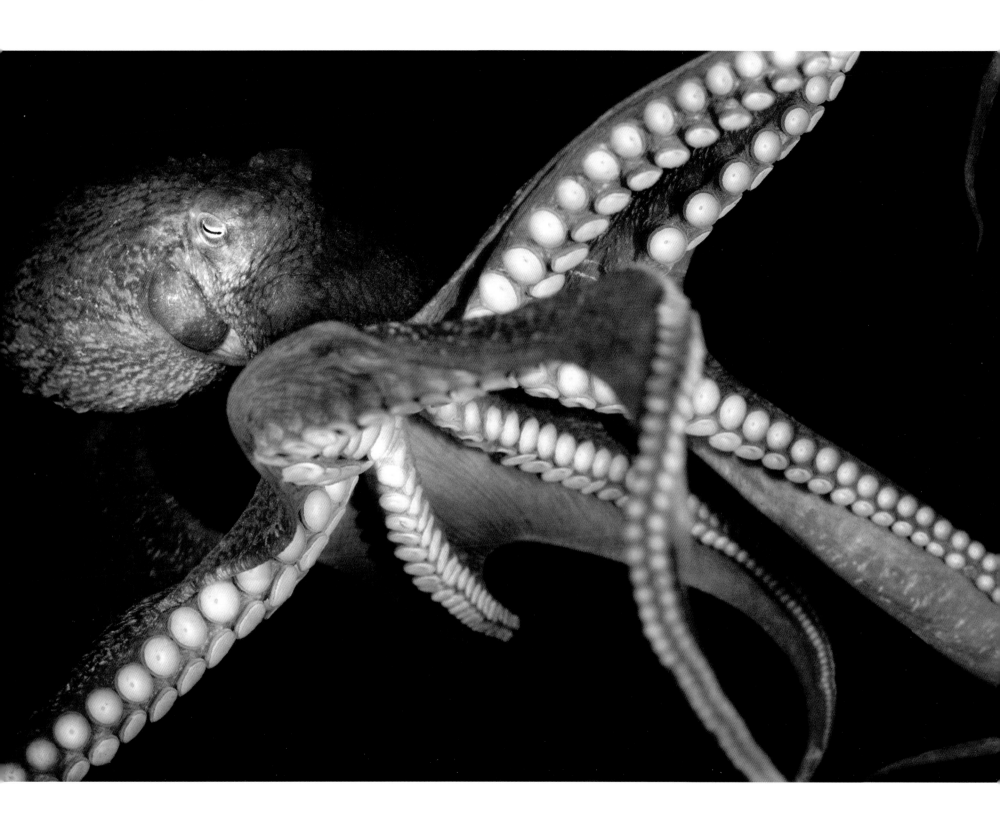

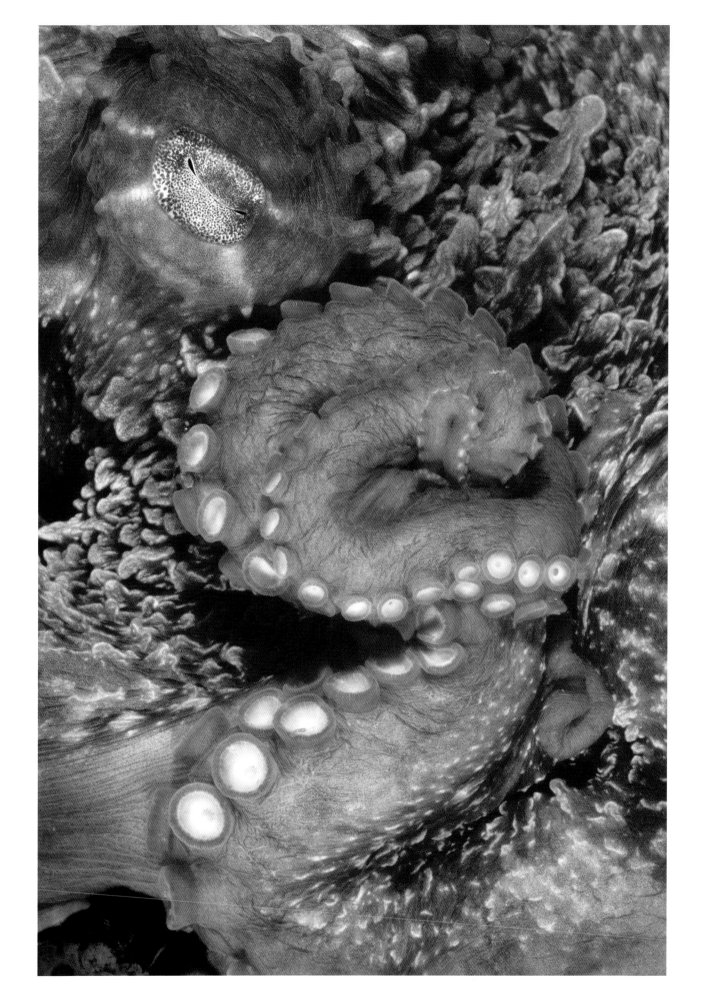

Giant octopus detail

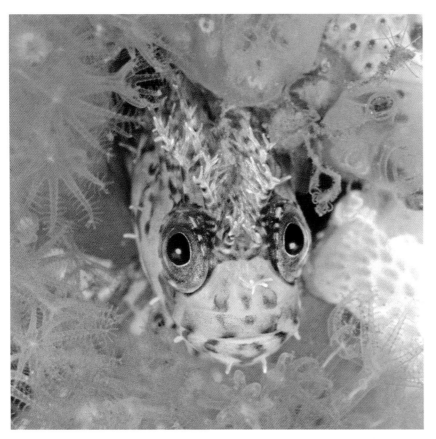
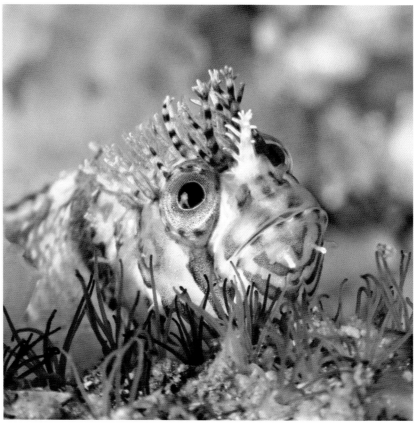

Mosshead warbonnets

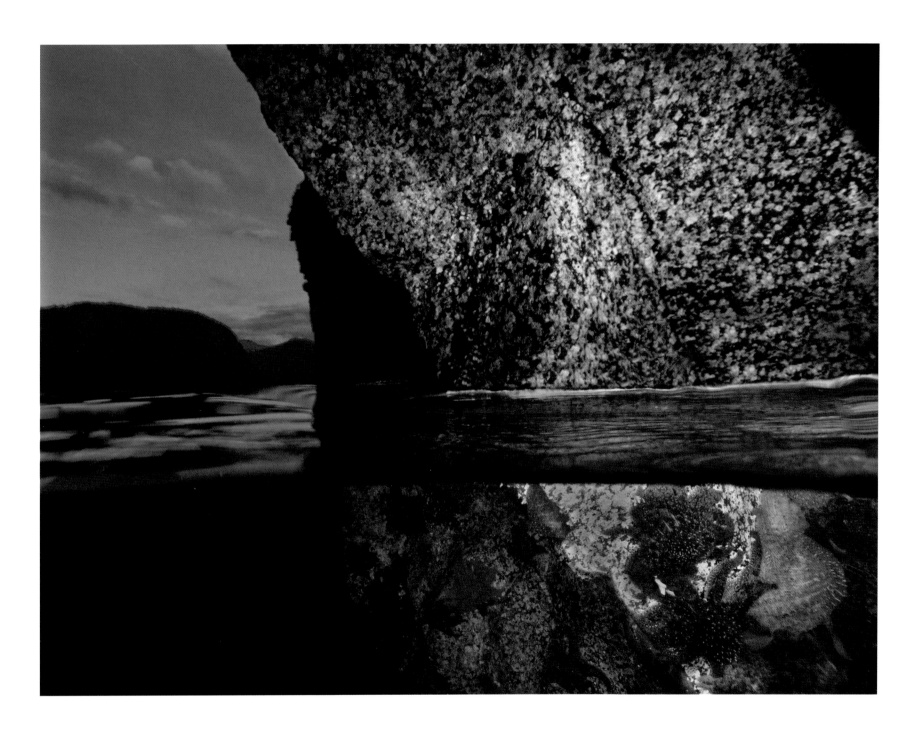

above: Sunflower sea stars

facing page: A young octopus with sunflower stars

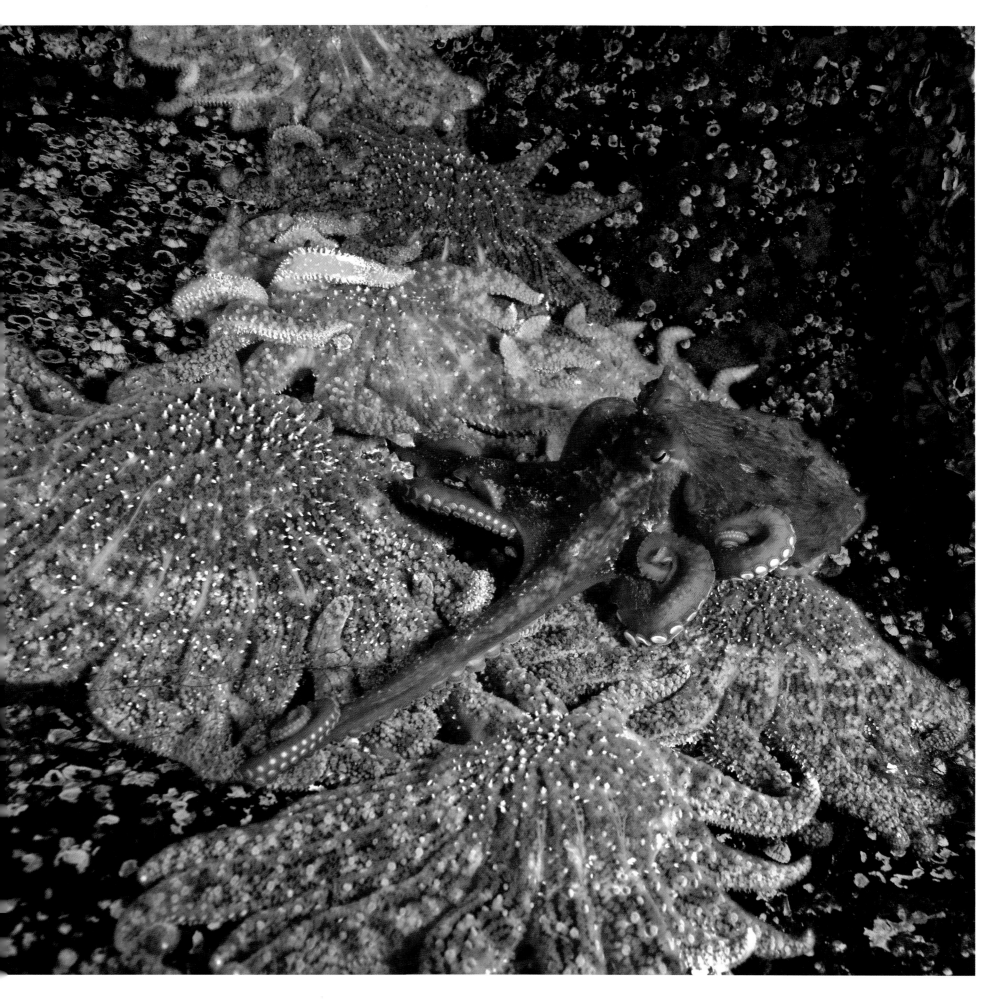

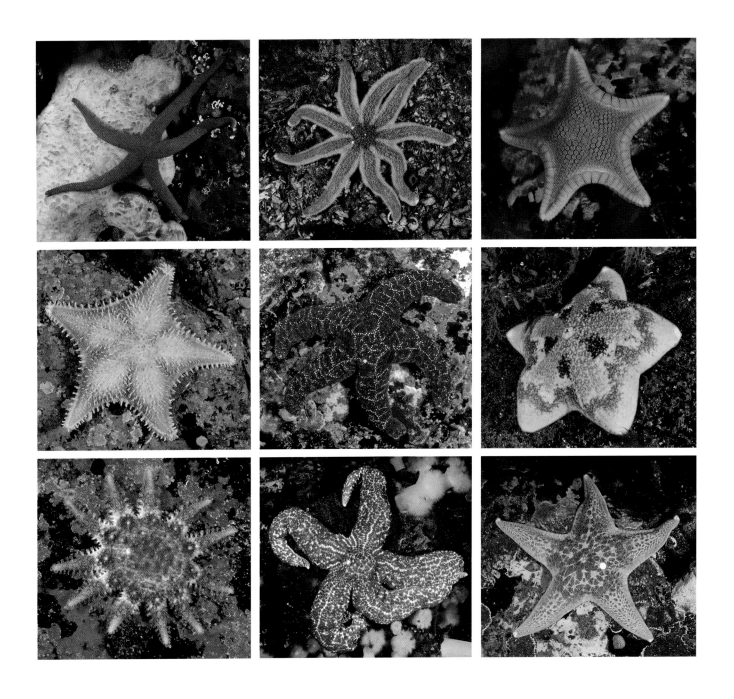

above: A few of the many sea stars found in the Pacific Northwest

facing page: A subtidal scene: purple sea stars preying on mussels

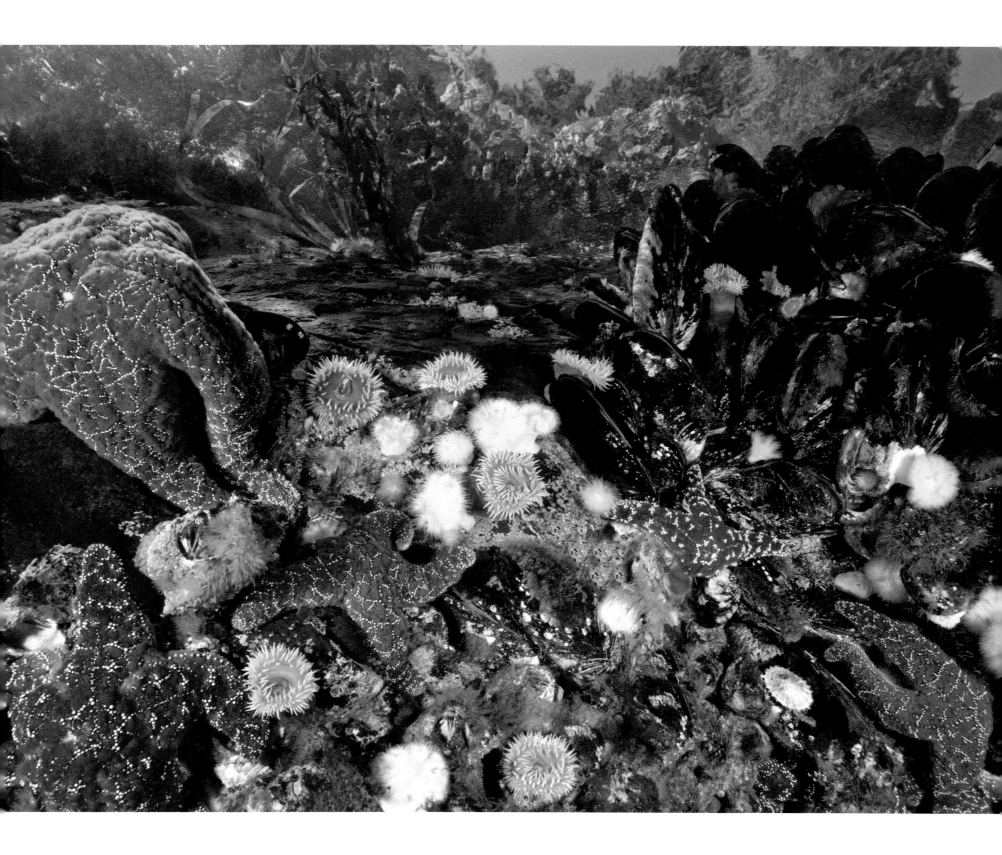

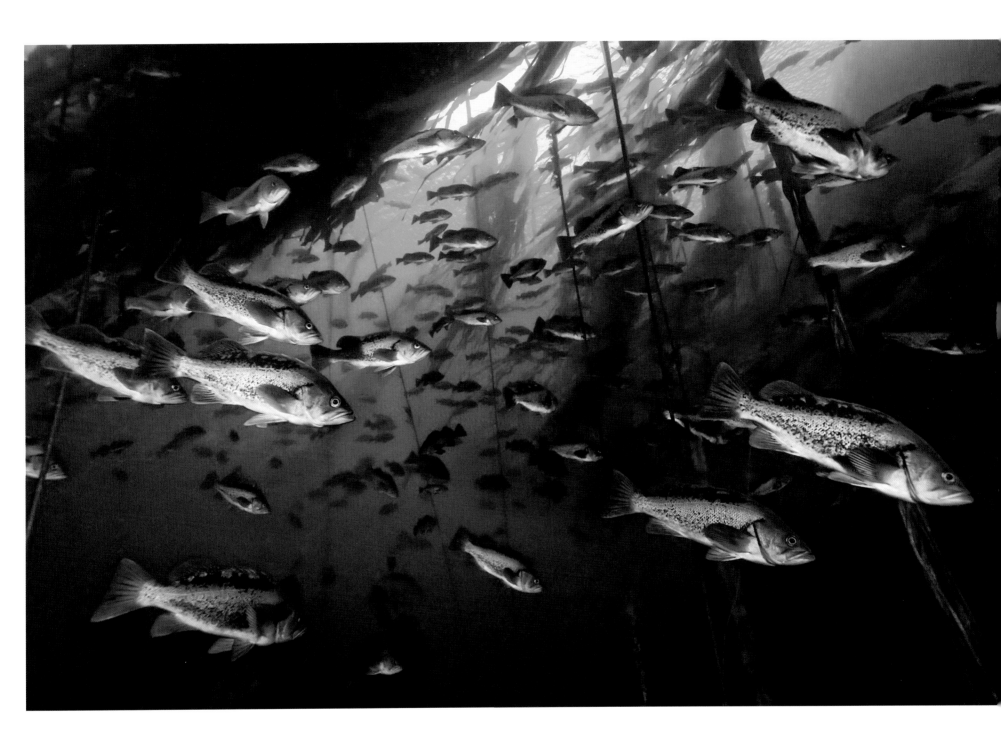

Black rockfish and bull kelp

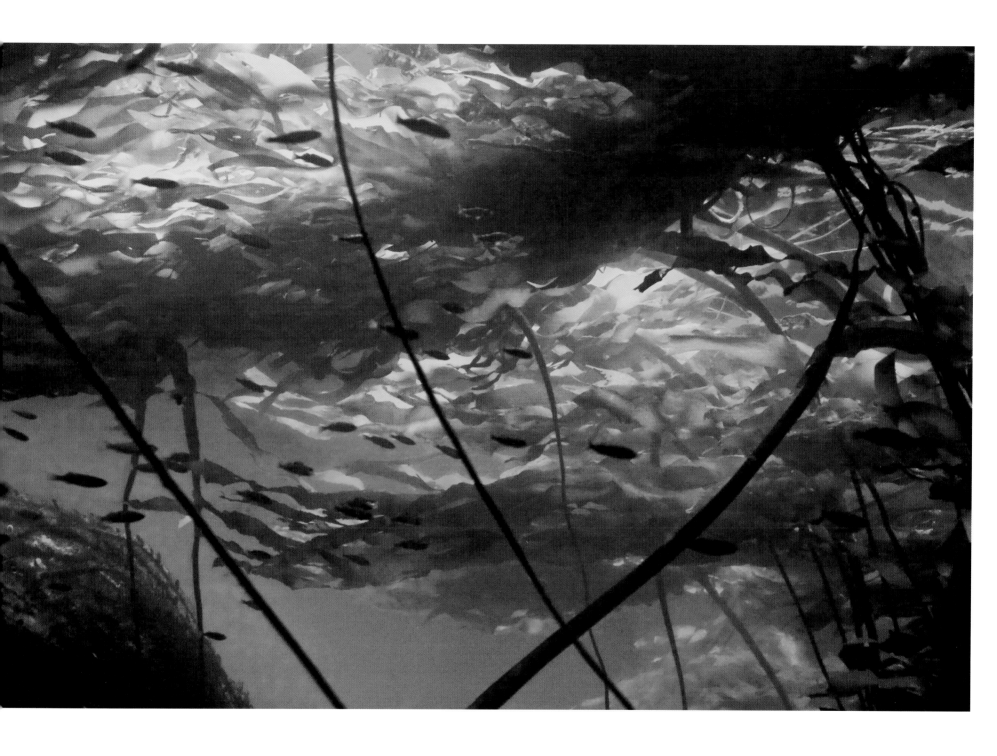

Bull kelp canopy with juvenile rockfish

Each photograph is identified by the number of the page on which it appears. All named locations are in British Columbia; the following names are abbreviated: Pacific Northwest (PNW), British Columbia (BC), and Queen Charlotte Strait (QCS). Where species identification is possible from the photograph, both common and scientific names have been provided.

1 Blue Rockfish and Lion's Mane Jelly (Jellyfish)
Sebastes mystinus; Cyanea capillata
HUNT ROCK, QCS
When I first saw this pair, I assumed the fish was nibbling the jelly's tissues, as sometimes happens. However, the detailed photographs suggest that the fish is feeding on bits of organic matter adherent to the jelly's tentacles.

2 Black Rockfish School with Bull Kelp
Sebastes melanops; Nereocystis luetkeana
BROWNING PASS, QCS

5 Harbor Seal
Phoca vitulina
WRECK OF THE *THEMIS*, CROKER ROCK, QCS
The young seal is staring directly into my lens and perhaps sees its own reflection in the dome port of my camera housing.

6 Moon Jelly and Cross Jellies
Aurelia labiata; Mitrocoma cellularia
Browning Pass, QCS

8 Rose Anemone
Urticina piscivora
WRECK OF THE *THEMIS*, CROKER ROCK, QCS
This lovely cnidarian is also called the fish-eating anemone. Cnidarians (formerly called coelenterates) are animals with radial symmetry, a central "mouth" with surrounding tentacles, a digestive system with only one opening, and stinging organelles (cnidocytes) used for capturing prey and for defense. Besides anemones, cnidarians include corals, hydroids, and jellies.

11 Northern Kelp Crab
Pugettia producta
HUSSAR BAY, NIGEI ISLAND, QCS
This is the ventral view of a fully grown adult male.

12 Lion's Mane Jelly
Cyanea capillata
HUNT ROCK, QCS
This spectacular jelly is the largest in the world, reaching a diameter of up to 6.6 ft/2m, with tentacles up to 30 ft/9m long. It has a powerful sting.

15 Mixed Seaweeds and Kelp at Low Tide
STAPLES POINT, WALKER ISLAND GROUP, QCS
Seaweeds (marine algae) can be divided into three large groups: green, red and brown.

Brown seaweeds are no longer regarded as plants. They include the kelps, which are especially diverse in the PNW; there are over 30 different species of kelp, more than anywhere else in the world. Seaweeds seen in this photograph include Turkish washcloth and sea lettuce above water (*Mastocarpus papillatus; Ulva* sp.); Turkish towel and rockweed above and below (*Gigartina exasperatus; Fucus gardneri*); broad-winged kelp (*Alaria marginata*), sea sacs (*Halosaccion glandiforme*), and an unidentified branching red seaweed below the surface.

16 Queen Charlotte Strait
An early-morning view, looking southeast from Gordon Channel.

19 Migrating Sockeye Salmon
Oncorhynchus nerka
ADAMS RIVER, BC

23 Kelp Forest Floor with Crimson Anemones and Red Soft Coral
Cribrinopsis fernaldi; Gersemia rubiformis
NORTH HANSON ISLAND, JOHNSTONE STRAIT
Also seen are crustose coralline algae and encrusting hydrocoral, which form a pink or magenta hard, flat covering on rocky surfaces.

24 Hooded Nudibranchs on Bull Kelp
Melibe leonina; Nereocystis luetkeana
CLAM COVE, NIGEI ISLAND, QCS
These transparent animals resemble jellies, but they are actually a kind of snail with no shell.

26 Proliferating Anemones and Lace Bryozoans on Kelp
Epiactis prolifera; Membranipora serrilamella
BROWNING PASS, QCS
These small anemones brood their young externally, as seen here.

27 Mosshead Warbonnets in an Empty Scallop Shell.
Chirolophis nugator
BROWNING PASS, QCS

28 Orange Sea Pens
Ptilosarcus gurneyi
HUSSAR POINT, NIGEI ISLAND, QCS
Sea pens are soft corals that can withdraw into the sand if disturbed.

29 Copper Rockfish
Sebastes caurinus
FANTASY ROCK, BOLIVAR PASS, QCS

30 Red Irish Lord with Short Plumose Anemones
Hemilepidotus hemilepidotus; Metridium senile
SEVEN-TREE ISLAND, BROWNING PASS, QCS
In spite of the bright colors revealed by artificial light from my electronic strobes, the red Irish lord is usually well camouflaged and easily overlooked. Over several days it can change color to blend with new surroundings.

31 Nakwakto Gooseneck Barnacles
Pollicipes polymerus
NAKWAKTO RAPIDS, SLINGSBY CHANNEL
The powerful tidal current at Nakwakto Rapids (at times exceeding 15 knots) results in unusual patterns of growth of various plants and invertebrates found there. *Pollicipes* is usually an intertidal organism, typically found in association with heavy surf. However, at Nakwakto, this species may be found as deep as 100 ft/30 m. The intense red color is the result of increased hemoglobin in the blood of this unique variety.

32 Red Irish Lord Sculpin
Hemilepidotus hemilepidotus
SEVEN-TREE ISLAND, BROWNING PASS, QCS

33 Red Irish Lord—Fin Detail
BROWNING PASS, QCS
Left: pectoral fin; *right*: dorsal fin

34–5 Stubby Squid (Pacific Bobtail Squid)
Rossia pacifica
HUSSAR BAY, NIGEI ISLAND, QCS
Bobtail squids appear to be an intermediate form between typical squids and cuttlefish; some researchers believe they are more closely related to the latter. The stubby squid is a 2.5 in/6 cm nocturnal bottom-dweller that is usually buried in sand during the day.

36 Northern Abalone
Haliotis kamtschatkana
HUSSAR BAY, NIGEI ISLAND, QCS
Overharvesting has resulted in severe population declines of this species, the only abalone that commonly occurs north of Oregon.

37 Painted Greenling (Male)
Oxylebius pictus
CRAMER PASS, GILFORD ISLAND
I spotted this unusually colorful fish while carrying a camera fitted with a wide-angle lens. I assumed that I would not be able to get close enough for good photographs with that lens but decided to see how close I could get before the fish swam away. To my amazement, I got within inches and the fish did not budge. I realized then that it was probably a male guarding a nest of eggs.

38 Orange Zoanthids
Epizoanthus scotinus
KYEN POINT, ALMA RUSSELL ISLANDS
These tiny, anemonelike animals most frequently reproduce by asexual budding, resulting in a cluster of genetically identical individuals.

39 Scalyhead Sculpin
Artedius harringtoni
BROWNING PASS, QCS
This 3–4 in/8–10 cm fish can be found in many color variations.

40–1 Candy Stripe Shrimps with Crimson Anemone
Lebbeus grandimanus; Cribrinopsis fernaldi
BROWNING PASS, QCS
This photograph shows a form of symbiosis (literally "living together") known as commensalism. The shrimps benefit by gaining protection from predators that are discouraged by the anemone's sting.

42 Crimson Anemone
Cribrinopsis fernaldi
BROWNING PASS, QCS
This is a photograph of the oral disc with the mouth in the center. Cnidarians have a digestive system with only one opening, and so the "mouth" is also the anus.

43 White-spotted Rose Anemone with Kincaid's Shrimps
Urticina lofotensis; Heptacarpus kincaidi
KYEN POINT, ALMA RUSSELL ISLANDS, BARKLEY SOUND
This shows another commensal relationship (see note for pp. 40–1).

44 Four Anemones of the Pacific Northwest
Clockwise from upper left: Crimson Anemone (*Cribrinopsis fernaldi*); Rose Anemone (*Urticina piscivora*), Brooding Anemone (*Epiactis* sp.); White-spotted Rose Anemone (*Urticina lofotensis*)

45 Rose Anemone (Oral Disc)
Urticina piscivora
BROWNING PASS, QCS

46 Black and White Amphipods
Chromopleustes oculatus
PORT NEVILLE, JOHNSTONE STRAIT
These tiny crustaceans were just 0.2–0.3in/5–7 mm long. They are scavenging for food on the arboral (upper) surface of a giant sunflower star.

47 *Left*: **Coonstripe Shrimp (Dock Shrimp)**
Pandalus danae
BROWNING PASS, QCS
The shrimp is resting on the surface of a red soft coral colony; the individual coral animals (polyps) can be clearly seen.

Right: **Yellow Sea Spider**
Tanystylum anthomasti
BROWNING PASS, QCS
Sea spiders (pycnogonids) are only distantly related to terrestrial spiders (arachnids). The central body of most sea spiders is so small that the digestive and reproductive organs extend into their legs. The tiny yellow sea spider uses piercing and sucking mouth parts to prey on the polyps of red soft coral.

48 Brooding Anemones on Kelp
Epiactis lisbethae
HUNT ROCK, QCS

49 Anemone Mouth
Urticina sp.
BROWNING PASS, QCA

50 Purple-ringed Topsnail
Calliostoma annulatum
NORTH WALL, BROWNING PASS, QCS
This lovely shell belongs to a snail that preys on hydroids. Also visible in the photograph are orange social tunicates (*Metandrocarpa taylori*) and lattice-work bryozoans (*Phidolopora pacifica*).

**51 Red Sea Cucumbers and
Giant Plumose Anemones**
Cucumaria miniata; Metridium farcimen
NORTH WALL, BROWNING PASS, QCS
Sea cucumbers are echinoderms, invertebrates with a hydrauliclike water vascular system for locomotion. Other echinoderms include sea stars, brittle stars, and sea urchins.

52 Giant Plumose Anemones and Kelp Greenling
Metridium farcimen; Hexagrammos decagrammus
NORTH WALL, BROWNING PASS, QCS
The giant plumose anemone is the tallest anemone in the world, at times reaching at least 3 ft/1 m in height.

53 *Left:* **Frosted Nudibranch**
Dirona albolineata
HUSSAR COVE, NIGEI ISLAND, QCS
Nudibranchs are shell-less snails that typically prey on other invertebrates. Their name means "naked gills," and they are among the most beautiful animals in the sea. Tropical nudibranchs are often quite small, but in the PNW many of them are much larger. Several species exceed 6 in/15 cm in length and two species reach 12 in/30 cm or more.

Right, top: **Festive Triton Nudibranch**
Tritonia festiva
ECHO BAY, GILFORD ISLAND

Right, bottom: **Nudibranch Eggs**
(Species not identified)
BROWNING PASS, QCS

54 Four Nudibranchs of the Pacific Northwest
Clockwise from top left: White-and-Orange-tipped Nudibranch (*Janolus fuscus*); Clown Nudibranch (*Triopha catalinae*); Red Flabellina (*Flabellina triophina*); Cockerell's Nudibranch (*Limacia cockerelli*)

55 Opalescent Nudibranchs
Hermissenda crassicornis
SEVEN-TREE ISLAND, BROWNING PASS, QCS
Also seen are transparent tunicates, *Distaplia occidentalis.*

56 Giant Nudibranch
Dendronotus giganteus
LONG BAY, JEDEDIAH ISLAND
This is the second-largest nudibranch in the PNW, reaching a maximum length of 12 in/30 cm; it preys on tube-dwelling anemones. Seagrasses—which are seen in this photograph—are the only higher (flowering) plants that grow in the ocean. Red and green seaweeds are simple, nonflowering plants (algae), while brown seaweeds, such as kelp, are no longer even classified as plants.

57 *Top:* **Red-gilled Nudibranch**
Flabellina verrucosa
BROWNING PASS, QCS

Bottom: **Golden Dirona Nudibranch**
Dirona pellucida
Toy-Man's Gap, Deserters Island, QCS

58 Opalescent Nudibranch
Hermissenda crassicornis
BROWNING PASS, QCS

59 Crescent Gunnel
Pholis laeta
SHOAL BAY, DISCOVERY PASSAGE
Gunnels are small, eel-shaped, cold/temperate-water fishes restricted to the North Pacific and North Atlantic. This individual was photographed under a dock on a winter night.

61 Irish Lord and Pygmy Rock Crab
*Hemilepidotus hemilepidotus;
Cancer oregonensis*
BROWNING PASS, QCS
I spent several minutes photographing these two, and when I left them the position of the crab in the fish's mouth had remained unchanged. The crab was apparently too wide for the sculpin to swallow in this position; the fish would first need to get the crab turned 90 degrees.

62 Graceful Decorator Crabs
Oregonia gracilis
Shown on the bottom row are three individuals of the same species that have disguised themselves in different ways—*left:* with bits of red seaweed, *center:* with pieces of white sponge and several tunicates, *right:* with golden stinging hydroids. These "decorations" hide the crab from its enemies and are distasteful to many of them. (The photograph on top is a frontal view of the same crab seen at lower left.)

63 Puget Sound King Crab
Lopholithodes mandtii
BROWNING PASS, QCS
This is the largest shallow-water crustacean in the PNW; the carapace of a full-grown adult is the size of a dinner plate. Barnacles growing on the exoskeleton of this individual indicate that it has not molted recently. Like a hermit, the king crab is an anomuran, or "false" crab,

and has just three pairs of walking legs instead of four. *Lopholithodes* is a lithode crab, a kind of anomuran that evolved from hermit crabs. There are more lithode crabs in the PNW than anywhere else.

64 Graceful Cancer Crab with Clam
Cancer gracilis
EAST THURLOW ISLAND, BC
The crab is attempting to break open and eat a softshell clam (*Mya arenaria*). It will take some time, but the crab will likely be successful. I was fortunate to come across this pair at night; in daylight the very shy crab would not have allowed me to get this close.

65 Helmet Crab
Telmessus cheiragonus
GOWLLAND HARBOUR, QUADRA ISLAND
The fine hairs that cover the exoskeleton of this crab probably help it to better locate objects in the dark.

66 Pygmy Rock Crab in Giant Barnacle Shell
Cancer oregonensis; Balanus nubilis
BROWNING PASS, QCS
The empty casing of a deceased giant acorn barnacle may be as much as 6 in/15 cm across and is used for shelter by many small animals.

67 Helmet Crab and Hooded Nudibranchs
Telmessus cheiragonus; Melibe leonina
HUSSAR COVE, NIGEI ISLAND, QCS
An unusual juxtaposition; possibly the crab was preying on the nudibranchs.

68 Six Hermit Crabs of the PNW
Top row: Bering Hermit (*Pagurus beringanus*); Maroon Hermit (*P.hemphilli*); Widehand Hermit (*Elassochirus tenuimanus*)
Bottom row: Blackeyed Hermit (*P.armatus*); Orange Hermit (*E.gilli*); Greenmark Hermit (*P.caurinus*)

69 Maroon Hermits Eating Kelp
Pagurus hemphilli
BROWNING PASS, QCS
These hermits are all wearing abandoned shells of the blue topsnail, *Calliostoma ligatum.*

70 *Left:* **Basket Star**
Gorgonocephalus eucnemis
LOU'S HOLE, SLINGSBY CHANNEL
Basket stars are echinoderms, allied with brittle stars. Five long arms that branch repeatedly enable the animal to form a wide basketlike structure for capturing plankton.

Right: **Cloud Sponges**
Aphrocallistes vastus
AGAMEMNON CHANNEL, SUNSHINE COAST
This 8 ft/2.5 m sponge formation was photographed at a depth of 130 ft/40 m. These delicate sponges provide shelter for a variety of fish and invertebrates.

71 Northern Kelp Crab and Sea Lettuce
Pugettia producta; Ulva sp.
CLAM COVE, NIGEI ISLAND, QCS

72 Puget Sound King Crab and Red Sea Urchins
*Lopholithodes mandtii;
Strongylocentrotus franciscanus*
STAPLES ISLAND, QCS
Urchins are echinoderms, related to sea stars and sea cucumbers. The red sea urchin grazes on seaweeds and kelps and, when overly abundant, may create large bare areas on the seafloor.

73 China Rockfish
Sebastes nebulosus
BROWNING PASS, QCS
This rockfish is a nonschooling species, usually found on or near the seafloor. Rockfishes are cold-water scorpionfishes (family Scorpaenidae) and have venomous spines in their fins.

74 Grunt Sculpin
Rhamphocottus richardsonii
BROWNING PASS, QCS
A peculiar small sculpin that "walks" on the sea bottom using its pectoral fins.

75 Calcareous Tubeworms
Serpula columbiana
NORTH HANSON ISLAND, JOHNSTONE STRAIT
The body of each Serpulid worm resides within the white limestone tube it has secreted. The exposed portion of the animal consists mainly of a pair of featherlike structures that form a "tentacular crown," used for filter-feeding and respiration.

76 Kelp Poacher
Hypsagonus mozinoi
BROWNING PASS, QCS
Seldom seen or photographed, the kelp poacher is one of the best-camouflaged fish I have encountered. Its color varies to match its surroundings, and numerous, protruding appendages obscure its outline. When hiding among seaweeds, this fish is virtually invisible.

77 Sailfin Sculpin
Nautichthys oculofasciatus
BLIND BAY, JERVIS INLET, SUNSHINE COAST
A nocturnal bottom-dweller with long dorsal and pectoral fins, this unusual fish hides in holes and crevices during the day.

79 Hooded Nudibranchs on Bull Kelp
Melibe leonina; Nereocystis luetkeana
HUSSAR BAY, NIGEI ISLAND, QCS
These transparent nudibranchs possess an "oral hood" for capturing plankton. The rhythmic expansion and contraction of this structure gives these mollusks a jellyfishlike appearance.

80 **Lion's Mane Jelly**
Cyanea capillata
"FANTASY ISLAND," BOLIVAR PASSAGE, QCS

81 **Fried Egg Jelly**
Phacellophora camtschatica
FRANK'S ROCK, NIGEI ISLAND, QCS

82 **A Swarm of Cross Jellies**
Mitrocoma cellularia
NORTH WALL, NIGEI ISLAND, QCS
The orange surface debris seen in this
photograph consists of bits of decaying
vegetation dropped from conifers along the
seashore.

83 **Cross Jellies at Night**
Mitrocoma cellularia
HUSSAR COVE, NIGEI ISLAND, QCS
I noticed that these small jellies tended to
swarm in large numbers at night, when
they would move into quiet bays or coves.

84–5 **Hooded Nudibranchs on Bull Kelp**
Melibe leonina; Nereocystis luetkeana
HUSSAR COVE, NIGEI ISLAND, QCS

86 **Lion's Mane Jelly**
Cyanea capillata
BROWNING PASS, QCS

87 **Red-eye Medusa**
Polyorchis pencillatus
CLAM COVE, NIGEI ISLAND, QCS
Like the cross jelly, the red-eye medusa
is not a true jellyfish (scyphyzoan) but is a
hydroid, or hydrozoan. Most hydrozoans
possess both a medusa (jellyfishlike) and
a polypoid (anemonelike) stage in their
life cycle.

88 **Hooded Nudibranchs on Bull Kelp**
Melibe leonina; Nereocystis luetkeana
CLAM COVE, NIGEI ISLAND, QCS

89 **Moon Jelly and Clouds**
Aurelia labiata (formerly *A. aurita*)
BROWNING PASS, QCS
A medium-sized jelly with a very mild sting.

90 **Lion's Mane Jelly and Feather Boa Kelp**
Cyanea capillata; Egregia menziesii
SEVEN-TREE ISLAND, BROWNING PASS, QCS

91 **Fried Egg Jelly**
Phacellophora camtschatica
FRANK'S ROCK, NIGEI ISLAND, QCS

92–3 **Nakwakto Gooseneck Barnacles**
Pollicipes polymerus
NAKWAKTO RAPIDS, SLINGSBY CHANNEL
Because of the outrageously powerful tidal
current (Nakwako is located at the narrow
entrance to a very large system of fiords),
any diving here must be done precisely
at slack tide and is usually limited to just
twenty minutes or so. (See also p.31.)

94 **Acorn Barnacles, Mussels, and Anemones**
*Semibalanus cariosus; Balanus glandula;
Mytilus* sp.; *Metridium senile*
BROWNING PASS, QCS
All four of these intertidal or subtidal
species rely on tidal currents to bring a
continuous supply of planktonic food.

95 **Acorn Barnacles, Mussels,
and Anemones at High Tide**
SEVEN-TREE ISLAND, BROWNING PASS, QCS

96 **Kelp Forest Floor with Anemones**
Urticina spp.; *Epiactis* spp.
HUNT ROCK, QCS

97 **Frilled Dogwinkles**
Nucella lamellosa
This is a spawning aggregation, and recently
laid yellow eggs ("sea oats") are visible near
the top, center. The shells of this snail are
highly variable in color and sculpturing.

99 **Migrating Sockeye Salmon at Dusk**
Oncorhynchus nerka
ADAMS RIVER, BC

100–1 **Sockeye in a Shallow Stream**
Oncorhynchus nerka
ADAMS RIVER, BC

103 **Sockeye Salmon—Male and Female**
Oncorhynchus nerka
Adams River, BC
After re-entering fresh water to spawn,
sockeye turn bright red; the male eventually
develops a humped back and hooked upper
jaw.

104–5 **Pacific White-sided Dolphins**
Lagenorhynchus obliquidens
GORDON CHANNEL, QCS
White-sided dolphins are commonly
encountered along the Pacific Coast of North
America. They remain together in large groups
or pods, sometimes consisting of hundreds of
individuals.

106 **Pacific Prawn**
Pandalus platyceros
NORTH HANSON ISLAND, JOHNSTONE STRAIT
This is the largest shrimp in the PNW and
grows to 10 in/25 cm. It is caught in
traps and sold commercially.

107 **Cabezon**
Scorpaenichthys marmoratus
EFFINGHAM ISLAND, BARKLEY SOUND
The largest sculpin of the PNW, the cabezon
may reach a length of 39 in/1 m and weigh
as much as 30 lbs/14 kg.

109–12 **Steller Sea Lions**
Eumatopias jubatus
HORNBY ISLAND
Steller, or northern, sea lions are the
largest sea lions in the world; males may
be weigh as much 2400 lbs/1100 kg.

113 **Pacific Sand Lance School**
Ammodytes hexapterus
SEVEN-TREE ISLAND, BROWNING PASS, QCS
These slender fish are usually out of sight,
buried in gravel, sand, or mud. Every now
and then they emerge in large numbers,
perhaps for reproductive purposes.

114 **Lingcod**
Ophiodon elongatus
WRECK OF THE *THEMIS*, CROKER ROCK, QCS
This aggressive member of the greenling
family is the largest commonly encountered
shallow-water reef fish in the PNW. The
maximum reported size is around
100 lbs/45 kg.

115 **Ochre and Purple Sea Stars**
Pisaster ochraceous
NORTH WALL, NIGEI ISLAND, QCS
The most common intertidal sea star
in the PNW, *Pisaster* preys on mussels,
barnacles, limpets, and snails. When
attacking a mussel, the sea star pulls the
shells apart slightly, everts its stomach,
and secretes digestive enzymes that
break down the mussel's tissues.
(See also note for p.153.)

116 **Short Plumose Anemone—Detail**
Metridium senile
BROWNING PASS, QCS

117 **Spotted Ratfish (Chimera)**
Hydrolagus collei
"FANTASY ISLAND," BOLIVAR PASSAGE, QCS
Related to sharks and rays, chimeras
also possess cartilaginous skeletons.
Most members of the family Chimaeridae
live below the limit for safe scuba diving.

118 **Rock Greenling**
Hexagrammos lagocephalus
NORTH WALL, NIGEI ISLAND, QCS
This fish is not commonly seen by divers,
because of inaccessible habitat (rocky shores
with breaking waves) and because it is
well-camouflaged among seaweeds of
similar color. When this male "yawned," I was
surprised to see that the inside of his mouth
was bright blue.

119 *Left:* **Blue Branching Seaweed**
Fauchea laciniata
ALMA RUSSELL ISLANDS, BARKLEY SOUND
Light reflecting off gland cells in the surface
layer of this alga results in the iridescence
seen in this photograph.

Right: **Armored Sea Cucumber**
Psolus chitonoides
SEVEN-TREE ISLAND, BROWNING PASS, QCS
This unusual sea cucumber is protected
from predation, and from dessication at
low tide, by a covering of hard plates.

121 **Male Wolf-eel**
Anarrhichthys ocellatus
WRECK OF THE *THEMIS*, CROKER ROCK, QCS
A male wolf-eel looks out from within the
wreckage of a sunken ship, which he
and his mate have made their home.

122–3 **Adult Male Wolf-eel**
Anarrhichthys ocellatus
Fierce looking but inoffensive, the male wolf-
eel can be as much as 8 ft/2.5 m long. His
powerful jaws and teeth are used for breaking
open shellfish.

124–5 **Juvenile Wolf-eel**
Anarrhichthys ocellatus
Left: HUSSAR POINT, NIGEI ISLAND, QCS
Right: CRAMER PASS, GILFORD ISLAND
The long, thin object protruding from the
mouth of the wolf-eel on p. 124 is the
antenna of a recently swallowed shrimp.

126–7 **Harbor Seal**
Phoca vitulina
GOWLLAND HARBOUR, QUADRA ISLAND
I photographed this harbor seal rubbing
its back on a large, barnacle-encrusted
boulder. A good way to scratch an annoying
itch, I would think.

128–9 **Harbor Seal**
Phoca vitulina
WRECK OF THE *THEMIS*, CROKER ROCK, QCS
This young seal seemed both curious
and friendly and spent several minutes
with my dive companion and me.

130 **Kelp Greenling (Male)**
Hexagrammos decagrammus
BROWNING PASS, QCS
The male and female kelp greenling differ
so markedly in color pattern that they were
originally described as separate species.
(The female appears on p. 29.)

131 **Stiletto Shrimp with Eggs**
Heptacarpus stylus
BLIND BAY, JERVIS INLET, SUNSHINE COAST
Caridean, or true shrimps brood their eggs
externally on appendages called pleopods,
which are also used for swimming. This
tiny female shrimp is resting on a single
blade of seagrass.

132 **Black Rockfish with Bull Kelp**
Sebastes melanops; Nereocystis luetkeana
HUNT ROCK, QCS

133 **Black Rockfish with Old Growth Kelp**
Sebastes melanops; Pterygophora californica
HUNT ROCK, QCS

134 **Spiny Pink Scallop**
Chlamys hastata
NORTH HANSON ISLAND, JOHNSTONE STRAIT
Note the row of tiny eyes along the margin of each shell. Nearby movement may trigger a flight response; this scallop can swim short distances by rapidly opening and closing its shells.

135 **Lined Chiton with Orange Tunicates**
Tonicella lineata; Metandrocarpa taylori
Tunicates, also called ascidians, are deceptively simple in appearance, especially in the adult form. However, the free-swimming larval stage of these small marine animals possesses a notochord, the embryologic precursor of the vertebrate spine. Tunicates are invertebrates, but are placed in the phylum Chordata with fish and other vertebrates.

136 **Six Chitons of the Pacific Northwest**
Top row: Three-rib Chiton (*Tripoplax trifida*); Lined Chiton (*Tonicella lineata*); Blue-line Chiton (*Tonicella undocaerulea*)
Bottom row: Merten's Chiton (*Lepidozona mertensii*); Ferreira's Mopalia (*Mopalia ferreirai*); White-line Chiton (*Tonicella insignis*).
Chitons (polyplacophorans) are flat, oval mollusks whose shell consists of eight hard, overlapping plates. The chiton fauna of the PNW is among the most diverse in the world, with around 35 intertidal and shallow-water species.

137 **Orange Peel Nudibranchs with Red Soft Coral**
Tochuina tetraquetra; Gersemia rubiformis
The orange peel nudibranch is the largest in the PNW and one of the largest in the world, measuring up to 18 in/45 cm. Its preferred prey is the red soft coral, *Gersemia*.

138 **Red Irish Lord and Sulfur Sponge**
Hemilepidotus hemilepidotus; Myxilla lacunosa
BROWNING PASS, QCS

139 **Giant Rock Scallop**
Crassadoma gigantea
SEVEN-TREE ISLAND, BROWNING PASS, QCS
Some of the invertebrates encrusting the scallop's shell or located nearby include: plumose anemones, *Metridium* sp.; transparent compound tunicates, *Distaplia occidentalis*; yellow compound ascidians, (probably California sea pork, *Aplidium californicum*).

141 **Giant Pacific Octopus**
Enteroctopus dofleini
SANDFORD REEF, BARKLEY SOUND
This species is the largest octopus in the world, at times exceeding 100 lbs/45 kg with an armspread of 20 ft/6 m or more, although most individuals encountered are much smaller.

142 **Giant Pacific Octopus**
Enteroctopus dofleini
VERNON ROCK, QCS
This young octopus was smaller than most individuals I have seen.

143 **Decorated Warbonnet**
Chirolophis decoratus
AGAMEMNON CHANNEL, SUNSHINE COAST
This fish with an elongate body and punk hairdo is notoriously shy. When spotted, it is usually peeking out from a small hole deep inside a dark crevice, taunting me or some other frustrated photographer.

144 **Decorated Warbonnets**
Chirolophis decoratus
BROWNING PASS, QCS
Despite the obvious size difference, these are probably a mated pair. The belly of the much larger female appears swollen with eggs.

145 **Giant Pacific Octopus**
Enteroctopus dofleini
BROWNING PASS, QCS
I noticed this large octopus on the wall in Browning Pass, near the end of my dive. I took one photograph, and the octopus immediately let go of the wall, moving quickly toward me. Not wanting to tangle with this eight-armed giant, I backed away as quickly as I could, capturing this image as I retreated. Years later I still wonder what caused the octopus to react in this unusual manner: was it startled and disoriented by the flash going off, or was it simply curious?

146 **Giant Pacific Octopus—Detail**
Enteroctopus dofleini
BROWNING PASS, QCS

147 **Mosshead Warbonnets**
Chirolophis nugator
BROWNING PASS, QCS
This smaller cousin of the decorated warbonnet seems less shy. It lives in shallower water and is more frequently encountered by divers.

148 **Sunflower Stars**
Pycnopodia helianthoides
WHITE NOB POINT, MINSTREL ISLAND
The world's largest sea star, the sunflower star may be 4 ft/1.2 m across and possess as many as 24 arms. It is a voracious predator on a variety of benthic (bottom-dwelling) invertebrates, including sea urchins, sea cucumbers, hermit crabs, and clams.

149 **Octopus and Sunflower Stars**
Enteroctopus dofleini; Pycnopodia helianthoides
NORTH HANSON ISLAND, JOHNSTONE STRAIT
This young octopus was dwarfed by the giant sunflower stars surrounding it. It appeared that the octopus was attempting to get across

the line of *Pycnopodia* while at the same time avoiding contact with the numerous pincerlike pedicellariae on the surface of each star.

150 **Nine Sea Stars of the Pacific Northwest**
Top row: Blood Star (*Henricia leviuscula*); Striped Sun Star (*Solaster stimpsoni*); Arctic Cookie Star (*Ceramaster arcticus*)
Middle row: Spiny Red Star (*Hippasteria spinosa*); Purple Star (*Pisaster ochraceus*); Cushion Star (*Pteraster tesselatus*)
Bottom row: Rose Star (*Crossaster papposus*); Mottled Star (*Evasterias troschelli*); Leather Star (*Dermasterias imbricata*).
The PNW has the greatest diversity of sea stars of any temperate area in the world, with approximately 50 species found in shallow, coastal waters.

151 **Purple Sea Stars and Mussels**
Pisaster ochraceus; Mytilus sp.
BROWNING PASS, QCS
The two stars on the left are draped over mussels that are being slowly digested and consumed; more mussels are present in the upper right. At the top, rocks, trees, and sky can be seen through the surface of the water. This image might be described as "the view from inside a tide pool."

152 **Black Rockfish with Bull Kelp**
Sebastes melanops; Nereocystis luetkeana
HUNT ROCK, QCS

153 **Juvenile Rockfishes with Bull Kelp**
Sebastes spp. *Nereocystis luetkeana*
BROWNING PASS, QCS
Juvenile black and yellowtail rockfishes seek shelter in the thick kelp canopy.

158 **Vermillion Rockfish**
Sebastes miniatus
HUSSAR BAY, NIGEI ISLAND, QCS

159 **Penpoint Gunnel**
Apodichthys flavidus
HUSSAR BAY, NIGEI ISLAND, QCS

160 **Pacific White-sided Dolphins**
Lagenorhynchus obliquidens
JOHNSTONE STRAIT

ABOUT THE PHOTOGRAPHY

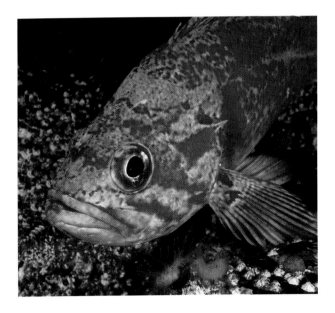

MANY OF the technical and logistical challenges of underwater photography are well-described by Chris Newbert in his Foreword to this book. While visibility in air is measured in miles, underwater photographers measure visibility in mere feet. Seawater contains numerous particles of organic and inorganic matter, and cold water usually contains many more such particles than tropical water. Along the Pacific Coast of North America, ocean water—blue in southern California—becomes increasingly green as one travels north, reflecting an increase in microscopic algae.

Algae and larger particulate matter affect underwater photographs in various ways. The blue-green or green water acts like a color filter, increasingly eliminating warm color tones as one descends and making it impossible to capture colorful images without the use of electronic strobes. While the artificial light provided by strobes allows me to render colors accurately, it can create unsightly "backscatter." This term refers to the appearance of numerous small white spots in an underwater photograph, caused by the reflection of strobe light from particles suspended in the water. This unsightly effect can be minimized by careful strobe placement, although in cold water it may be impossible to eliminate it completely.

I used the following equipment to make the photographs for this book:

CAMERAS
- Nikonos II with 15mm lens
- Nikonos RS with 13mm, 18mm, 20–35mm, and 50mm macro lenses (the 50mm was at times used with a 2× teleconverter)
- Canon EOS 5D and EOS 5D Mark II in Subal housings with 15mm, 17–40mm, 20mm, 50mm macro, and 100mm macro lenses (the 100mm was sometimes used with a 2× wet diopter)

STROBES
- Nikon SB-104
- Ikelite SS-50, SS-200, DS-51, DS-125

facing page: Vermilion rockfish

above: Penpoint gunnel

THE DAVID SUZUKI FOUNDATION

THE DAVID SUZUKI FOUNDATION works through science and education to protect the diversity of nature and our quality of life, now and for the future.

Our vision is that within a generation, Canadians act on the understanding that we are all interconnected and interdependent with nature. We collaborate with scientists, communities, businesses, academia, government and non-governmental organizations to find solutions for living within the limits of nature.

The Foundation's work is made possible by individual donors across Canada and around the world. We invite you to join us.

For more information, please contact us:

The David Suzuki Foundation
219–2211 West 4th Avenue
Vancouver, BC Canada
V6K 4S2 www.davidsuzuki.org
contact@davidsuzuki.org
Tel: 1-800-453-1533

Checks can be made payable to The David Suzuki Foundation.
All donations are tax-deductible.

Canadian charitable registration: (BN) 12775 6716 RR0001
U.S. charitable registration: #94-3204049

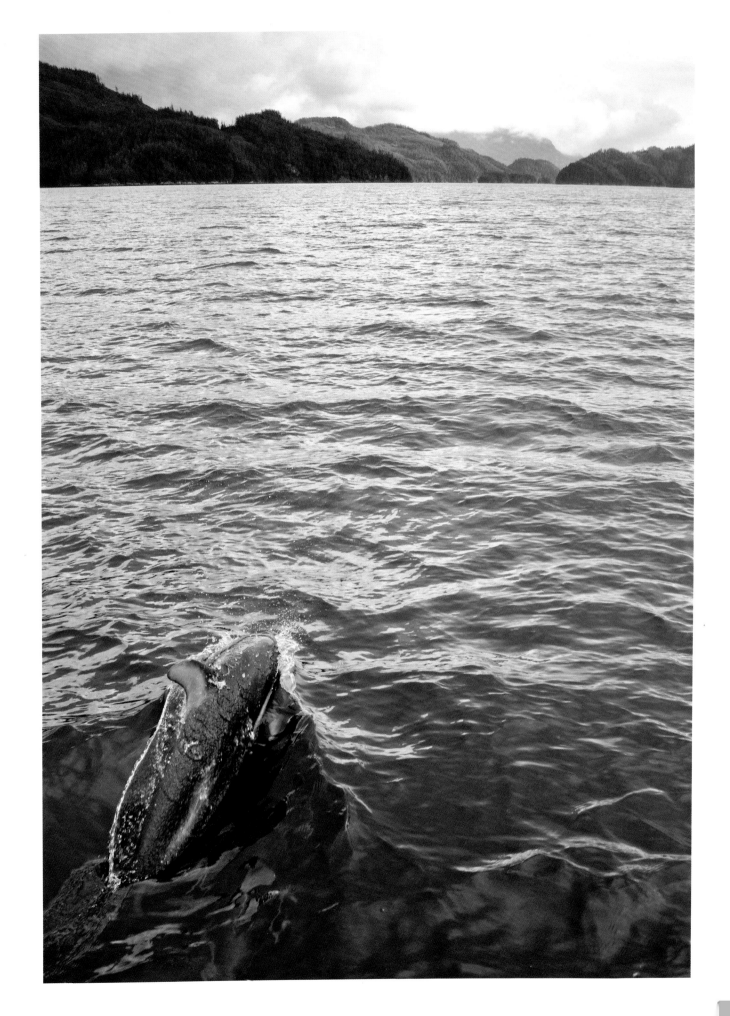

White-sided dolphins